Retro*PHOTO*

AN OBSESSION

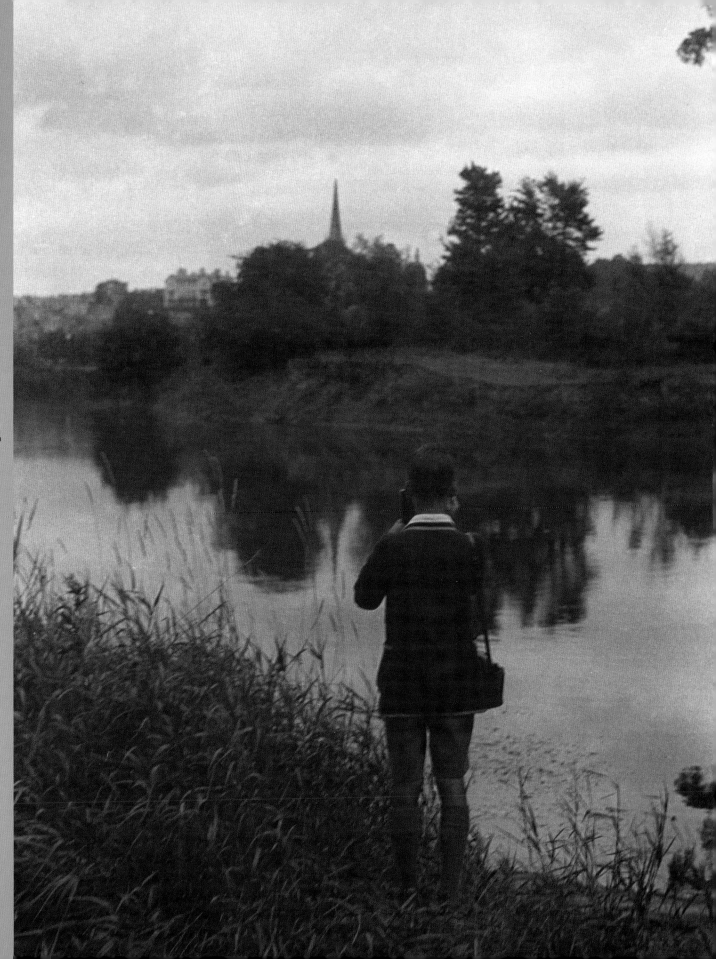

BOY WITH CAMERA
Found negative (6 x 9in format)
I've always loved this image. The
negative was found, along with
a few others, in the bottom of a
Thornton-Pickard camera case
purchased at an antique fair.

All photography © by David Ellwand,
except p. 12 "Angry Geese" and p. 31
"Mural, Bologna" © by Lydia Ellwand

First U.S. edition 2016
First published in England in 2015 by
Old Barn Books Ltd

Library of Congress Catalog Card
Number pending
ISBN 978-0-7636-9250-6

LEO 21 20 19 18 17 16
10 9 8 7 6 5 4 3 2 1

Printed in Heshan, Guangdong, China

This book was typeset in Goudy Modern
and Univers.

Candlewick Studio
an imprint of
Candlewick Press
99 Dover Street
Somerville, Massachusetts 02144

www.candlewick.com

▷ *A Personal Selection of Vintage Cameras and the Photographs They Take*

David Ellwand

CANDLEWICK STUDIO

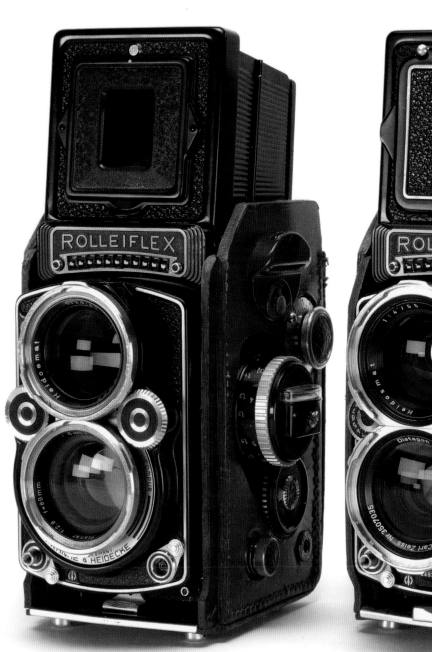
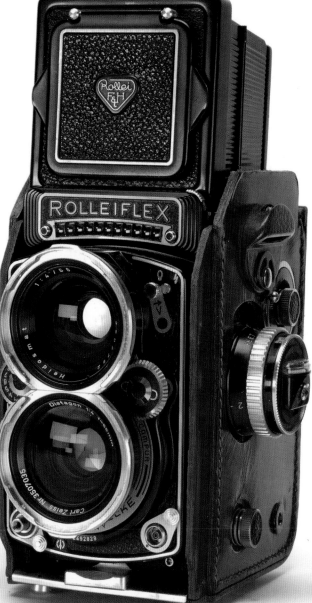
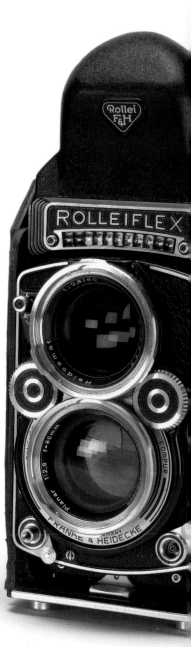

CONTENTS

ROLLEIFLEX 2.8F
fitted with Rolleikin 35mm
conversion kit

ROLLEIFLEX WIDE MARK 1
Lens: 55mm Distagon

ROLLEIFLEX 2.8F
with prism finder

All in original half-leather cases

INTRODUCTION

▽

There can't be many instances in history of a technological change that has left so many beautiful products redundant as the change from film photography to digital. Since William Henry Fox Talbot's announcement of his negative positive photographic process in 1839, the basic principles had stayed in place for more than 150 years. As a result of Talbot's invention, the photographic industry was born. We owe the whole of photography's history to the brilliance of Talbot. Without Talbot, there would be no Kodak, and without Kodak, there would be no digital.

I remember the first time I put a roll of film in a camera. I was sitting in the backseat of my dad's Ford Zephyr, parked outside a chemist's shop. I'd be around eight or nine years old. We had just bought a roll of 620 film to put in a Kodak Junior folding bellows camera that had belonged to an older relative. The smell of film is like nothing else — it's intoxicating and, I'm sure, slightly addictive. Winding the film through the camera, peeking through the little red window, watching the arrows on the backing paper until you reach number 1. You only had a few shots — just eight in this case. This made you think hard about composition and exposure.

I've been lucky to straddle the cusp of change and witness the amazing transformation from traditional chemical-based photography to digital. It wasn't too long ago that processing shops were on the main streets of every major town, there were mini-lab machines to process film in airports and supermarkets, photo-processing companies would put envelopes through your door — you simply put your film in and sent them off and a week later a packet of photos would arrive. In major cities, big professional labs ran twenty-four hours a day processing films for the fashion industry, architects and real-estate agents. Couriers would run film from photographer to labs and then to editors and designers. There were traditional wet darkrooms in hospitals, museums and police forensic offices. Nearly all of this has gone, replaced by the quicker, more convenient and instantaneously miraculous digital process. As a result of the change, there are now a huge number of film and plate cameras for sale in thrift shops, at antique fairs and tag sales, and on the Internet. Whilst researching the book, I was staggered to read how many cameras have been manufactured, and I'm sure it's impossible to even estimate how many billions of feet of film have been made and sold.

Now that digital photography dominates the marketplace, why would you still choose to use film?

The combination of traditional film photography with digital technology is a marvel. To shoot a roll of film or hand-coat a wet collodion plate, expose and process it, then scan it in super-high resolution seems a natural solution, the best of both worlds.

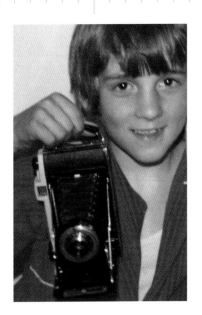

35MM

In 1889 the brilliant George Eastman, founder of Kodak, and his team of chemists perfected the first commercially available transparent roll film, using a flexible nitrocellulose film base coated in photographic emulsion. By 1976, Kodak was said to command 90 percent of film sales and 85 percent of camera sales in the United States.

Photographic folklore has it that in 1893 Thomas Edison's assistant Dickson took a piece of 70mm film, cut it in half, and added sprocket holes to enable small loops to be played on the newly invented Kinetophone, on which a single person could watch a short film, incorporating sound. This story is disputed, but there seems to be no doubt that 35mm film first appeared out of Edison's workshop. Thirty-five-millimeter still photography was launched on the back of the motion picture industry, once film quality had improved sufficiently to enable photographic enlargements to be made from the very small negatives. The sprocket holes, or perforations, are punched into the film during manufacture. A sprocket, or claw, transports the film through the camera using these perforations. Current 35mm film always uses the Kodak standard perforation.

Nitrocellulose film had one major flaw: it was extremely flammable. There have been many terrible instances of devastating fire caused directly by nitrocellulose film. It has the ability to spontaneously combust, and the older it gets, the more unstable it becomes. In 1929, seventy-one people, mostly children, were killed during a matinee film performance at the Glen Cinema in Paisley, Scotland. A reel of film that had just been shown was put back into its canister and accidentally placed on top of a battery, causing the battery to short-circuit and the film to combust. Nitrocellulose film even burns underwater. There have been many instances of film archives becoming unstable and spontaneously combusting. A film vault in George Eastman House self-combusted in 1978. Nitrocellulose film was phased out in 1952. Ironically, Kodak had produced the safer acetate film for the amateur market in smaller formats since 1909.

The 35mm film format was recognised as a standard in 1909. Now camera manufacturers were free to design knowing that film would always be available. The standardisation of materials in the photographic industry has contributed enormously to its development throughout history.

Most 35mm cameras take the standard 24 x 36mm format, a rectangle in the ratio 2:3, but camera manufacturers have used the versatility of 35mm film to create many different formats.

Half-frame
18 x 24mm

Square
format
24 x 24mm

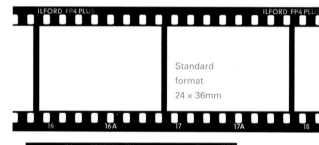

Standard
format
24 x 36mm

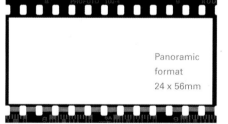

Panoramic
format
24 x 56mm

A half-frame camera takes standard 35mm film, but only exposes half the standard format—typically, 18 x 24mm. Half-frame cameras take twice as many photos as standard 35mm cameras, but inevitably the image quality is inferior, due to the reduced image size. The format gained popularity in the 1960s after the introduction of the Olympus Pen series, launched in 1959. It was called the 'Pen' because it was considered to be as easy to use as a pen. The Pen series of cameras sold in excess of 17 million units. The model featured here is the EE.3, named for the 'electric eye' selenium meter which surrounds the lens.

ANGRY GEESE
Taken with Olympus Pen EE.3
using Kodak Tri-X 400ASA film

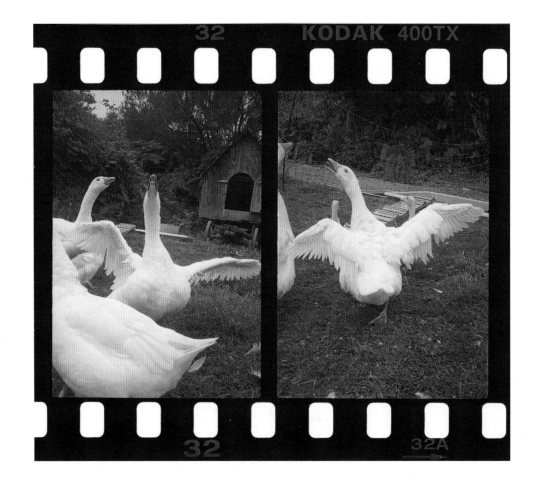

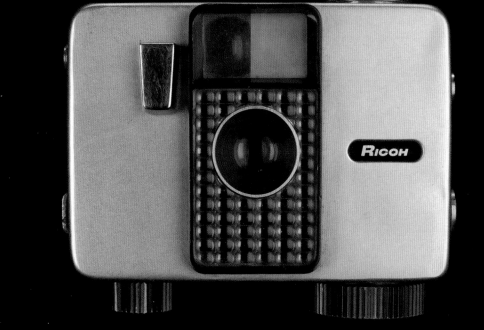

RICOH AUTO HALF
1960–1963

Lens: Ricoh 1:2.8 25mm
Riken Optical, Tokyo,
Japan (later Ricoh
Company Ltd)

Clockwork motor-driven point-
and-shoot auto-exposure camera.
One winding of the clockwork
motor can give up to
30 exposures.

OLYMPUS PEN EE.3
1973–1983

Lens: Olympus D.Zuiko
1:3.5 28mm
Olympus Kogaku, Japan

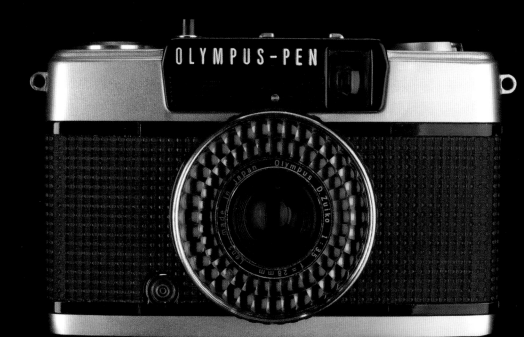

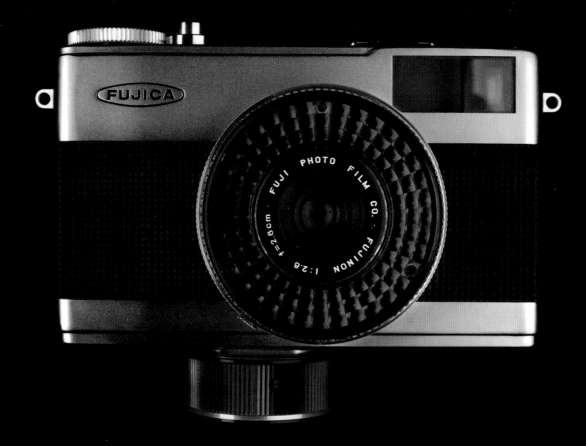

FUJICA RAPID D1
1966

Lens: Fujinon 1:2.8 28mm
Clockwork-driven
Fuji Photo Film Co., Japan

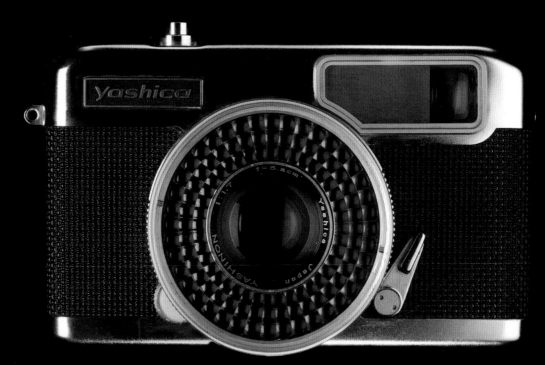

YASHICA HALF 17 RAPID
1965

Lens: Yashinon 1:1.7 32mm
Yashica Co. Ltd, Tokyo,
Japan

In the 1930s, Agfa developed its own cassette system, known as the Karat. The system was revived in the 1960s as the Rapid Film system. Agfa stopped production in 1992.

Cameras that took Agfa Rapid film can be bought very cheaply and used successfully by reloading the Rapid cassette with a short length of 35mm film.

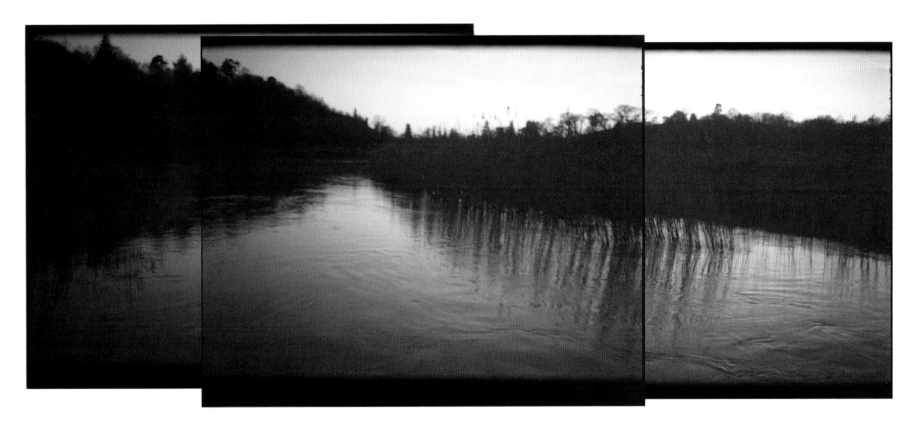

LAST LIGHT ON THE RIVER
Three landscape half-frame shots taken with the Fujica Rapid on Agfa 200 film. The images have been scanned and digitally overlaid.

Original Agfa Rapid cassette

The Karat system allowed film to be transferred from one cassette to the other, bypassing the need for a film rewind mechanism. The cameras shown here were designed to use the Karat system but can be run now by reloading the Rapid cassettes, as described on the previous page.

▷ **AGFA KARAT**
1938–1941

Lens: Agfa Solinar
1:3.5 50mm
Agfa, Munich,
Germany

▷ **AGFA KARAT**
1937

Lens: Agfa Anastigmat Igestar
1:6.3 50mm
Agfa, Munich,
Germany

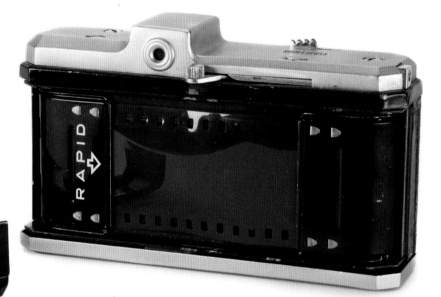

TWO ORIGINAL FULL-FRAME
AGFA KARAT CAMERAS
You can identify these by the lack
of rewind mechanism on top
of the camera.

▷ **BILORA RADIX 56**
[SQUARE FORMAT]
1949

Lens: Biloxar Anastigmat
1:5.6 40mm
Format: 24 x 24mm
in Agfa Rapid cartridges
Kuerbi & Niggeloh,
Radevormwald, Germany

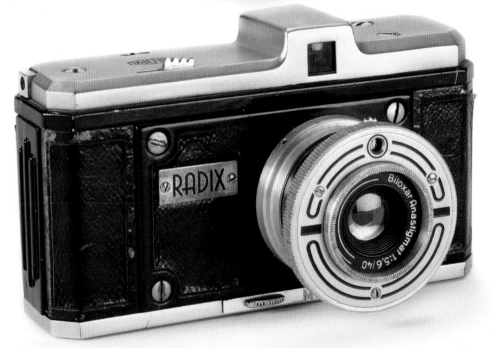

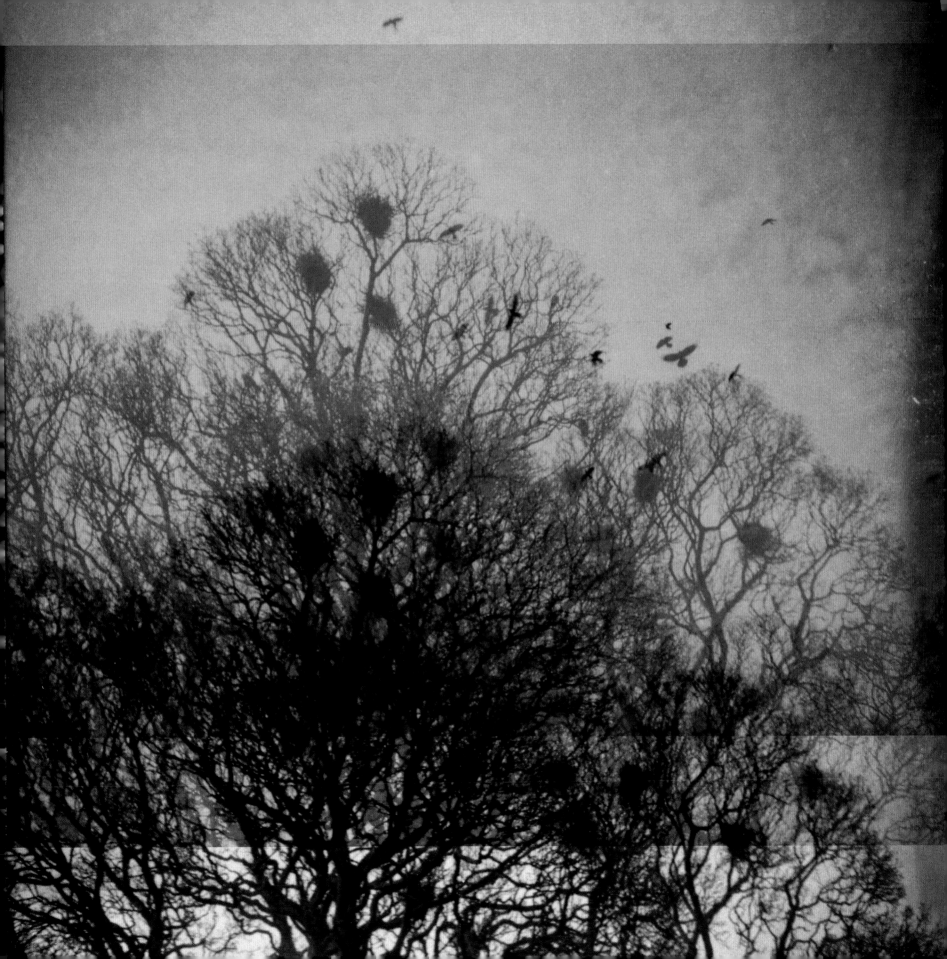

▷ **ALTIX III 35MM**
1949–1953

Lens: ROW Tegonar
1:3.5 35mm
Format: square 24 x 24mm
Eho-Altissa, Dresden,
Germany

The Altix is a tiny (11 x 7.5 x 5cm)
stylish, beautifully built camera
that fits in most pockets.

CROWS' NESTS
Agfa 200 Vista. Layered
photographic composite.

35MM STANDARD 135 CASSETTE
SQUARE FORMAT. 24 X 24MM

In 1934, Kodak introduced the 135 metal cassette for holding
35mm film. Prior to this, manufacturers such as Leica had
produced their own film cassettes.

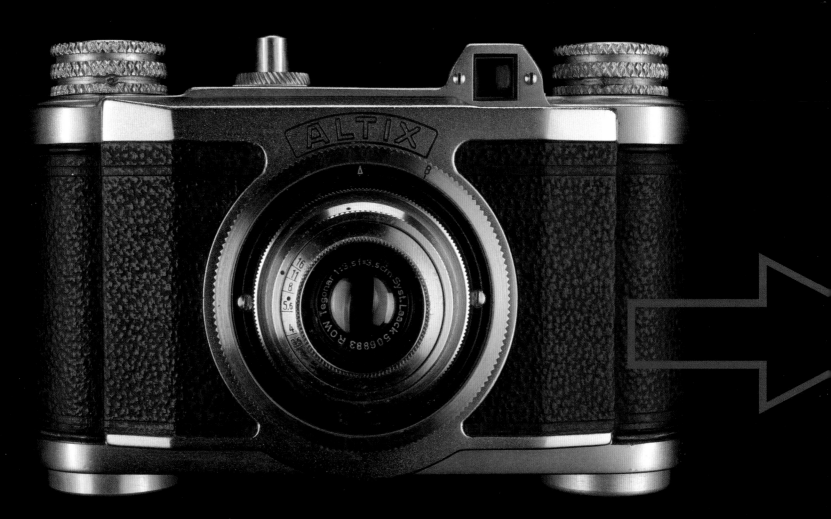

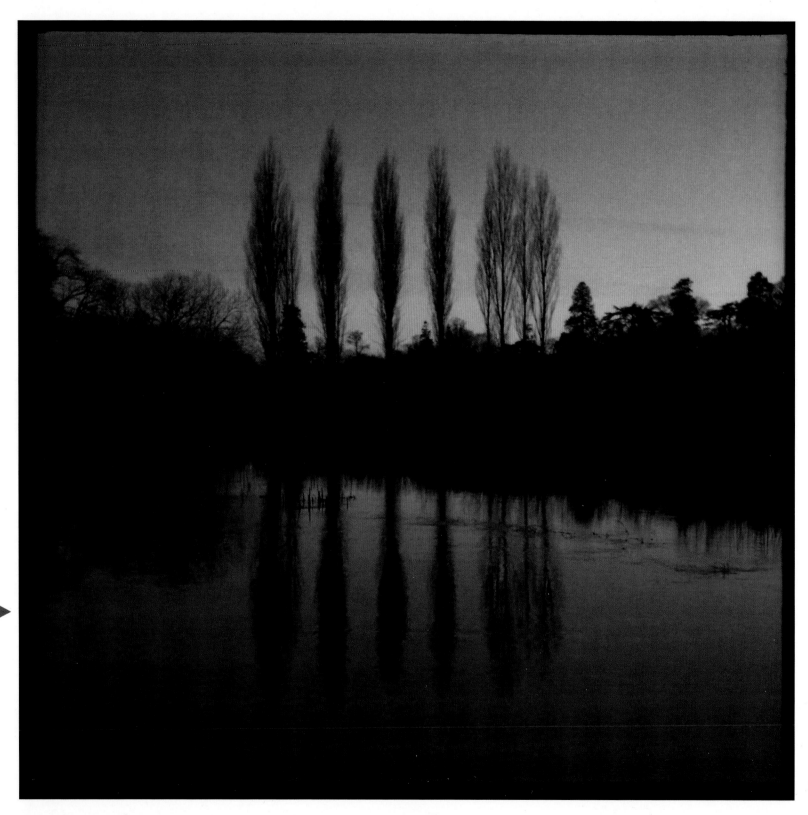

POPLARS, ARUN

Agfa 200

ROBOT STAR 25
1969

Lens: Schneider-Kreuznach
Xenar 1:2.8 38mm
Format: square 24 x 24mm
Robot Foto, Germany

11 x 8.5 x 7.5cm

One of the greatest 35mm cameras ever made. Superstrong with fantastic optics. The Robot camera at first glance looks cheap, rather like a toy. It was designed by Heinz Kilfitt, a watchmaker, in the early 1930s. Kilfitt patented the design and later sold it to Hans Heinrich Berning, who took on some of the people who had worked

with Kilfitt and developed the business. Kilfitt continued with camera and lens design, making some remarkable macro lenses and designing the camera which, once sold to the Japanese company, became the Kowa Six (see page 108).

The Robot Star has a heritage of use in the espionage business. Once the clockwork mechanism

is wound, the camera can shoot up to 25 square shots at relatively high speeds.

The cameras were small enough to be hidden inside briefcases or under coats and triggered via a long cable release. If you ever get the chance to buy a Robot, particularly the 25, 50 and Royal models, I urge you to give it a try.

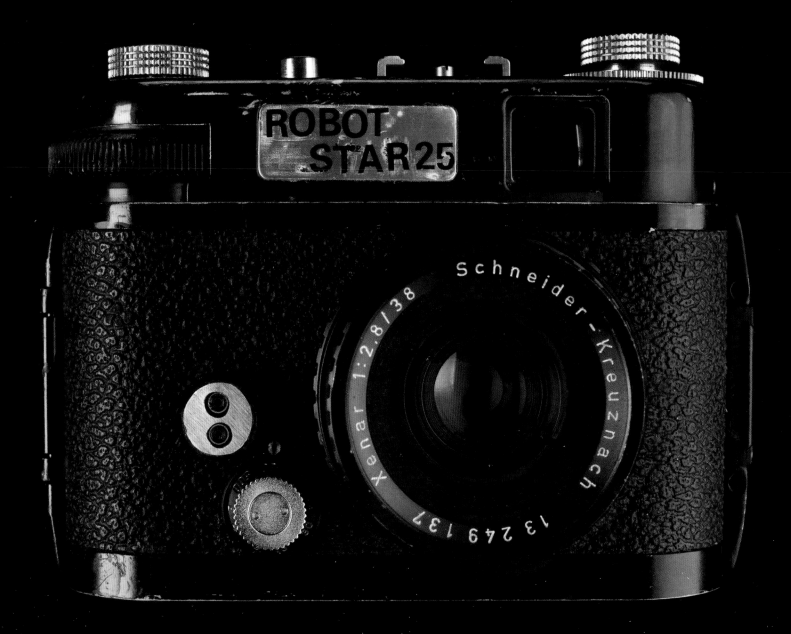

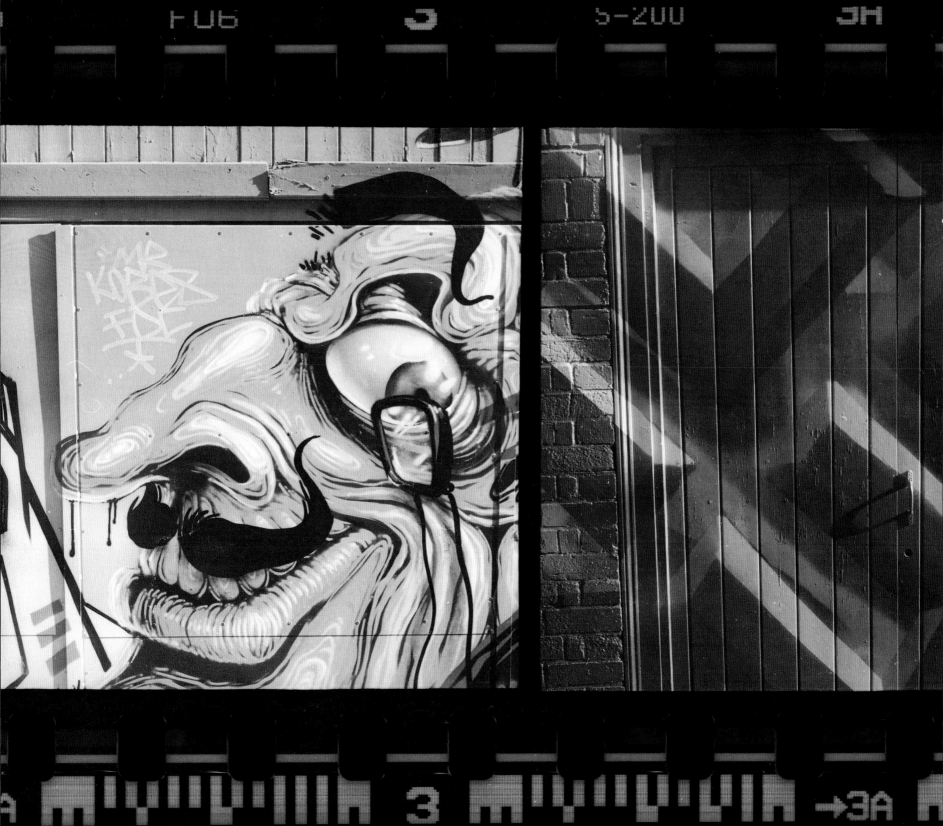

FULL-FRAME VIEWFINDER 35MM CAMERAS

Mainly manufactured for the amateur market

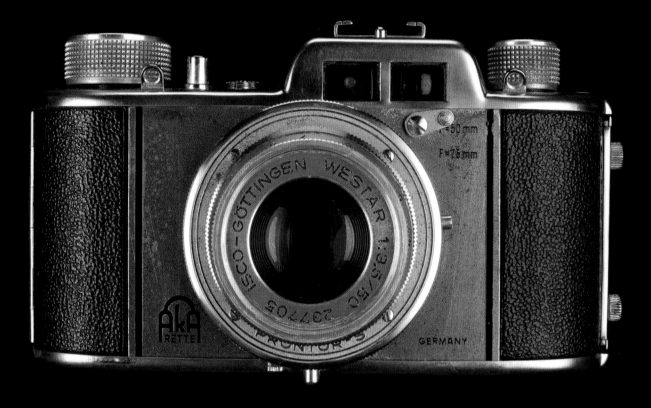

▷ **AKARETTE II**
late model 1950–1954

The viewfinder is switchable for 50mm & 75mm focal lengths.
Lens: Isco-Göttingen Westar 1:3.5 50mm
Format: full-frame 35mm
Apparate & Kamerabau, Germany

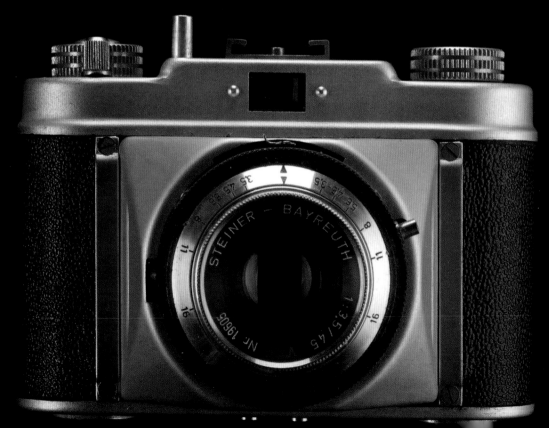

▷ **HUNTER 35**
1957

Lens: Steiner-Bayreuth 1:3.5 45mm
Format: full-frame 35mm
R.F. Hunter, London, England
A rebranded German Steiner Steinette

PENTONA II 35MM
1963

Lens: Meyer-Optik Görlitz
Trioplan 1:3.5 45mm
Format: full-frame 35mm
Kamera Werkstätten,
Germany
(later VEB Pentacon)

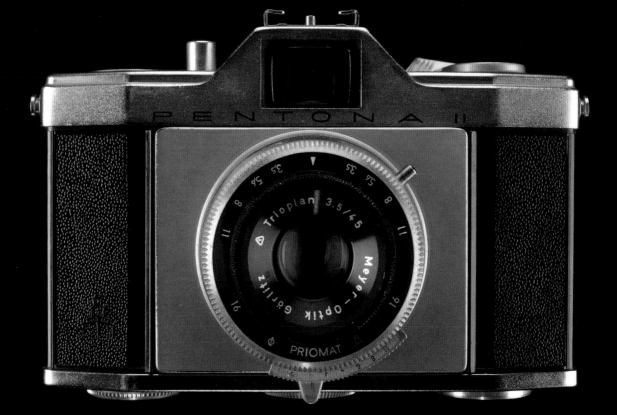

BEIRETTE
1963

Lens: E. Ludwig Meritar
1:2.9 45mm
Format: full-frame 35mm
Beier, Freital, Germany
(became part of VEB
Pentacon in 1980)

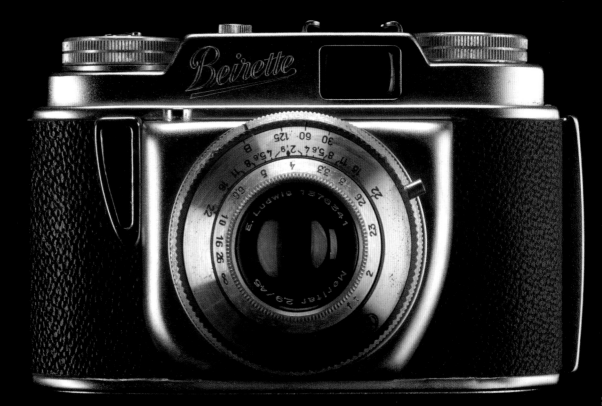

This Finetta camera takes soft, muted colour photos, giving a true retro feel. With a viewfinder camera there are no focusing aids—you simply rotate the lens focusing ring and manually set the scale to the approximate distance. Often the lenses are marked with red dots or an engraved spot on the aperture and focus ring. By setting these you achieve the optimum sharpness for general shooting conditions. Any alterations in exposure are simply made via the shutter speed.

▷ **FINETTA IV D**
1950

Lens: Finetar 1:4 43mm
Format: full-frame 35mm
Finetta-Werk, Goslar,
Germany

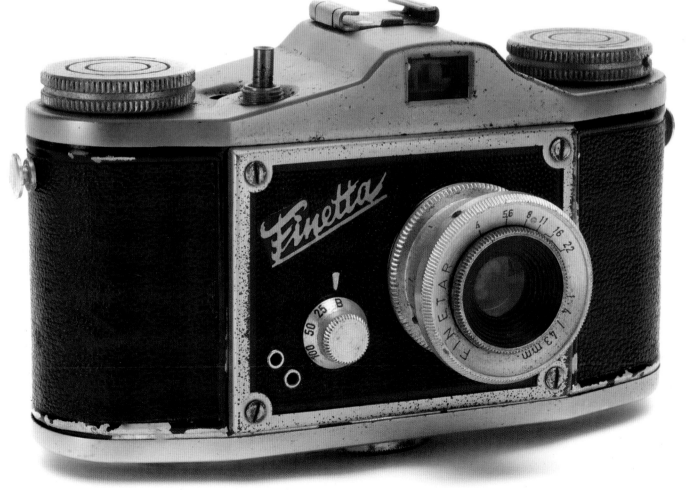

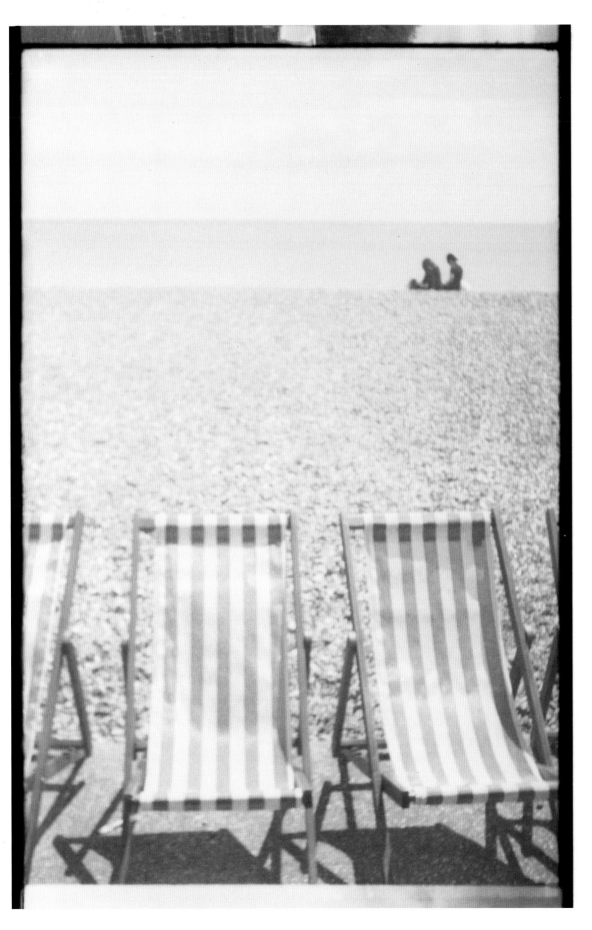

DECKCHAIRS, BOGNOR REGIS
Kodak 100 Gold

A blatant copy of the 1960
Ricoh Auto 35. Sixty thousand
units of this model were made.

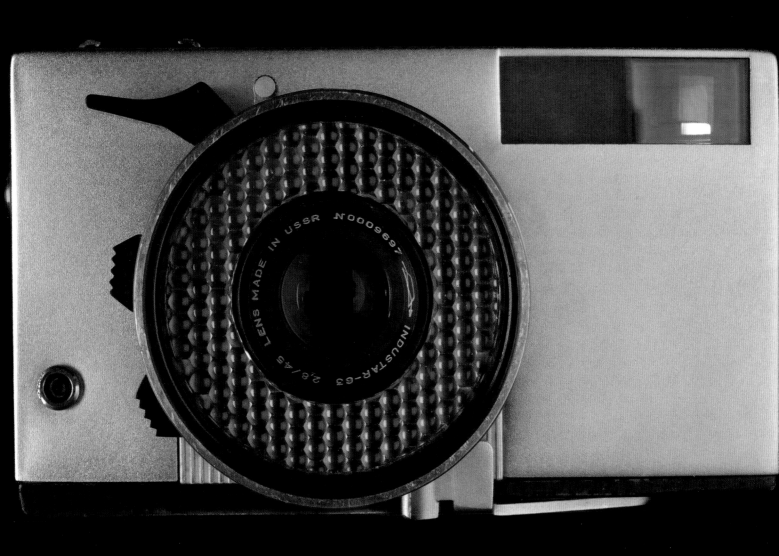

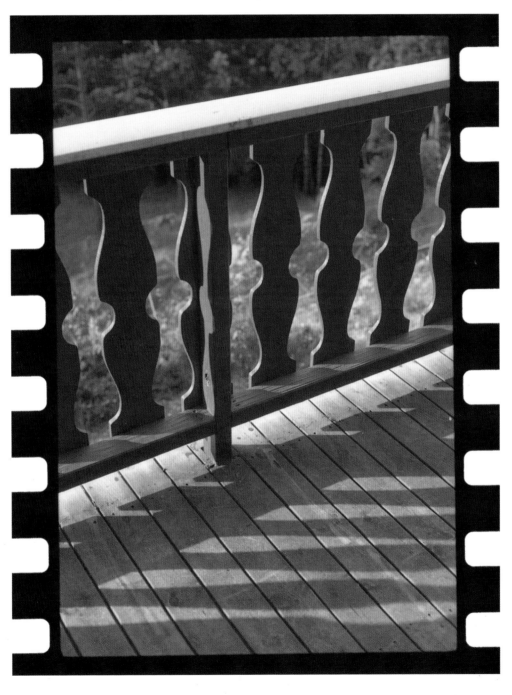

VERANDAH, NORWAY
Ilford FP4

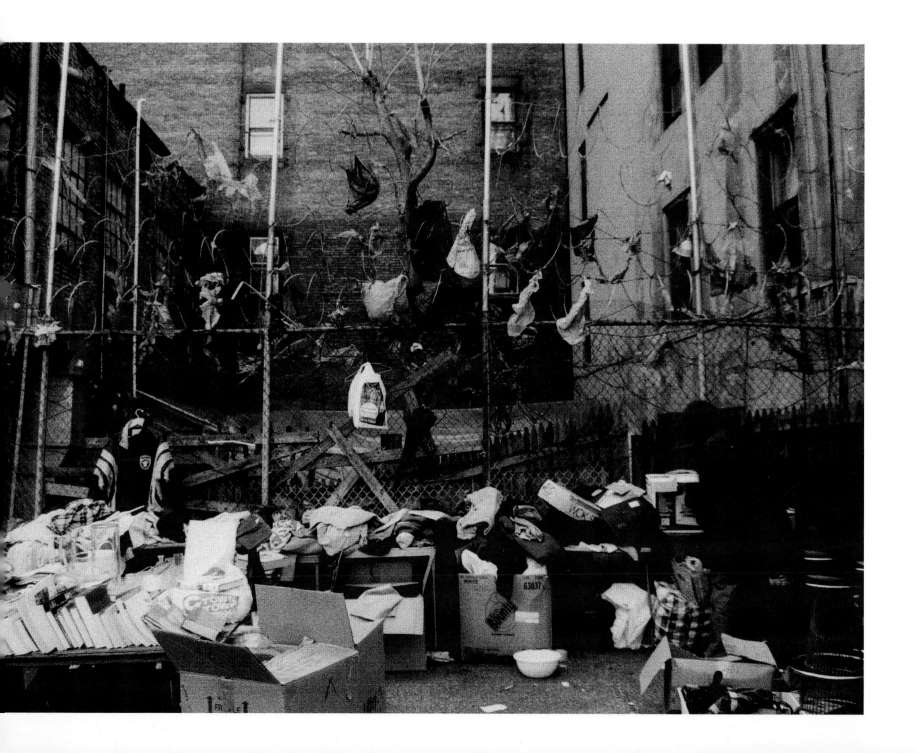

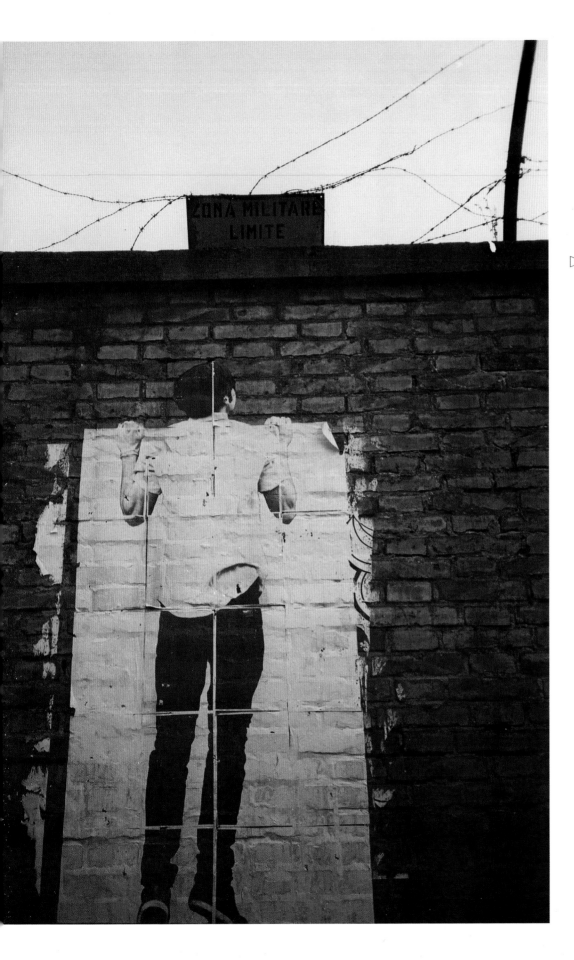

▷ OLYMPUS MJU 1 35MM
1991

Lens: Olympus 1:3.5 35mm
multi-beam autofocus
Called the Infinity Stylus
in the USA
Olympus Kogaku, Japan

Over 5 million sold. One of the
best compact point-and-shoot
autofocus cameras ever made.

STREET MARKET, NEW YORK
Kodak Tri-X

MURAL, BOLOGNA
Kodak Tri-X

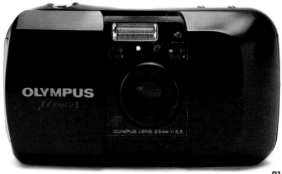

▷ **LEICA IIIc**
1940–1946

Lens: Summar 1:2 50mm
Format: full-frame 35mm
Ernst Leitz, Wetzlar,
Germany

The Leica is considered the finest rangefinder camera, and rare examples can fetch astronomical sums. A record for the world's most expensive camera was set in 2012 when a 1923 prototype Leica 0-series camera was sold for $2.8 million at the WestLicht Photographica auction in Vienna.

For some reason I've never had any luck with Leicas. I had an M4 model and burned a hole in the shutter trying to photograph an eclipse. And I foolishly took an M2 on a canoeing trip and capsized and lost the camera in the river. I now have this less valuable screw-lens Leica.

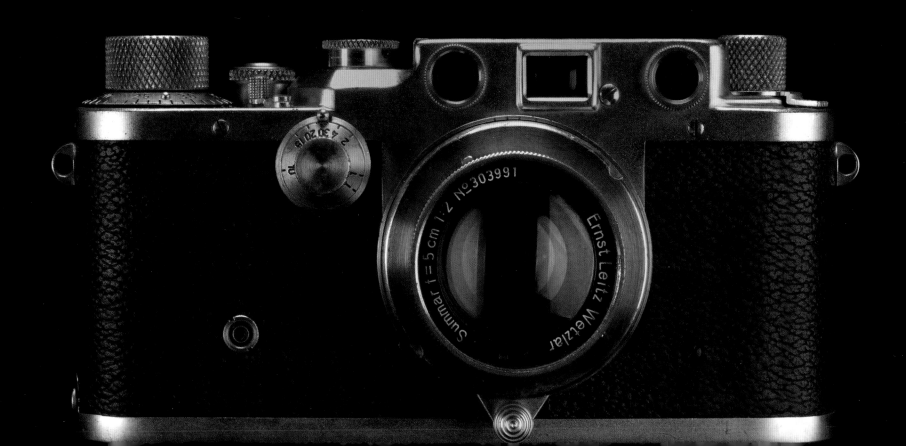

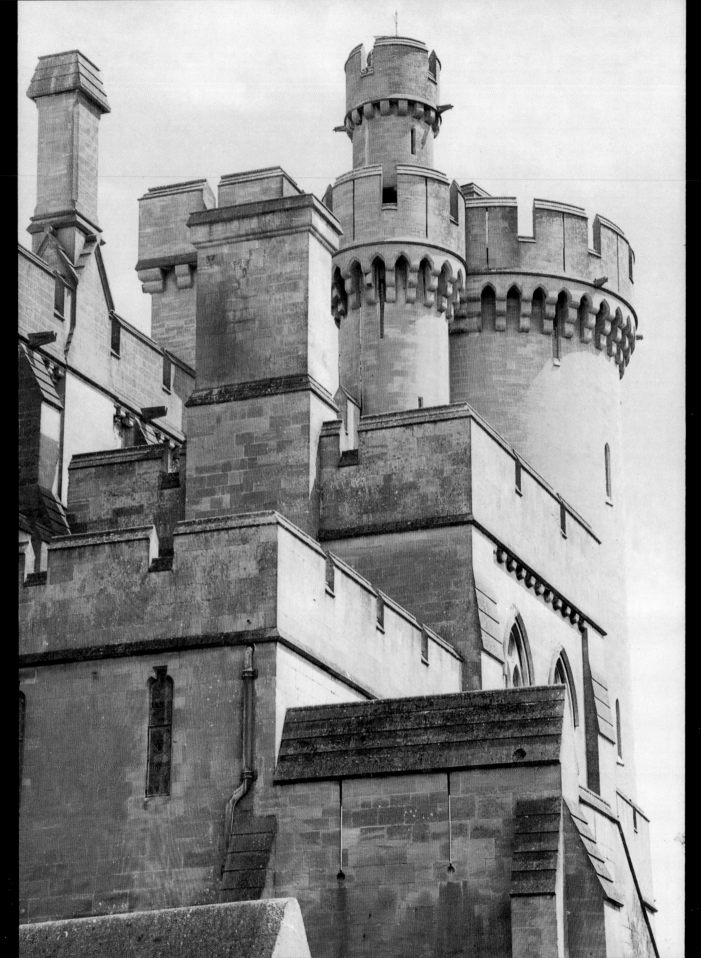

ARUNDEL CASTLE
Fujicolor 200

● LEICA

The big leap in camera design that helped popularise 35mm still photography came in 1913 from the mind of Oskar Barnack. He was head of development at the renowned optical works of Dr Ernst Leitz in Wetzlar, Germany, and had previously worked for Carl Zeiss.

Barnack was in poor health and struggled with the size and weight of the cameras available for outdoor photography at the time. He set out to make a small, high-quality camera with superior optics which produced images on 35mm motion-picture film. Barnack's first camera, known as the Ur-Leica (the 'original'), was fairly fat and contained enough film for 50 shots. Its design heritage is still visible today in the Leica M digital cameras, which are fatter than their film counterparts. From 1913 to 1924, many different preproduction Leicas were made, but the First World War intervened and meant that the first commercially available Leica did not appear until 1925.

ARGUS C3 MATCHMATIC RANGEFINDER
1968

Lens: Argus 1:3.5 50mm coated Cintar
Format: full-frame 35mm
Argus, Ann Arbor, Michigan, USA

Known as the 'brick' or the 'lunchbox' because of its thick rectangular shape, which actually makes it hard to handle.

The camera attained cult status after a Matchmatic was featured in the Harry Potter film *Chamber of Secrets*. It was used by the character Colin Creevey.

There is an urban legend that the Argus Museum in Michigan was trying to collect as many cameras as they could to build a wall within the building.

CRATES
Ilford HP5 Plus

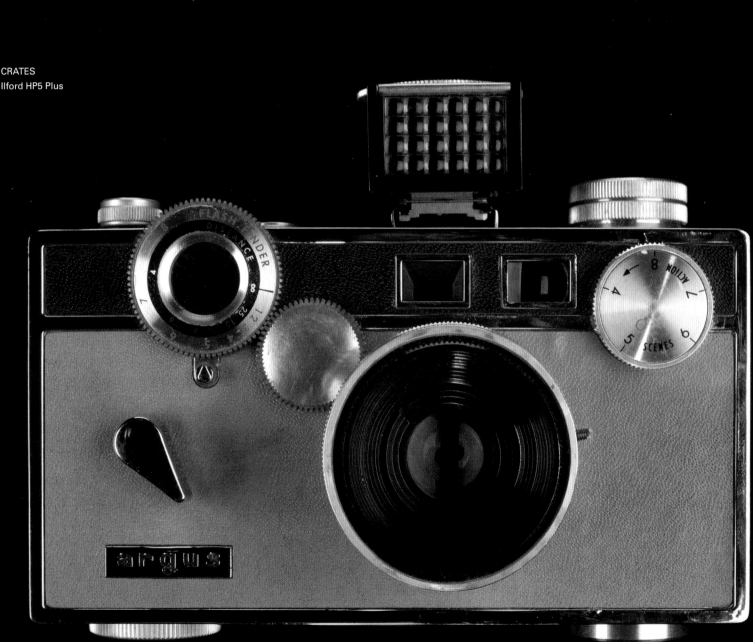

RANGEFINDER 35MM CAMERAS

Rangefinder cameras do not view the image through the lens. Instead, they have an optical viewfinder to the side of the camera. Through this, you see in the centre of the frame a double image, created by a tiny mirror and prism mechanism housed within the camera. As you turn the focus control on the lens, the overlaying image moves until the double image becomes one, confirming focus. This type of camera is far less bulky than SLR types because of the lack of mirror box and pentaprism.

One drawback is that you don't see exactly what you shoot and they are notoriously difficult to shoot close-up. Some cameras have rangefinders which are not coupled to the lens.

▷ **KIEV 4 RANGEFINDER**
1957–1980

Lens: Jupiter 8M 1:2 53mm
Format: full-frame 35mm
Arsenal, Kiev, Ukraine
Kiev made inferior-quality copies of other manufacturers' cameras. The Kiev 4 was a copy of a Contax III.

ROADSIDE SHACK, VERMONT
Kodak Plus-X Pan

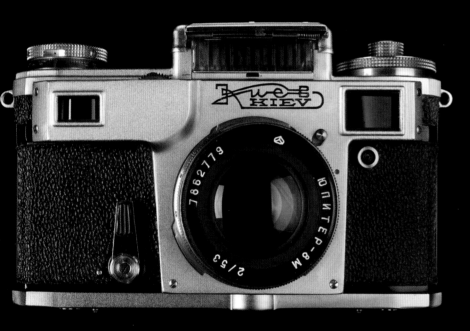

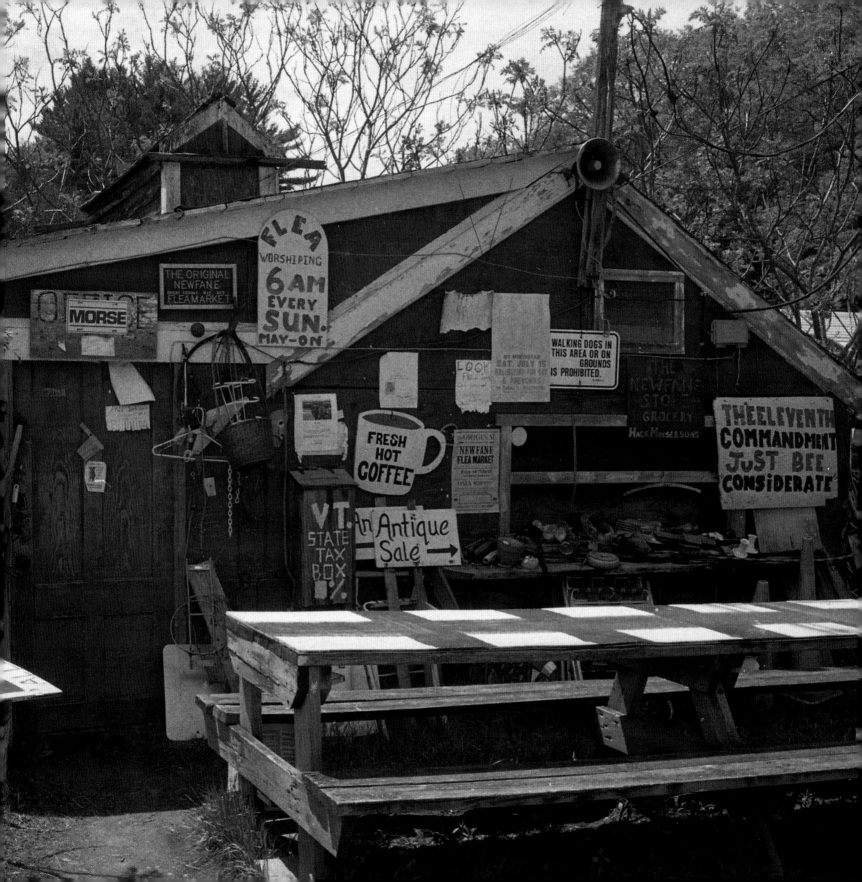

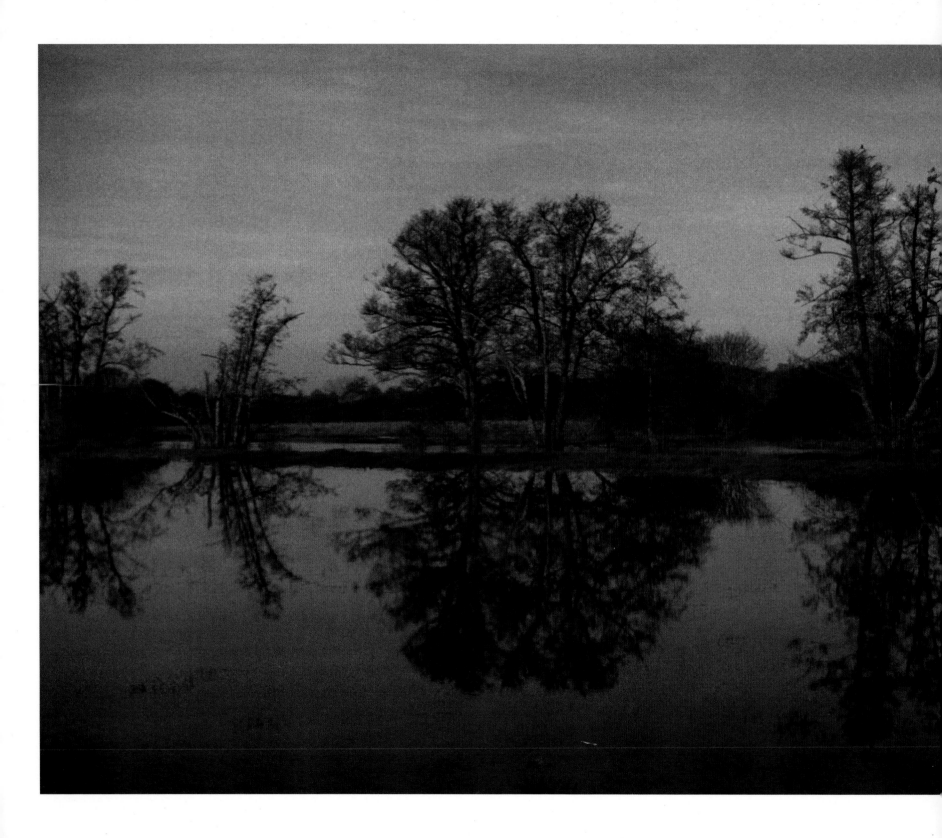

FLOODWATERS, EVENING LIGHT
Kodak 400

Lens: Riken Ricomat
1:3.5 45mm
Format: full-frame 35mm
Riken Optical, Toyko,
Japan

A great camera featuring an
underslung rapid-winder system.
Super fast to use.

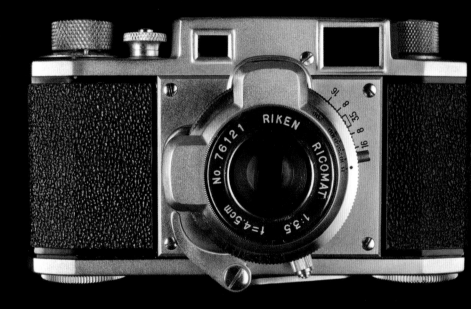

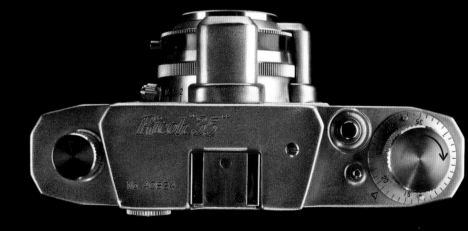

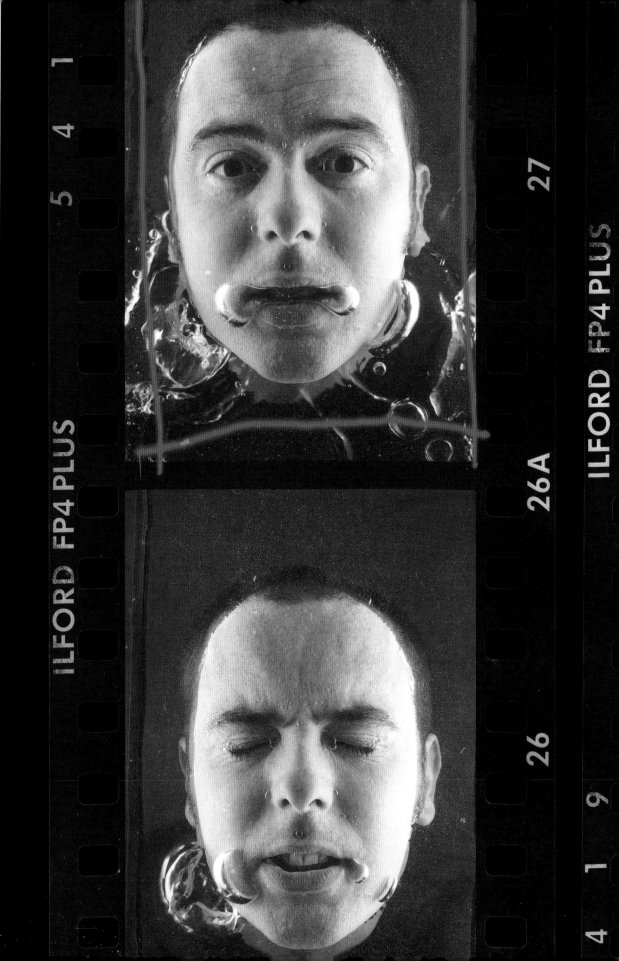

CONTACT SHEET FOR
SOUNDTRACK TO *SPLEEN*

▷ **PENTAX K1000 35MM**
1976–1997

*Lens: SMC (super multi-coated)
Pentax-M 1:1.7 50mm
Format: full-frame 35mm
Asahi Optical Co. Ltd,
Tokyo, Japan*

More than 3 million K1000s were made. In 1981, Pentax made a limited edition Gold LX, their professional model, to celebrate their ten millionth single lens reflex camera. They were the first manufacturer to achieve this milestone.

This is the camera I used whilst studying photography. The cameras are bombproof. In thirty years it has never gone wrong and never been serviced.

The Pentax K1000 is the perfect starter camera, and there are a huge number available secondhand, along with many millions of PK Pentax fit lenses. In 1981, a Pentax K1000 with standard 50mm lens cost $134.85. The same outfit would cost you about $50–$80 on the secondhand market now.

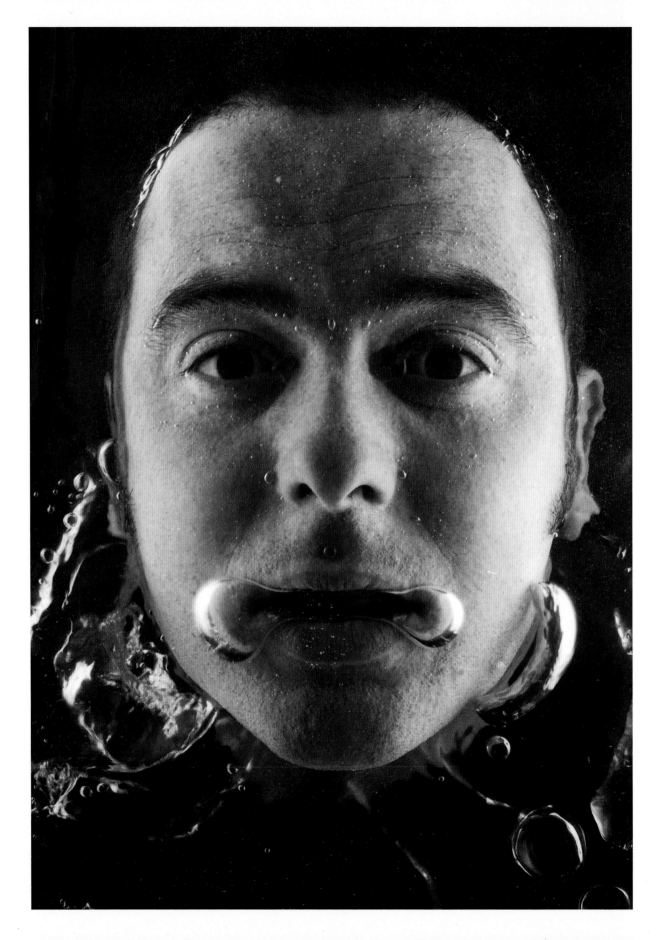

On an SLR camera, the viewfinder sees the image created by the 'taking' lens via a mirror and prism assembly. When the shutter is released, the mirror swings up and the shutter opens to expose the film. The great benefit of these types of cameras is that what you see is what you take.

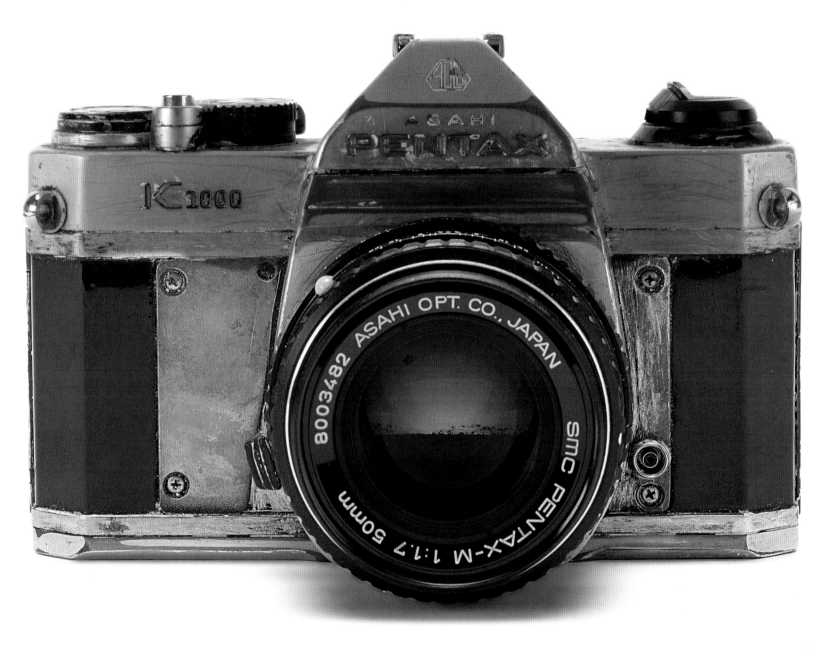

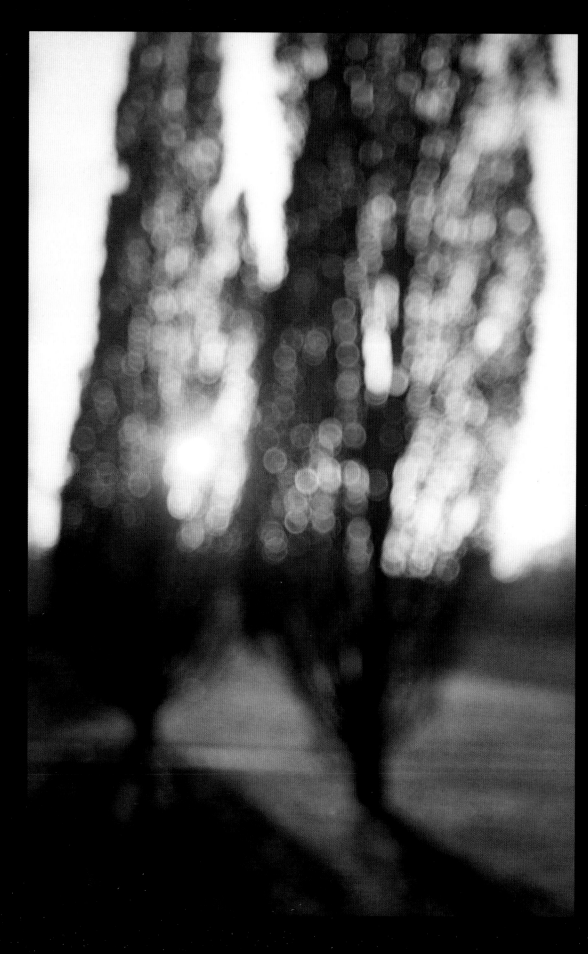

▷ **CONTAFLEX SUPER B 35MM**
1963–1968

Lens: Carl Zeiss Tessar
1:2.8 50mm
Format: full-frame 35mm
Zeiss Ikon AG, Germany

At some point in its history, this camera was dropped and the lens mount suffered damage. As a result, the lens will not focus correctly or stop down. It still works, producing very soft images with a dreamy quality.

After you have loaded a roll of 35mm film into a camera and taken a few shots, rewind the film slightly to tension it. When you wind on again, the winding knob will spin, confirming the film is running correctly through the camera and avoiding the terrible mistake of taking pictures without film.

POPLARS IN THE PARK
Fuji C200

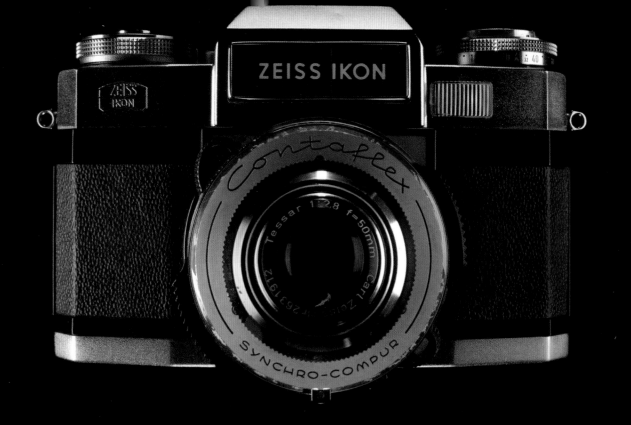

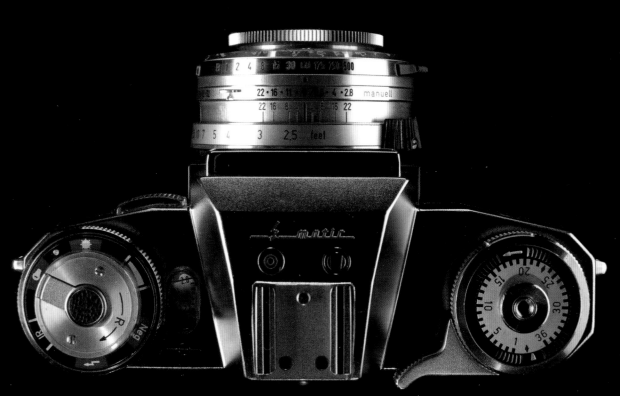

▷ ## ASAHI PENTAX SV 35MM

1962

Lens: Super-Takumar
1:1.8 55mm
Format: full-frame 35mm
Asahi Optical Co. Ltd,
Tokyo, Japan

SUNBATHERS,
NEW YORK
Ilford HP5

Complete with top-mounted
exposure meter

THE SHADOW
OF EMPIRE
Ilford HP5

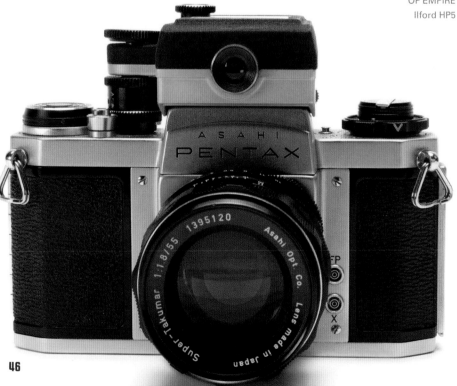

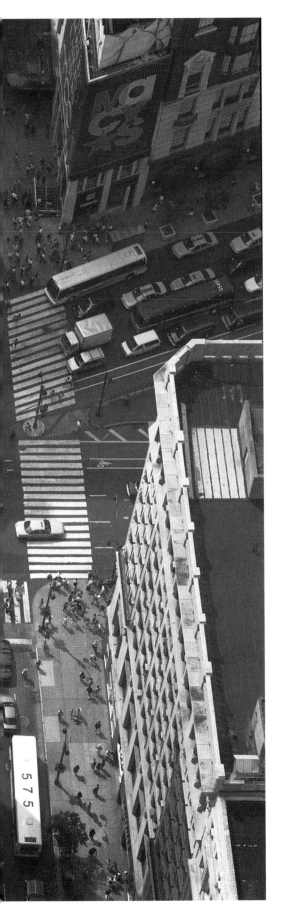

35MM SINGLE LENS
REFLEX CAMERAS

The name Carl Zeiss is central to photographic history and is a byword for quality. Zeiss opened his first optical workshop in Jena, Germany, in 1846. The company produced an astonishing range of high-quality lenses for binoculars, microscopes, telescopes and periscopes. On Carl's death, in 1889, the Carl Zeiss Foundation was formed. Foundation funds enabled university research into glass technology. At the outbreak of World War I, Zeiss switched from civilian production to military. Then, having been implicated with the Nazi dictatorship during World War II, the company was split in the postwar division of Germany.

The US Army occupied Jena immediately after the war and requisitioned many patents and designs as part of the restitution. When Jena became Soviet-occupied territory, parts of the Zeiss works were relocated to West Germany, while much of the rest of the factory and tooling was taken back to the Soviet Union to become part of the Kiev Camera Works. The two units operated independently until 1991, when they were brought back together after the reunification of Germany.

The historical division of the company meant that Zeiss lenses appeared on cheaper models of cameras, such as Praktikas and Pentacons, as well as the premium brands, such as Rolleiflex and Hasselblad. Many of the East German Zeiss lenses from the '50s, '60s and '70s are now becoming highly prized amongst digital cinematographers for the atmospheric quality of the images they produce. Adaptors are freely available.

▷ **EXA 500**
1966–1969

Lens: Carl Zeiss Jena
Biometar 1:2.8 80mm
Format: full-frame 35mm
Ihagee Kamerawerk,
Dresden, Germany

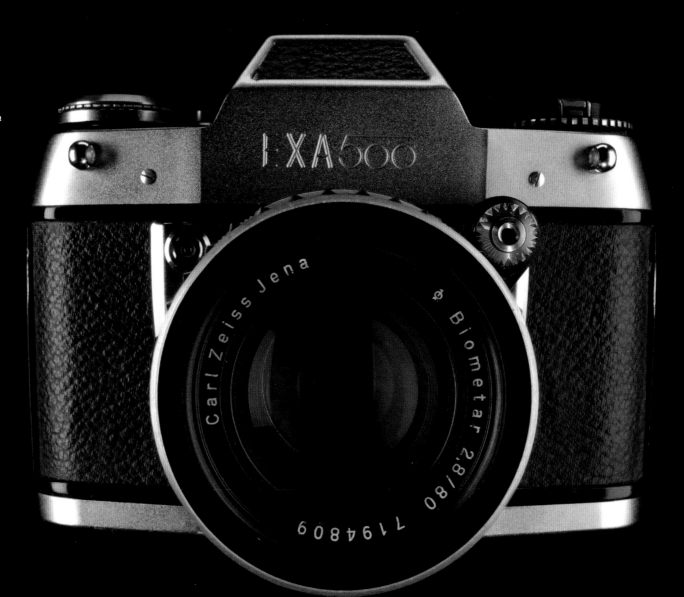

CROP CIRCLE,
HAMPSHIRE, ENGLAND
Kodak Pro 100

TATTOO PARLOUR,
BRIGHTON
Ilford HP5

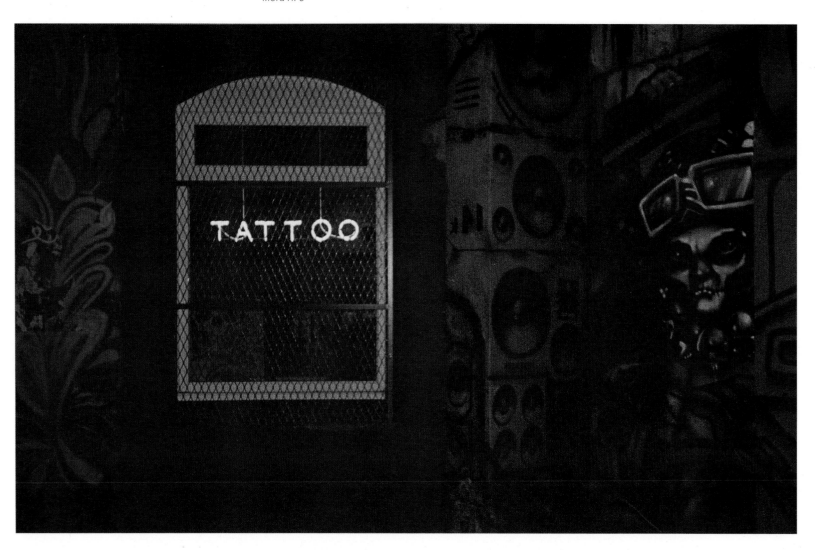

CANON T80
1985

Lens: Canon AC 1:1.8 50mm autofocus
Format: full-frame 35mm
Canon, Tokyo, Japan

The T80 was Canon's first autofocus camera and only in production for a year, so relatively rare. The T80 had multi-programmable autoexposure with autoload and a built-in motor drive. Three AC lenses were specially designed for it.

Along with the 50mm standard lens were 35–70 and 75–200 zooms. These lenses had small motors fitted to the lens housing, making them rather bulbous. The T80 lens mount accepts all the Canon FD manual lenses, as well as the specially designed autofocus lenses. When using a manual focus lens, the camera beeps to confirm focus. This made the camera particularly useful for the spectacles-wearer or partially sighted user. A great feature of the T80 is that it uses readily available AAA batteries.

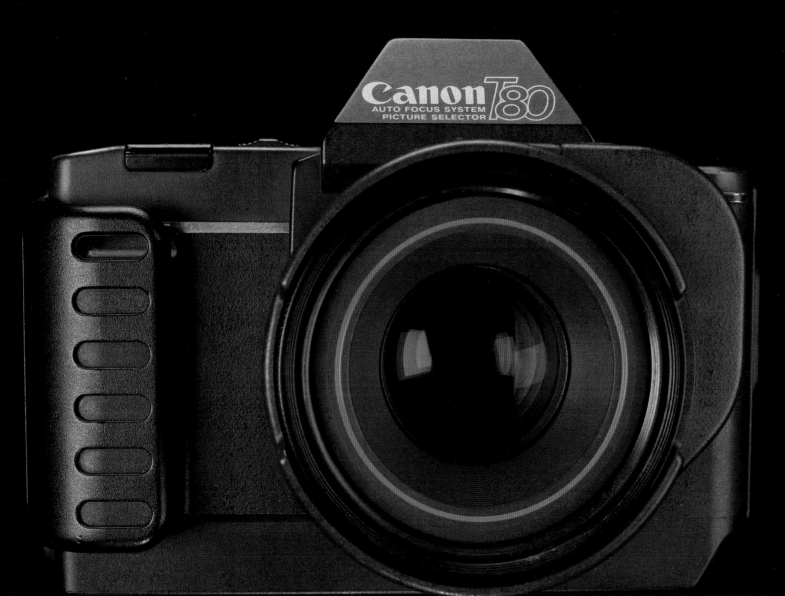

▷ **ZENITH ET**
1981–1982

Lens: Helios-44m-5 1:2 58mm
Format: full-frame 35mm
KMZ, Moscow, USSR

Depth of field is the one part of photography that baffles many students. Think of it as depth of focus: the more you want in focus, the bigger the aperture number (f/22, for example). The shallower you want the focus, the smaller the aperture number (f/2.8, for example).

CATKINS
(shot with the lens fully open using a supplementary close-up filter)
Agfa Vista 200

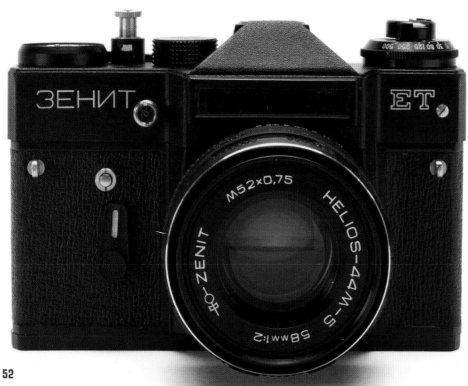

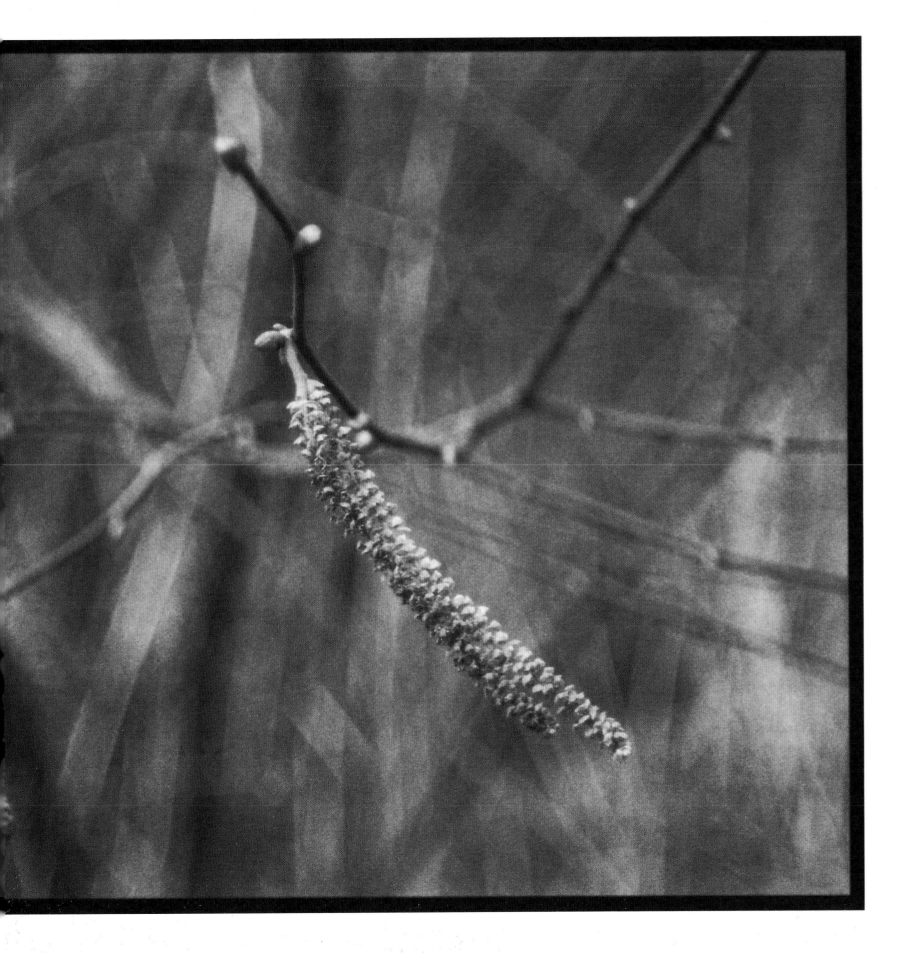

DUNSTANBURGH CASTLE,
NORTHUMBERLAND
Kodak Tri-X

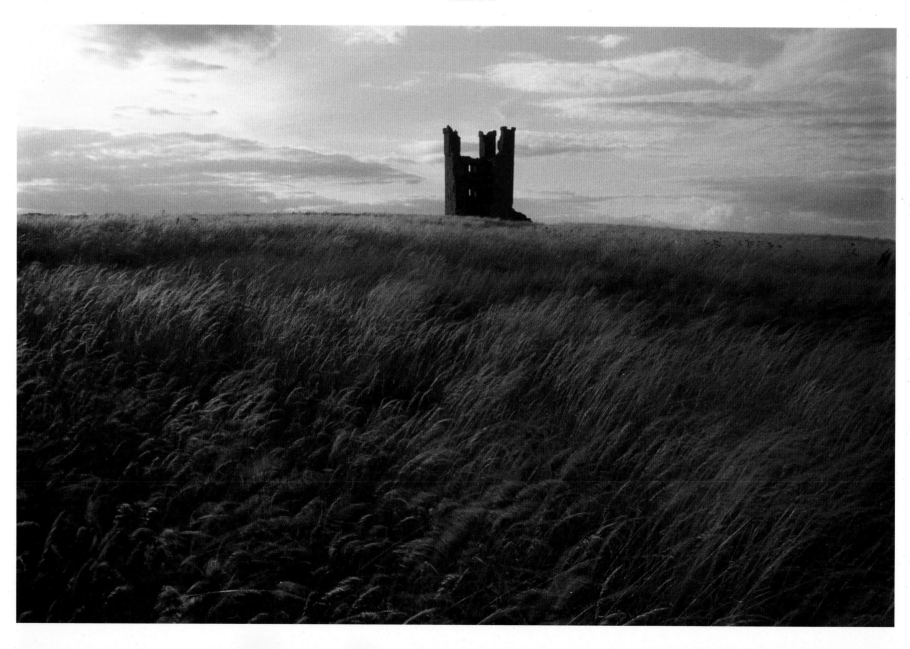

NIKON F PHOTOMIC
1965

Lens: Nikkor-H auto
1:3.5 28mm
Format: full-frame 35mm
Nippon Kogaku K.K.,
Tokyo, Japan

Nikon's analogue professional SLR series has always been known as Nikon F. The series-defining feature is the removable pentaprism and focusing screen. The Nikon F was introduced in 1959 and went through six iterations, with each model evolving to include the latest photographic technologies.

It has always been a favourite of sports photographers and photojournalists as it's able to withstand immense punishment. Don McCullin's life was famously saved by his Nikon F when the camera stopped a Khmer Rouge bullet in the killing fields of Cambodia in 1970. The F series came to an end with the F6 in 2004. By this time, the D-series of digital professional cameras had been established. In 2015 this had reached D4.

By 2013, Nikon had produced over 80 million Nikkor lenses.

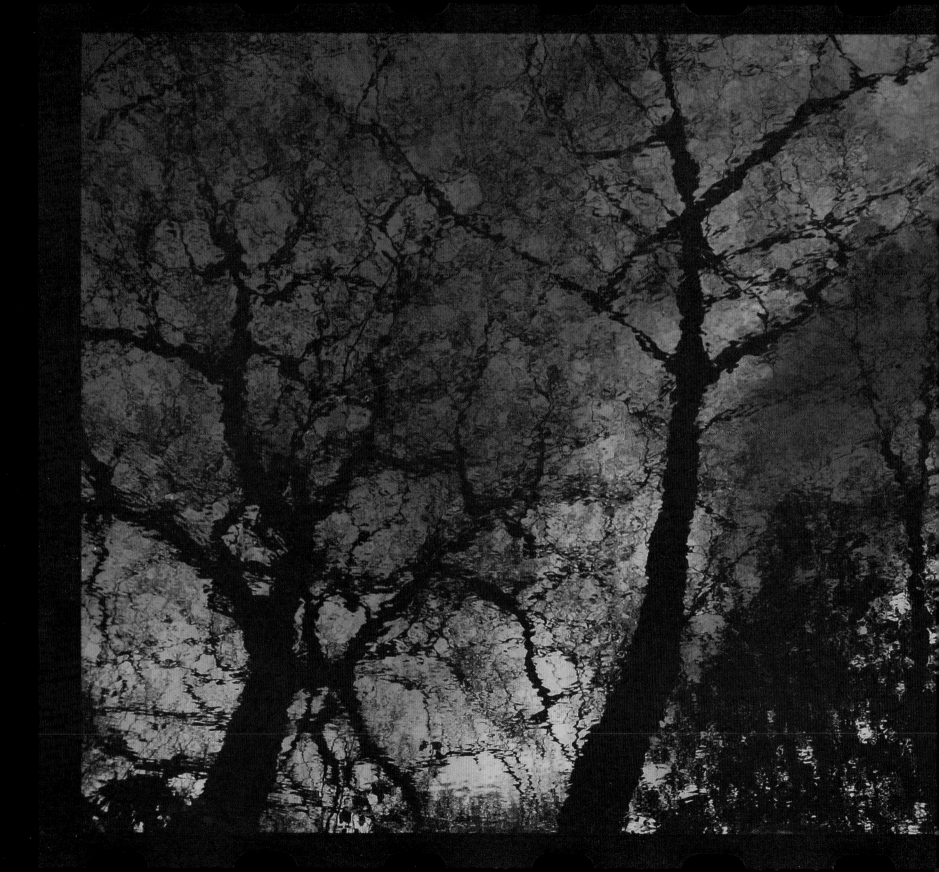

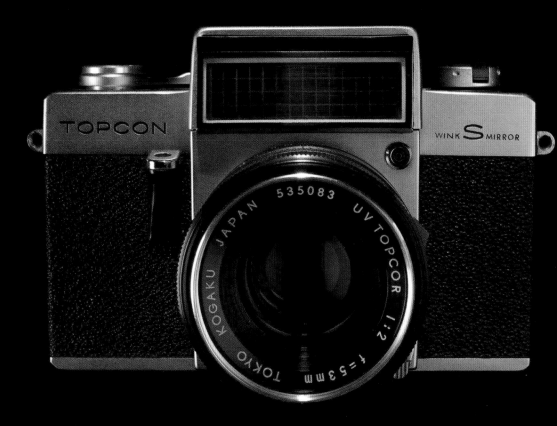

▷ **TOPCON WINK MIRROR S**
1963

Lens: UV Topcor 1:2 53mm
Format: full-frame 35mm
Tokyo Optical Co., Japan

ILFORD ADVOCATE
1949

Lens: Dallmeyer 1:4.5
35mm
Format: full-frame 35mm
Ilford Ltd, London,
England

The beautiful Advocate has an unusual enamelled die-cast metal body. The use of the wider than usual Dallmeyer 35mm lens as standard makes this camera quite special. It was designed by Kennedy Instruments, a subsidiary of Ilford Ltd, who also produced the renowned 35mm Monobar, a precision technical camera which shared some of the features of the Advocate.

OLYMPUS ECRU
1991

Lens: Olympus 1:3.5 35mm
Format: 24 x 36mm
Olympus Kogaku, Japan

The Ecru (French for 'unbleached') was a retro-looking camera designed with the help of Naoki Sakai, a Japanese industrial designer. It was sold in a limited edition of 20,000 units. The camera was basically an Olympus Mju repackaged in a stylish white box-like form with a faux suede bag and strap and a square polished aluminium lens cap. It's interesting that at this stage in photography companies started to look back and produce cameras with a retro design, such as the Olympus O-product and the Minolta Prod. I wonder whether the Ecru was inspired in any way by the Advocate. The white colouring and simple lines were meant to invoke a clean, simplified, modern lifestyle.

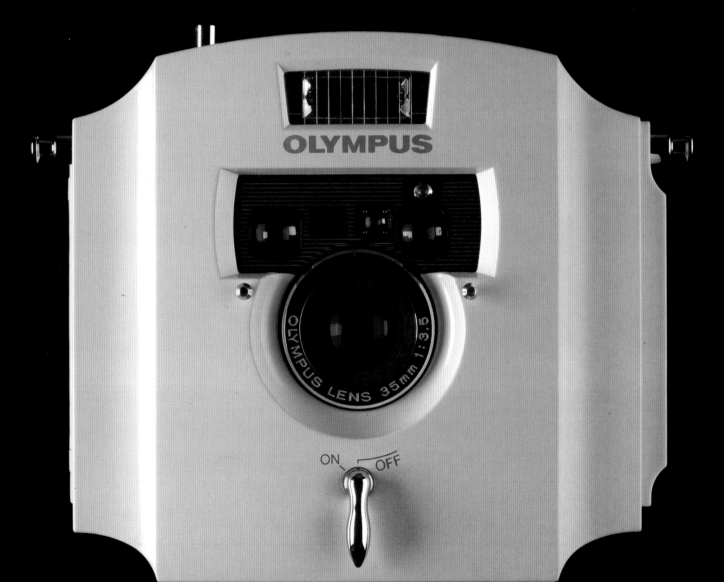

▷ **WIDELUX FVI 35MM
24 X 59MM
PANORAMIC CAMERA**
c. 1960

*Lens: Lux 1:2.8 26mm
Format: 24 x 59mm
on 35mm film
Panon Camera Co. Ltd,
Japan*

The Widelux range of cameras are
mechanical swing-lens panoramic
cameras with a curved focal
plane. The lens pivots on its axis
and during the exposure travels
from left to right across the film.
When using the Widelux, it is
really important to remember to
keep your fingers away from the
front of the body, or they'll be
included in the photo! The actor
Jeff Bridges is a great proponent
of the Widelux and has produced
many wonderful images.

Panon also produced a larger
version taking 120 roll film. These
cameras are highly prized.

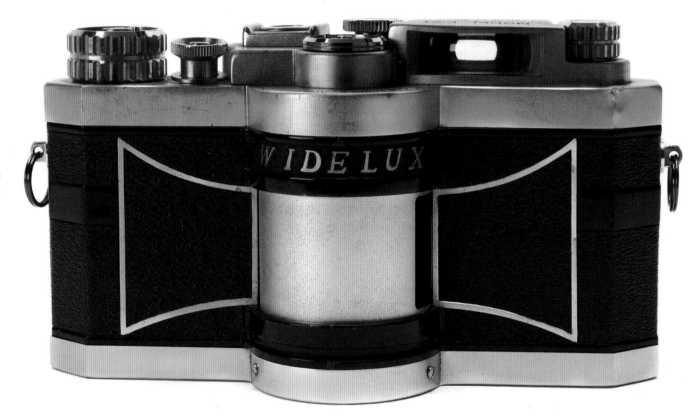

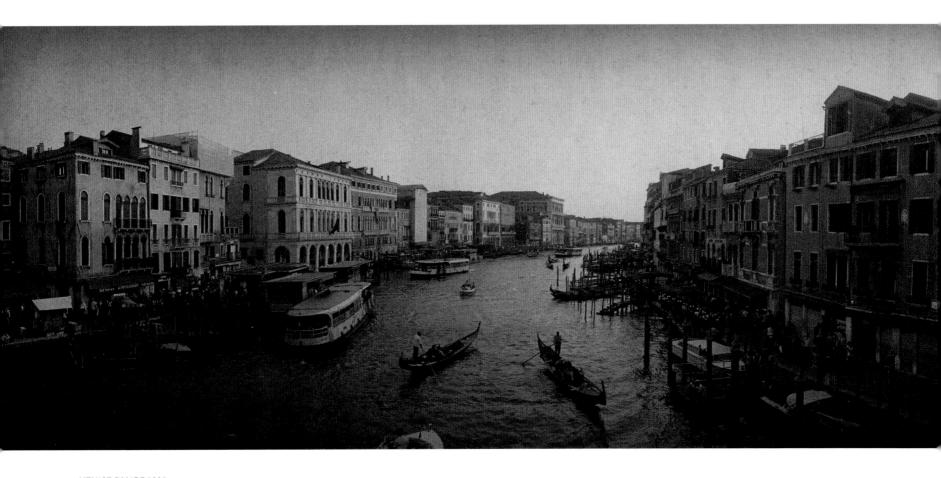

VENICE PANORAMA
Ilford HP5

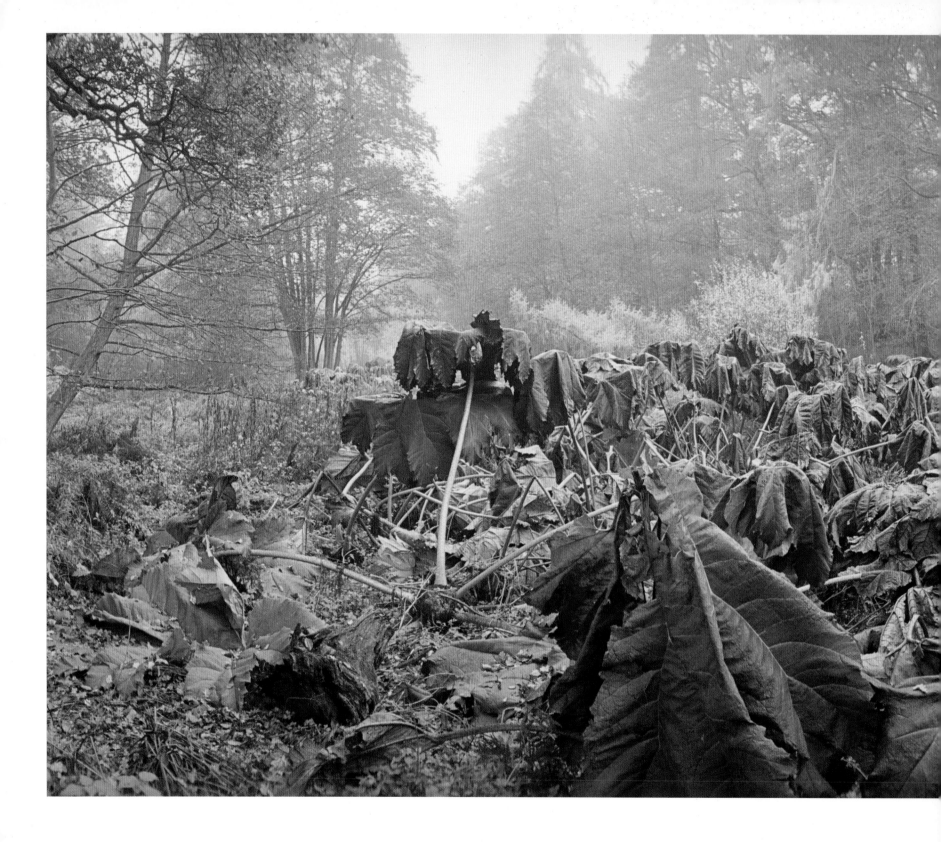

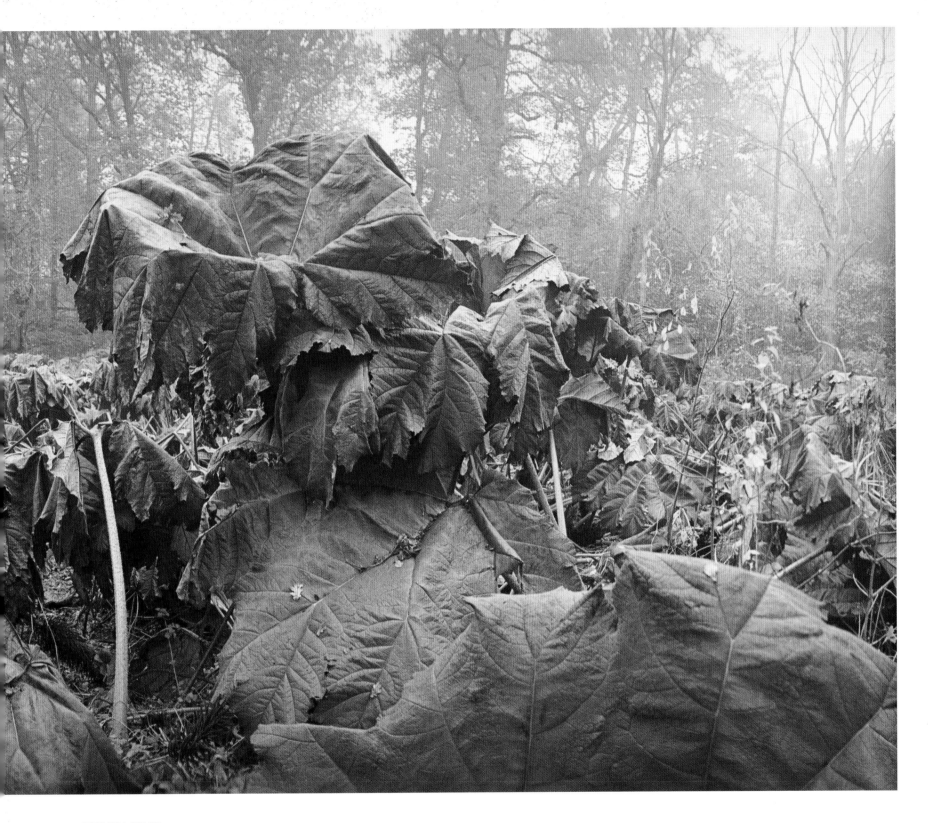

GUNNERA FIELDS
Kodak Pro 100
Taken with the Widelux FV1

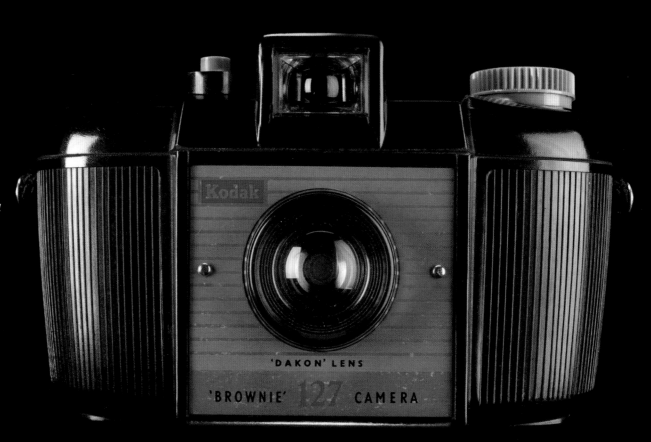

▷ **KODAK BROWNIE 127**
1953–1959

Lens: Dakon
Bakelite body
Format: 6 x 4cm
on 127 roll film
Kodak Ltd, London, England

▷ **KONEX K35**
c. 1990

Lens: fixed focus
Format: 35mm
Konex, Taiwan

It's amazing to think how little basic consumer camera design changed for several decades. A camera from the 1990s is fundamentally the same as a camera from the 1950s.

'DAKON' LENS

Kodak

'BROWNIE' 127 CAMERA

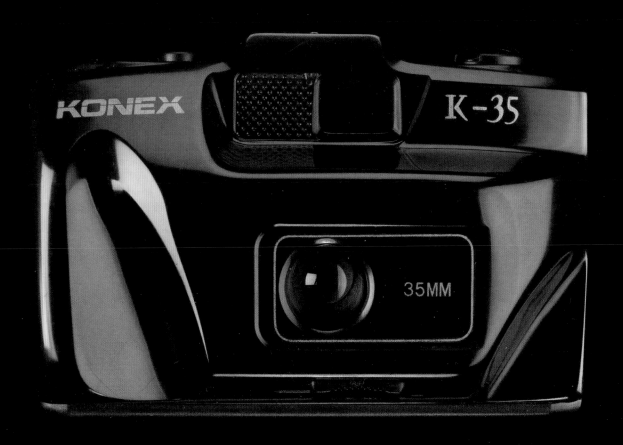

2

MEDIUM FORMAT ROLL FILM

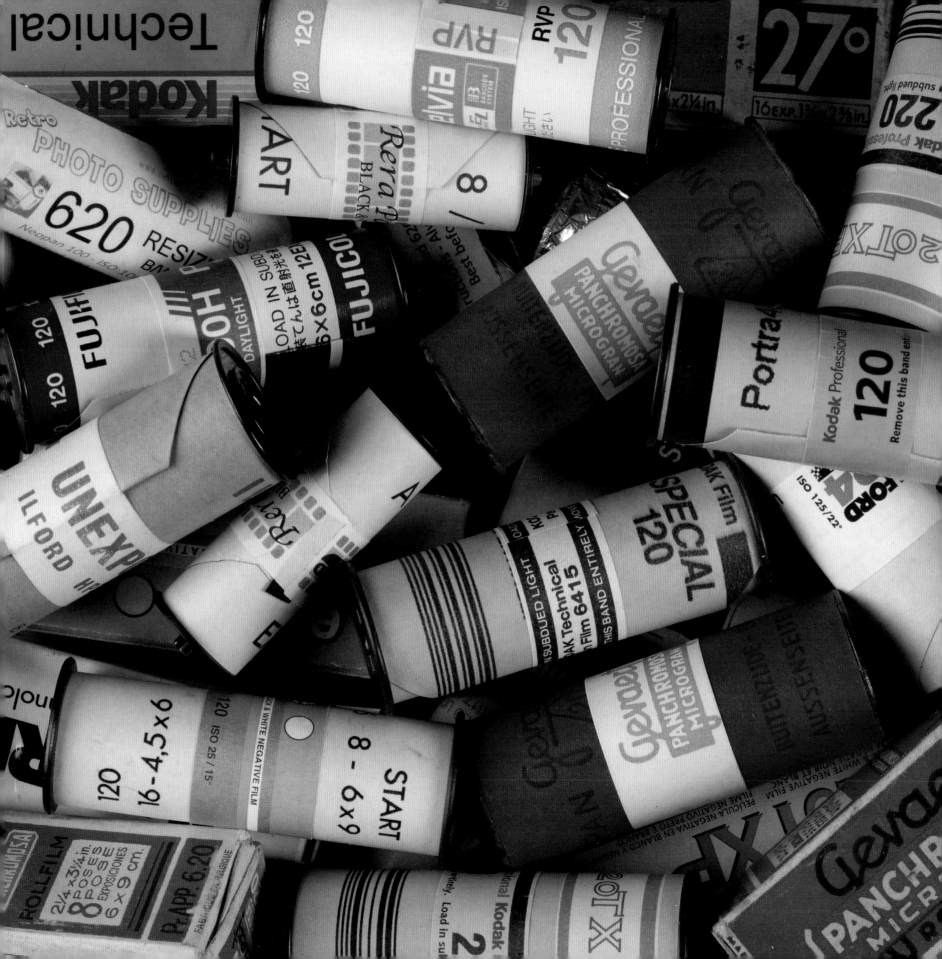

MEDIUM FORMAT ROLL FILM

The roll consists of a length of film without sprocket holes. This is taped onto a black backing paper longer than the film, creating a leader and tail. The film is very tightly rolled around a metal or plastic spool and sealed with a gummed paper band.

The majority of medium format cameras take 120 film as standard. The format was introduced by Kodak in 1901 for its Brownie No. 2. The name 120 does not in any way refer to the film size — it was one of a long line of films produced by Kodak with codes from 101 to 129. Although 127 film still survives, along with 120, the rest are obsolete. A film known as 220 is produced which is basically a double-length roll of 120, giving twice as many exposures. It looks identical to 120 from the outside, but does not have backing paper — a leader and tail are taped to the film. Some cameras, like the Pentax 67, accept both 120 and 220 film, and all medium format modular cameras like Hasselblads offered 220 backs. In my experience 220 film can be tricky. It's far more susceptible to light leaks, and the length of 220 can be difficult to load on spirals for processing.

In 1932, Kodak introduced another roll film, 620, which was exactly the same size film and backing paper as 120, but on a slimmer spool. This allowed Kodak to produce cameras with smaller bodies, and the film was in production until 1995. Kodak manufactured many types of 620

film cameras and millions of them, but because the film is no longer made, these cameras are available at far cheaper prices than 120 film cameras. The Kodak Medalist camera (see pages 130–131) is a great example. It uses 620 film and is often referred to as the 'medium format Leica'. I'm sure that if the Medalist took the freely available 120 film, it would be far more highly prized. It is, however, relatively easy to take a 120 film and transfer it to a 620 spool.

A lot of medium format cameras can take plate or sheet film backs.

Like 35mm film cameras, various different image format (6 x 4.5cm, 6 x 6cm, 6 x 7cm, 6 x 17cm, 6 x 9cm) cameras were produced for 120 film.

Note that 127 roll film is a lot smaller than 120 and is only available from specialist suppliers.

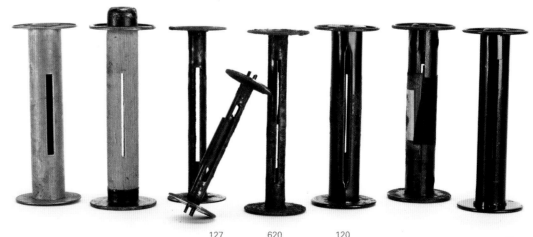

127 620 120

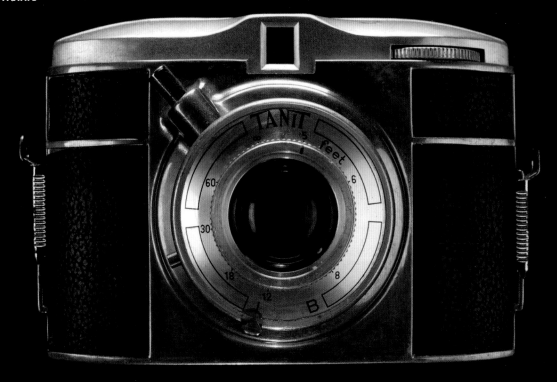

FERRANIA TANIT
1955

Lens: unmarked
Format: 3 x 4cm
on 127 roll film
Ferrania, Milan, Italy

PHOTO-MAGIC TOY CAMERA
NO. 4065
c. 1950

Lens: Meniscus
Format: 4 x 6.5cm
on 127 roll film

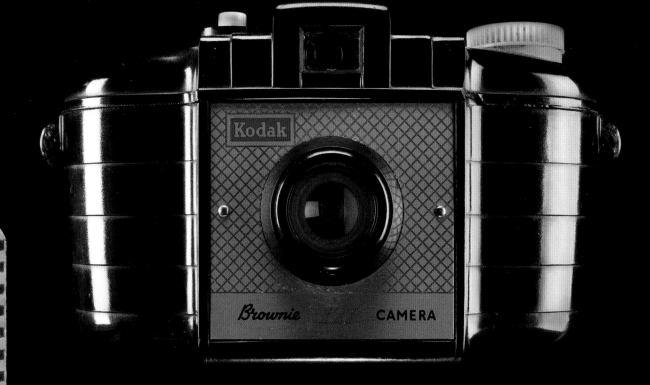

▷ **KODAK BROWNIE 127**
1953–1959

Lens: unmarked
Bakelite body
Format: 6 x 4cm
on 127 roll film
Kodak Ltd, London,
England

127 backing paper

Vintage unexposed
Ektachrome 127 film

Rerapan black & white 127 film

71

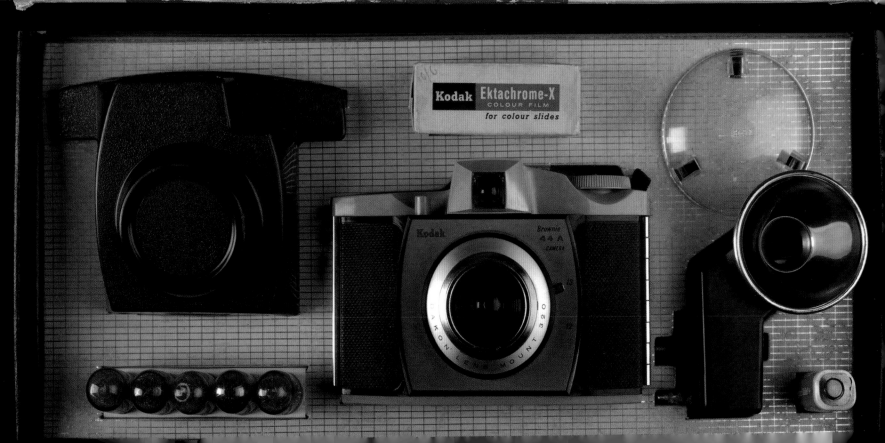

▷ **KODAK BROWNIE 44A**
1956–1966

Lens: Dakon 320
Format: 4 x 4cm
on 127 roll film
Eastman Kodak, Rochester,
New York, USA

Kodak was well known for its gift
boxes during the 1950s, '60s and
'70s. This example shipped with
everything you needed, including
a clip-on flash and flashbulbs.
Unfortunately, the higher-voltage
batteries needed for the flash are
no longer available.

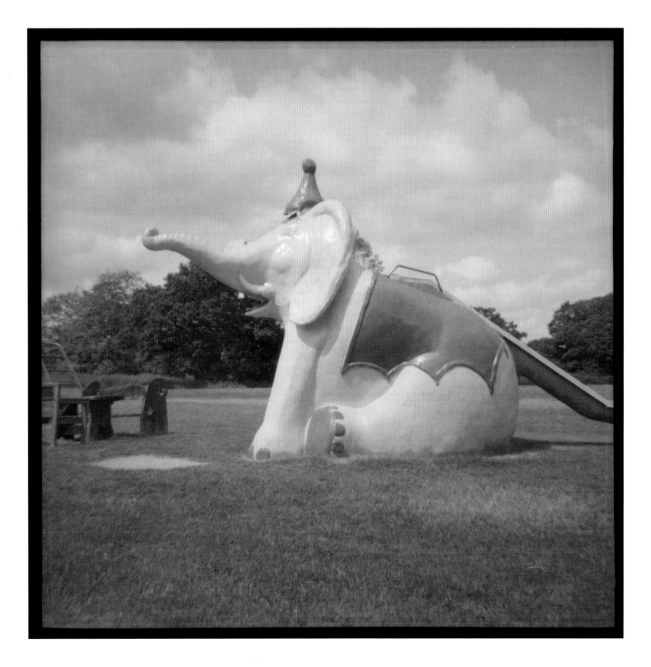

THE ELEPHANT SLIDE
Rerapan black & white 127 film

UNDER THE BOARDWALK
Rerapan black & white 127 film
Even though this camera was
designed for the mass market
and very cheaply produced,
it is capable of surprisingly
good, atmospheric, results. One
drawback is that the film does not
lie flat on the film plane, hence
the wobbly edges.

▷ **IMPERIAL SATELLITE 127**
1955

*Format: 4 x 4cm on 127 roll film
Herbert George, Chicago, Illinois,
USA*

The Herbert George Company
was founded in 1945 in Chicago,
Illinois, by Herbert Weil and
George Israel. The company
made a range of cameras
predominantly for children.
An ad in *Time* magazine from
1953 features an officially
merchandised 'Roy Rogers and
Trigger' camera outfit. They also
produced the official cameras for
the Boy Scouts and Girl Scouts.
The design of this Satellite is
inspired by the space race of
the 1950s. This basic plastic
camera came in a large range
of colours and styles and was
responsible for introducing a
huge number of children to the
joys of photography. In 1961,
the company was renamed the
Imperial Camera Corporation. This
camera originally had a large clip-
on flash, which is, sadly, missing.

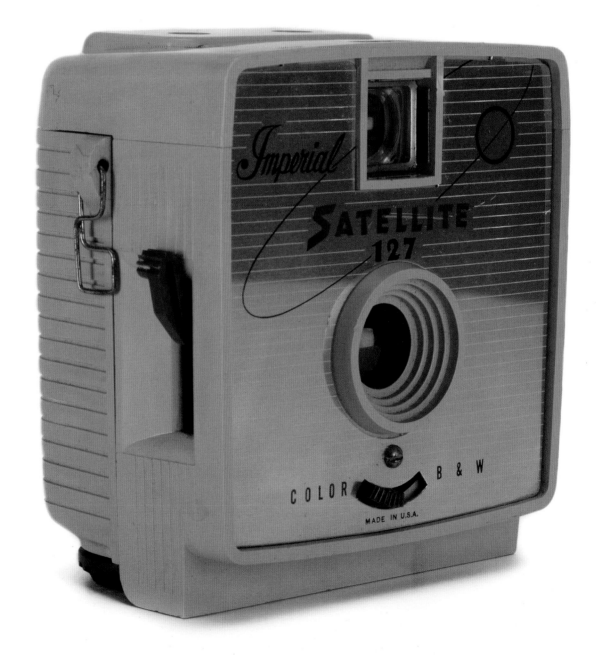

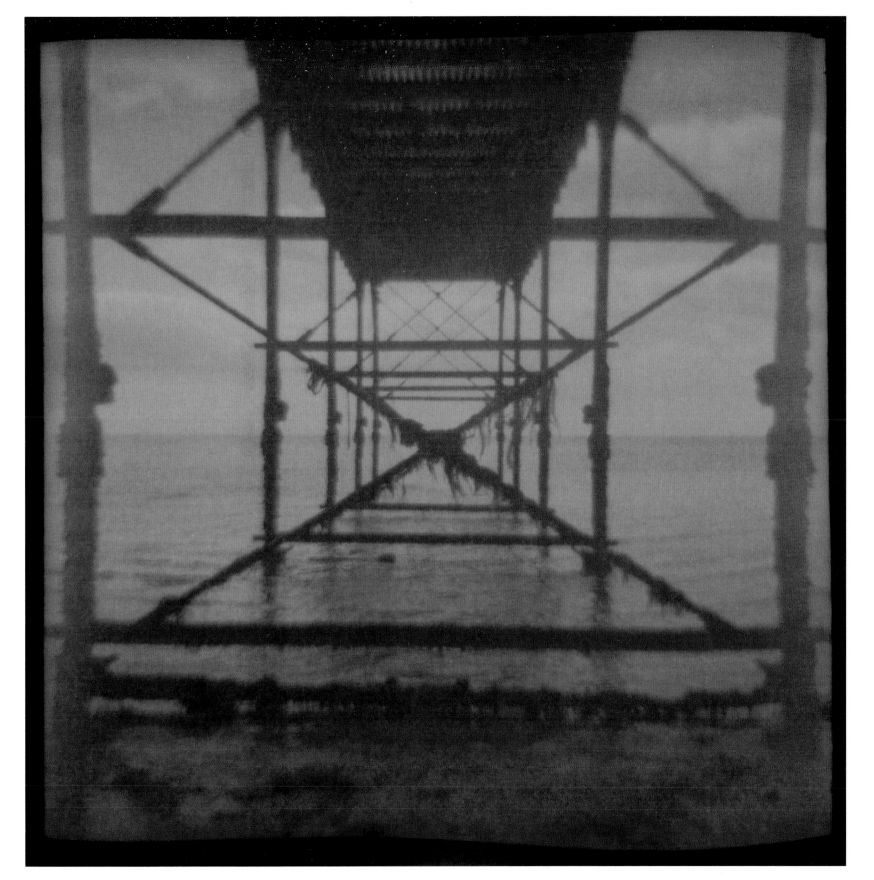

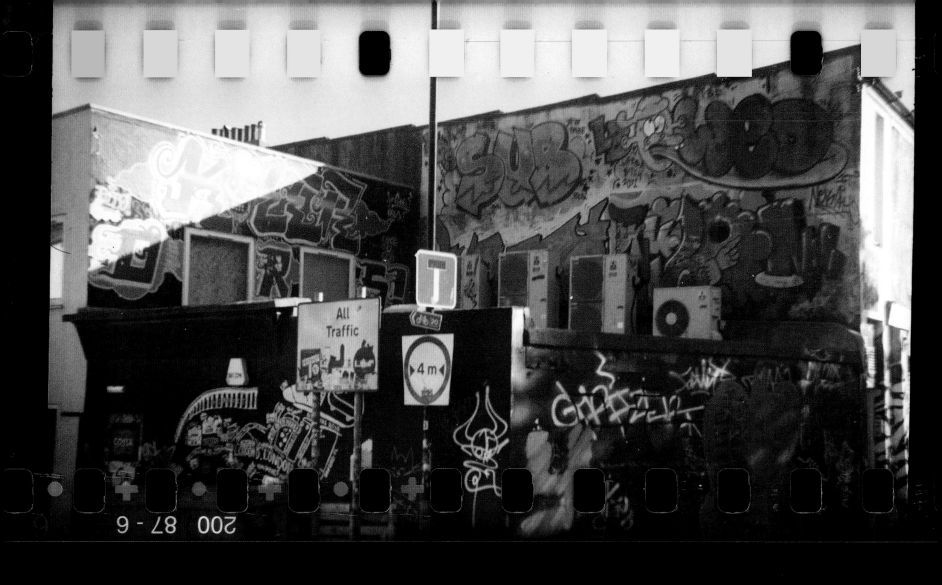
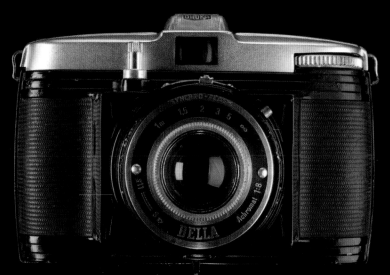
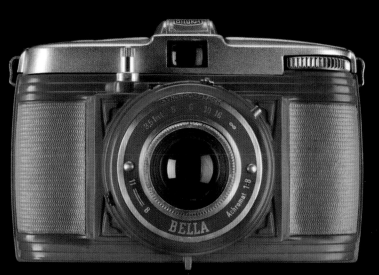

▷ **BILORA BELLA 55 BLACK**
1955

Lens: Achromat 1:8
Format: 4 x 6cm
on 127 roll film

▷ **BILORA BELLA D**
BLUE-GREY
1956

Lens: Achromat 1:8
Format: 4 x 6cm
on 127 roll film
Bilora, Germany

Although the Bilora Bellas were designed for 127 roll film, they, along with a few other 127 cameras, have a film chamber big enough to accept a 35mm cassette. By taping up the red exposure window on the back of the camera, you can quite happily expose the entirety of 35mm, including the area around the sprocket holes. I marked the wind-on wheel with a marker pen and worked out that three revolutions transported the film to roughly the correct distance.

SNAPSHOTS, BRIGHTON
Agfa 200

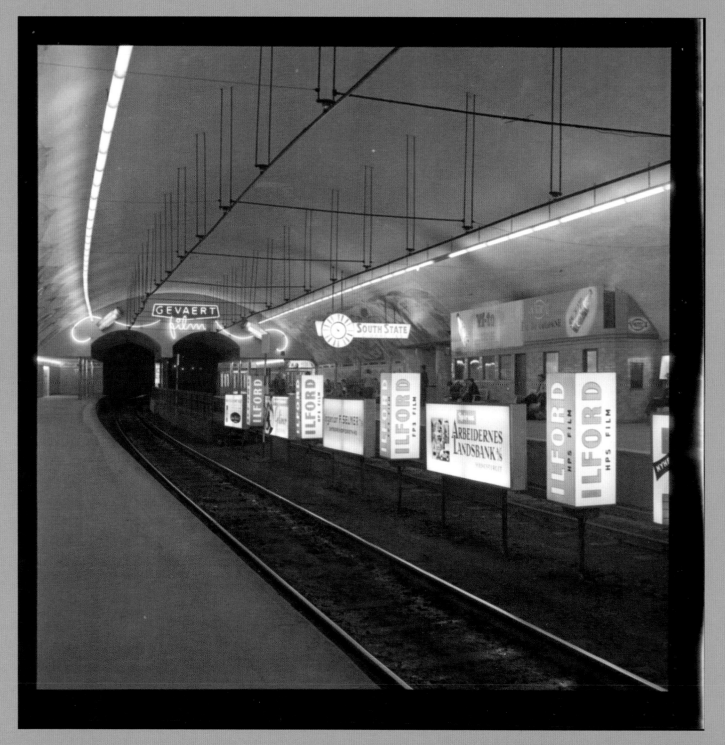

SOUTH STATE STATION
Ilford and Gevaert advertising.
Photographer unknown. Found negative.

COLLECTION OF BOX CAMERAS

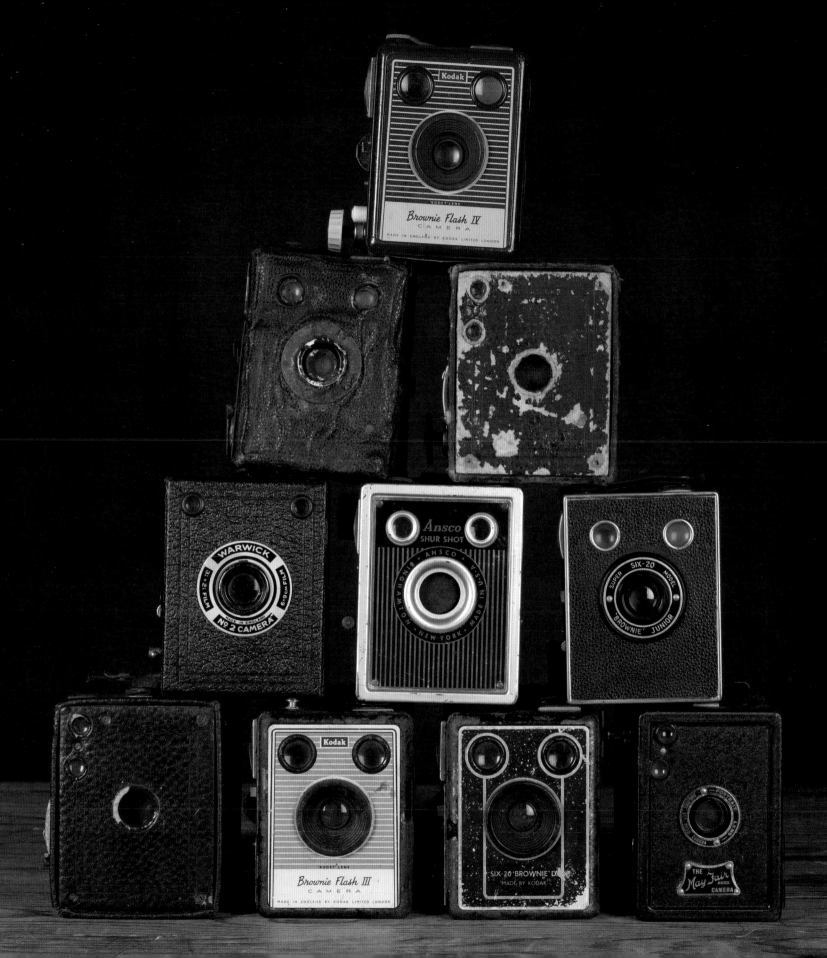

There were millions of box cameras produced by a great many makers from the late nineteenth century through the 1950s. The most basic were constructed from cardboard, covered with leatherette, with a simple, single element meniscus lens. Basic box cameras have no control over focusing — the lens is positioned to achieve hyperfocal distance. They are fitted with a very simple reflex viewer to aid with approximate composition. Box cameras are a great introduction to the world of medium format roll film photography.

▷ AGFA BOX CAMERA
1930

Format: 6 x 9cm
on 120 roll film
Agfa, Munich, Germany
This model was made by
Agfa England.

Of all the box cameras I've tested, one of the best is this Agfa. Its simple pressed metal construction makes it more rigid than the earlier cardboard Kodaks. It's very, very simple to use, with just two controls — the shutter and the wind-on.

LITTLEHAMPTON
Kodak 400

▷ ### THE MAY FAIR BOX CAMERA
1930

Format: 6 x 9cm on 120 roll film
Houghton Ltd, London, England

This model of box camera was unusual in that it came with a supplementary lens for portraiture and close-up work. The May Fair features a small compartment on the side to store the lens. The still life here was shot by simply putting a piece of photographic paper in the back of the camera instead of film. This 'paper negative' is then processed, scanned and inverted in Photoshop to create the final image. This is probably the sharpest box camera I've tested, capable of results comparable to far more expensive and complicated cameras.

LILIES (paper negative)
Very outdated, 1950s, Ilfospeed
Grade 4 paper

DEAD TREE
Fuji Pro 400H

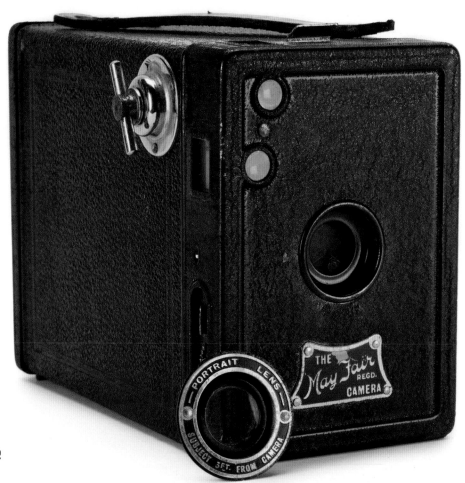

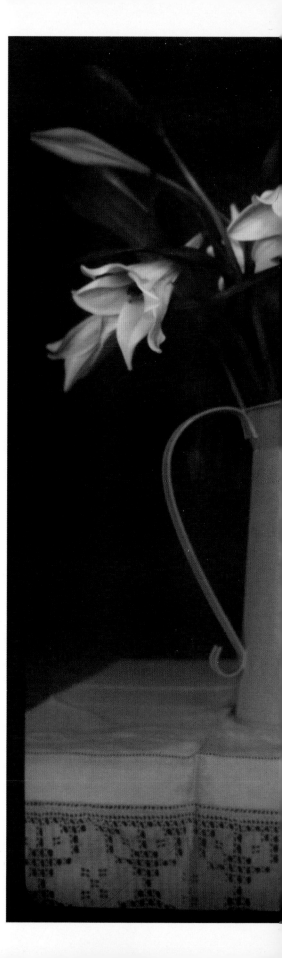

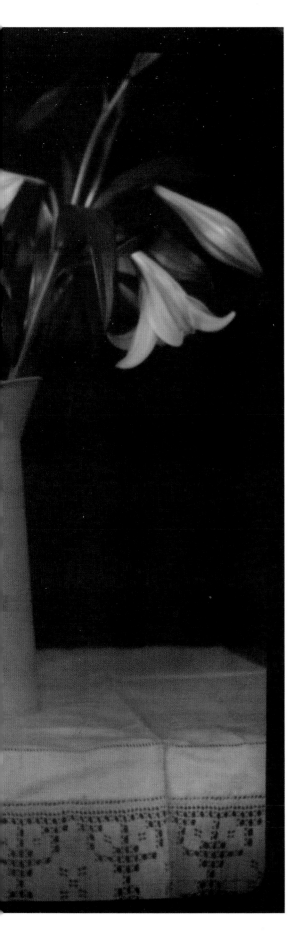
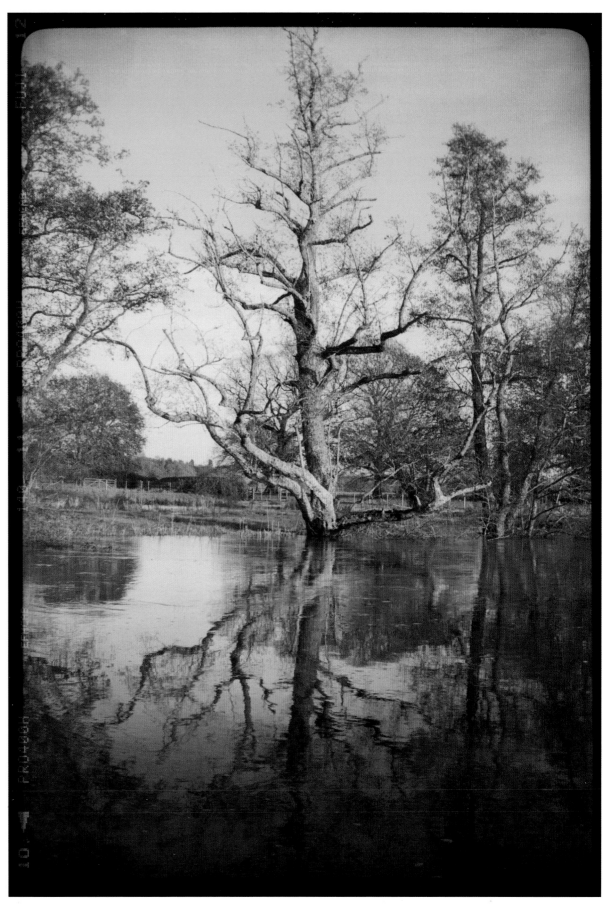

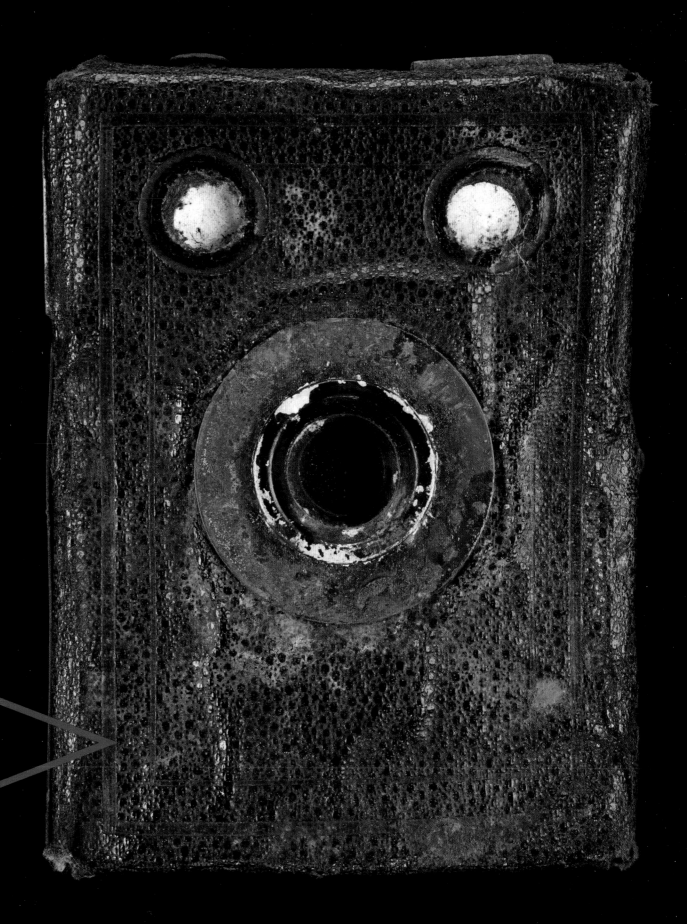

▷ **KODAK POPULAR BROWNIE**
1937–1940

Format: 6 x 9cm
on 620 roll film
Kodak Ltd, London,
England

The camera is totally dilapidated, having been stored in damp conditions. It was bought very cheaply just to salvage the 620 film spindle to reload 120 film onto.

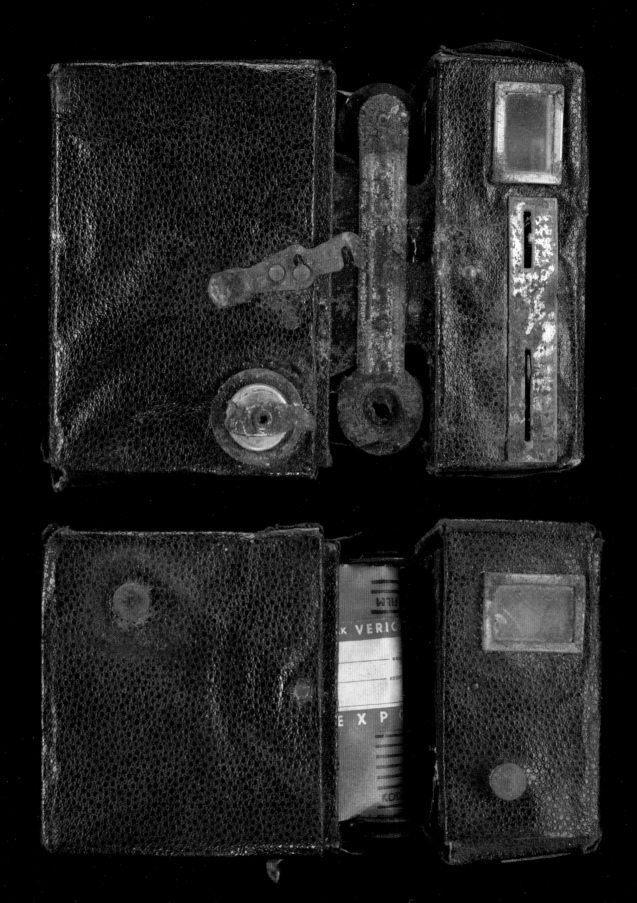

▷ **KODAK BROWNIE NO. 2**
MODEL E
1919

Lens: Meniscus
Format: 6 x 9cm on 120 roll film
Eastman Kodak, Rochester,
New York, USA

One of the key ingredients of photographic film emulsion is gelatin, derived from the hide and bones of pigs and cattle. In the 1930s, Kodak established its own rendering plant for the production of gelatin. The company needed to take control of gelatin quality after a batch of gelatin from cows fed on sulphur-rich mustard seed caused the film produced to fog before it could be exposed. Kodak also made the Wratten range of gelatin lens filters. Kodak sold its gelatin factory in 2011 as part of a post-digital restructuring.

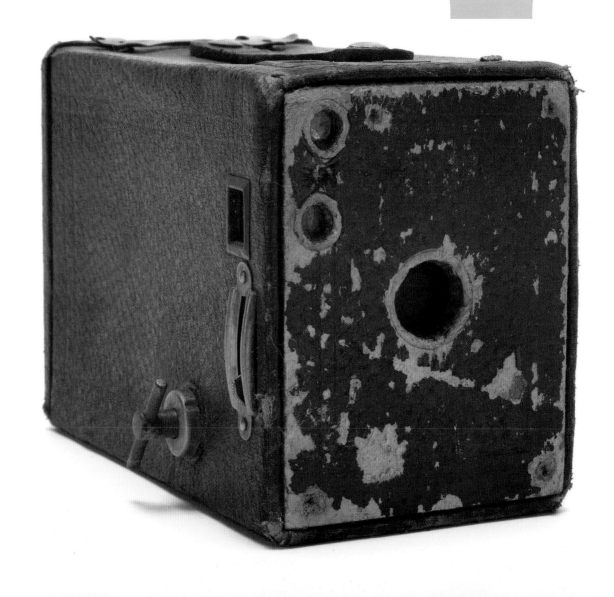

KODAK SIX-20 BROWNIE D

1946–1953

Format: 6 x 9cm on 620 roll film
Kodak Ltd, London, England

KODAK BROWNIE FLASH III

1957–1960

Lens: Kodet
Format: 6 x 9cm on 620 roll film
Kodak Ltd, London, England

These more advanced box
cameras feature a pull control
on the side to slide a close-up
lens or contrast filter in place.
The Brownie Flash III, as its name
suggests, also features contacts
for flash photography.

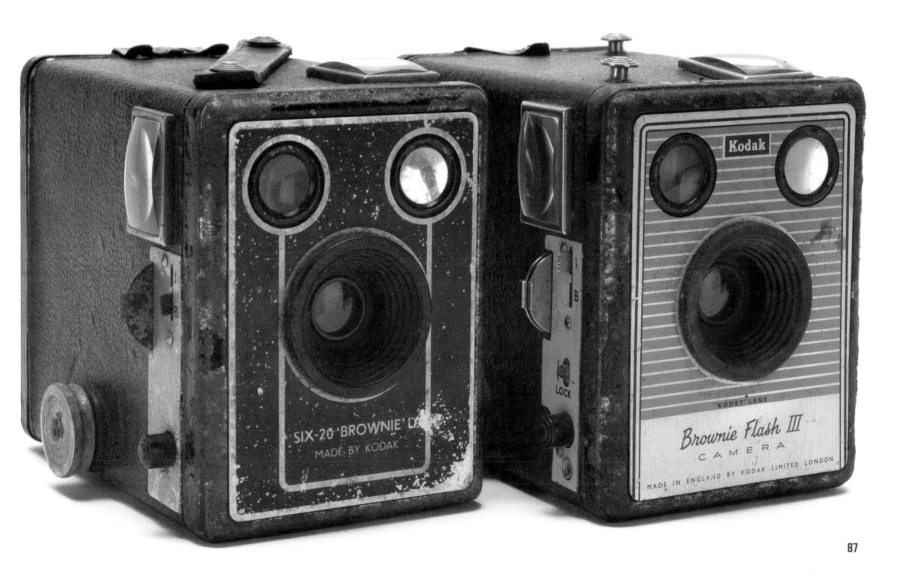

MULTIPLE EXPOSURES

With a box camera, it's very easy to make multiple exposures — just don't bother winding on. Sometimes it's worth halving the exposure to avoid an overexposed negative when producing multiple exposures. When using roll film in old cameras which rely on the red window viewers to wind the film on, it's a good idea to tape over the window when taking your shot and peel back the tape to check when winding on. This helps to prevent light passing through the red window and fogging the film through the backing paper. This is particularly important when using higher ASA films.

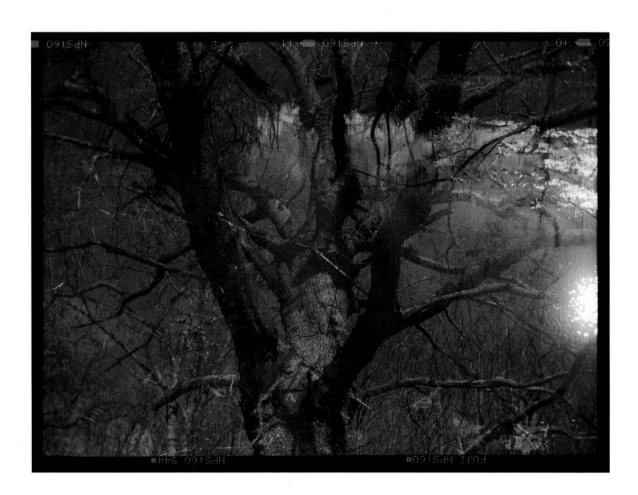

ANSCO SHUR SHOT
1948

Format: 6 x 9cm on 120 roll film
Ansco, Binghamton,
New York, USA

TWO MULTIPLE
EXPOSURE TESTS
Fuji NPS 160 120 film

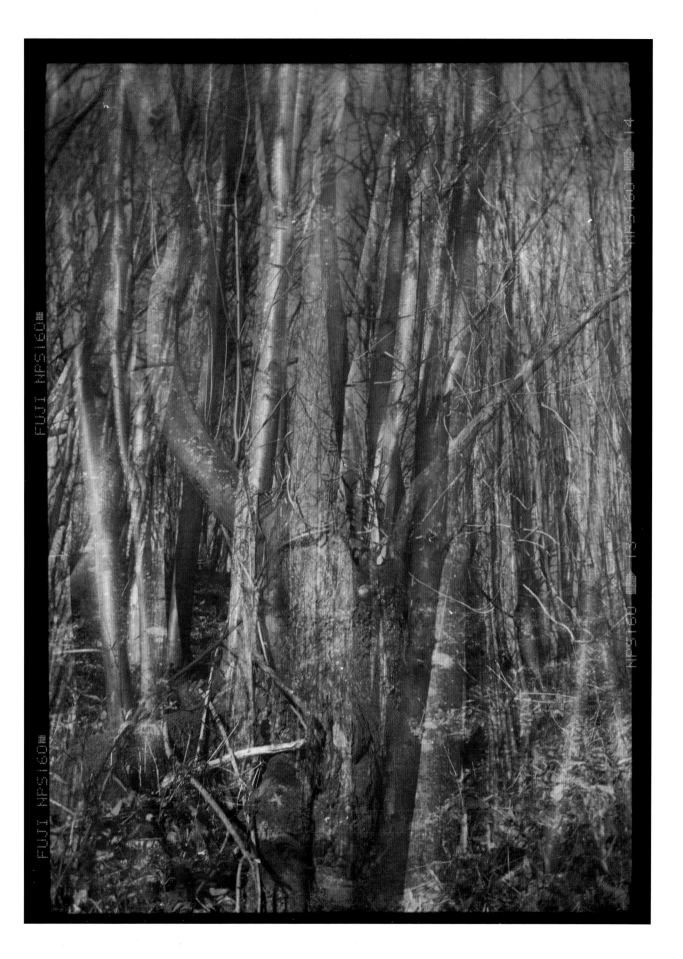

▷ **ILFORD ENVOY**
1953

Lens: Optimax Lens
Format: 6 x 9cm on 120
or 620 film
Ilford Ltd, London, England

Nicely designed Bakelite camera
with the slogan "For faces pull
out, for places push in" written on
the lens.

▷ **LUMIÈRE LUX BOX**
1952

Format: 6 x 9cm on 620 roll film
Lumière & Jougla, Lyon, France

This beautiful pressed-metal
camera shows real French style.

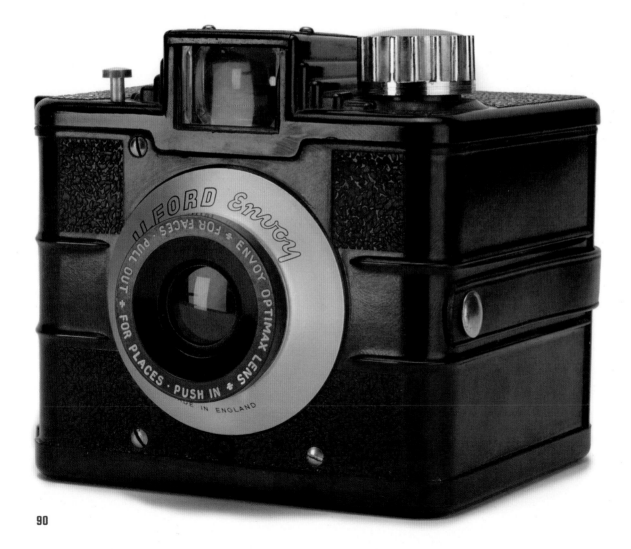

1949–1951

Format: 6 x 6cm on 620 roll film
Kodak Ltd, London, England

In my opinion the best-looking of
all the box-type cameras.

FILM SPEED		DIN	ASA
The term 'film speed' refers to the emulsion's sensitivity to light.		15	25
It is a standardised system.		18	50
The German DIN (Deutsches		21	100
Institut für Normung) system was		24	200
introduced in 1934. ASA (American		27	400
Standards Association). was			
finalised in 1945.			

The basic principle is the bigger the number, the faster the speed. So if you want to shoot in low light, use a faster film.

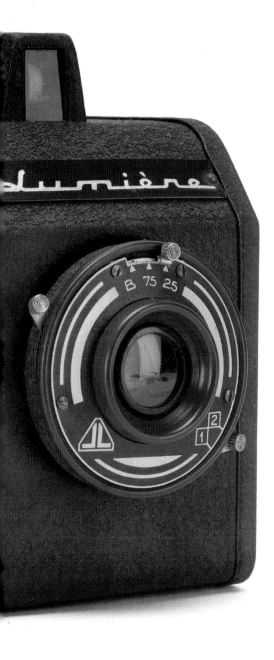

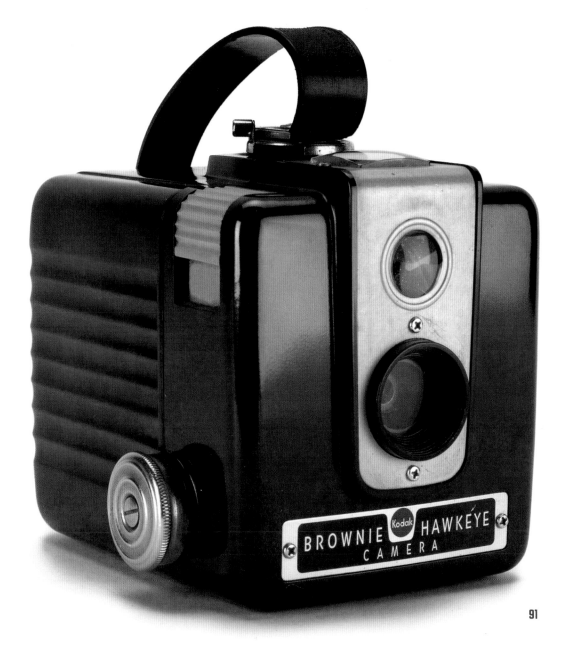

91

▷ AGFA CLICK-I

1958–1972

Lens: Meniscus
Format: 6 x 9cm on 120 roll film
Agfa, Munich, Germany

A really basic, cheap, mass-
produced camera, which
generally gives very poor results.

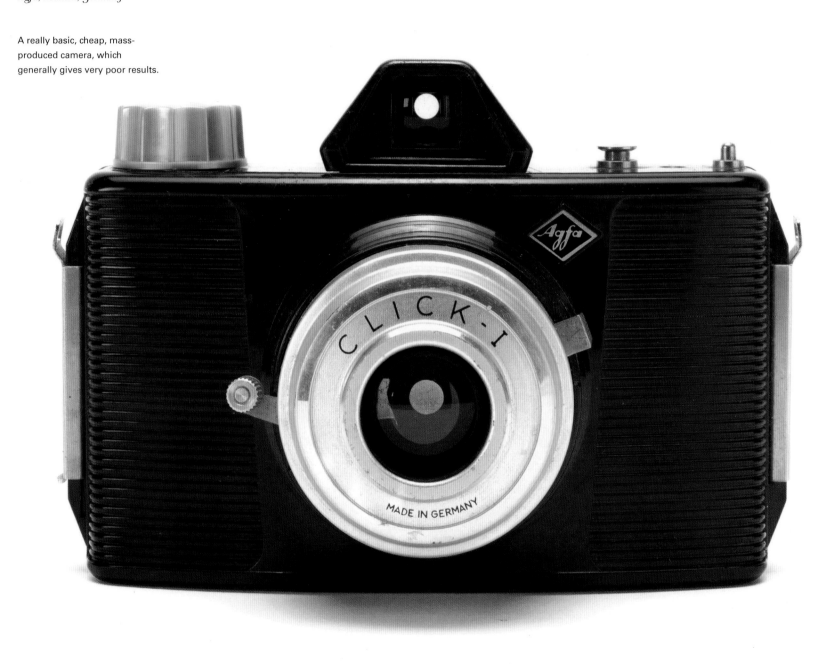

1950–1956

Lens: Sportar 1:11 85mm
Format: 6 x 9cm
on 120 roll film
Truvox, England

An unusual Bakelite camera,
featuring an extending lens with
click-stop focusing.

▷ **FERRANIA IBIS 66**
1953

Lens: Primar 85mm
Format: 6 x 6cm
on 120 roll film
Ferrania, Milan, Italy

My very favourite of all the
mass-market amateur cameras.
The Ibis was made in many
models, including the 66 for
120 film and the 44 for 127. The
extending lens makes this a very
portable 6 x 6cm camera. The
negatives have unusual notches
on either side, formed by the
grooves cut out of the body
to allow the lens to extend.

THE ICE CREAM SHOP
Fuji 100

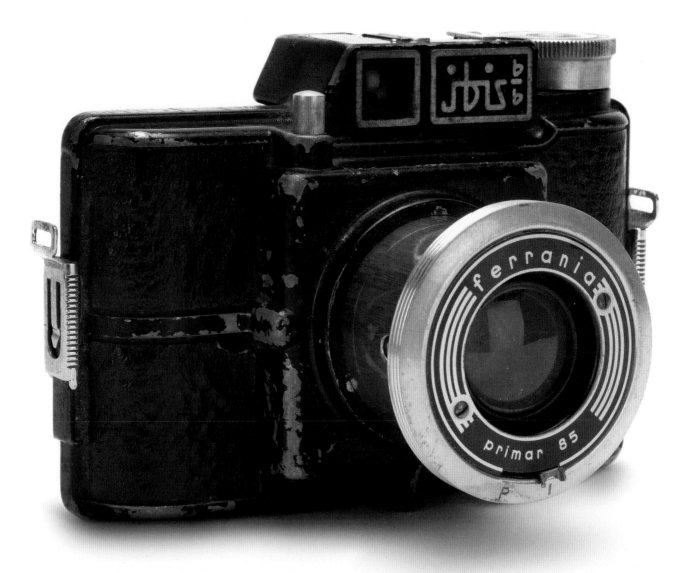

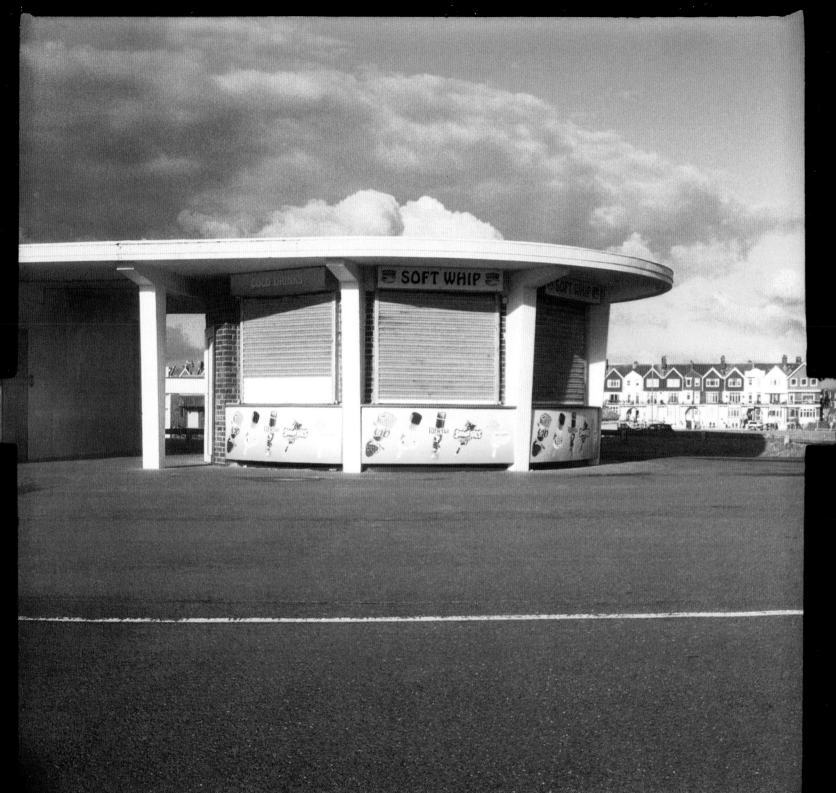

▷ **ENSIGN ENSIGNETTE**
c. 1911

*Lens: Achromatic Meniscus
fitted behind the shutter.
Format: 1 ¹/₂ x 2 ¹/₄ in
on Ensign E1 roll film
Houghton Ltd,
London, England*

This tiny strut camera was quite
revolutionary. Some say this
is the first truly mass-market
pocket camera. They were made
in many different finishes:
brass, nickel and the extremely
rare solid silver Ensignette No.
2. These cameras take a now
defunct film (the Ensign E1) and
the picture size was 1¹/₂ x 2¹/₄ in.
The best way to use an Ensign
now is to pop open the back in
a darkroom and insert a piece
of photographic paper or film
to use the camera in a one-shot
form.

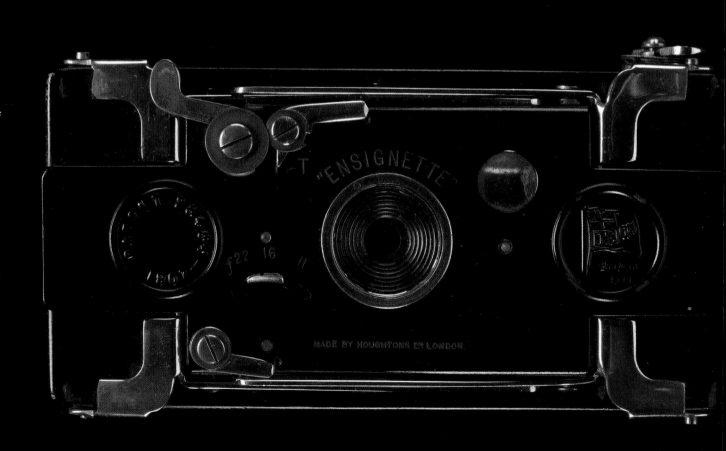

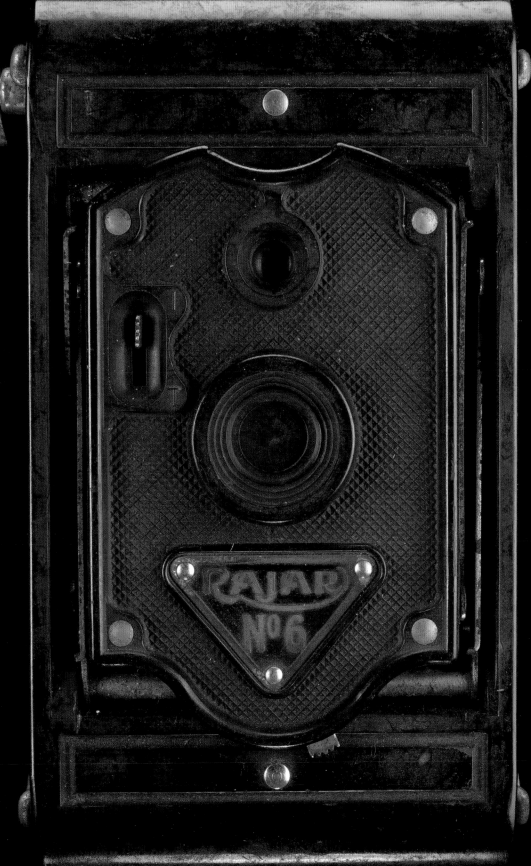

RAJAR NO. 6 FOLDING CAMERA
1929

Lens: Meniscus, set behind the shutter
Format: 6 x 9cm on Rajar No. 6 film (no longer available)
APM (Amalgamated Photographic Manufacturers Ltd), London, England

Rajar foolishly thought it would be a good idea to make their own film format, and now the camera can only realistically be used by exposing onto paper or cut-sheet film.

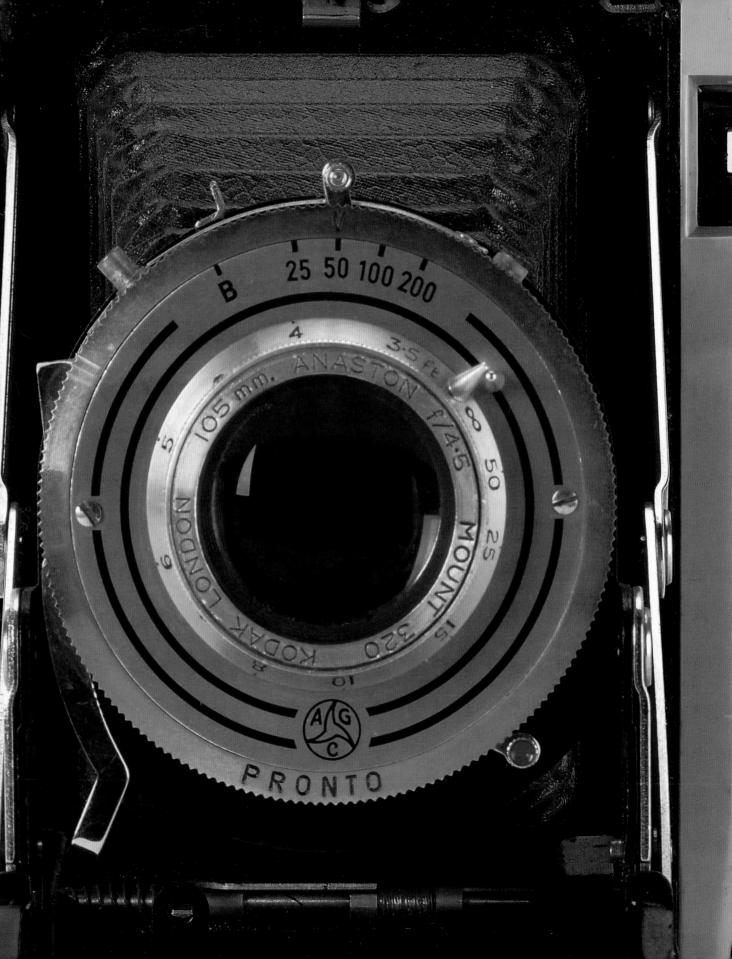

▷ **KODAK STERLING II**
1955–1960

Lens: Anaston 1:4.5
105mm
Format: 6 x 9cm
on 620 roll film
Kodak Ltd, London,
England

▷ **KODAK SIX 20A**
1951–1955

Lens: Anastar 1:4.5
100mm
Format: 6 x 9cm
on 620 roll film
Kodak Ltd,
London, England

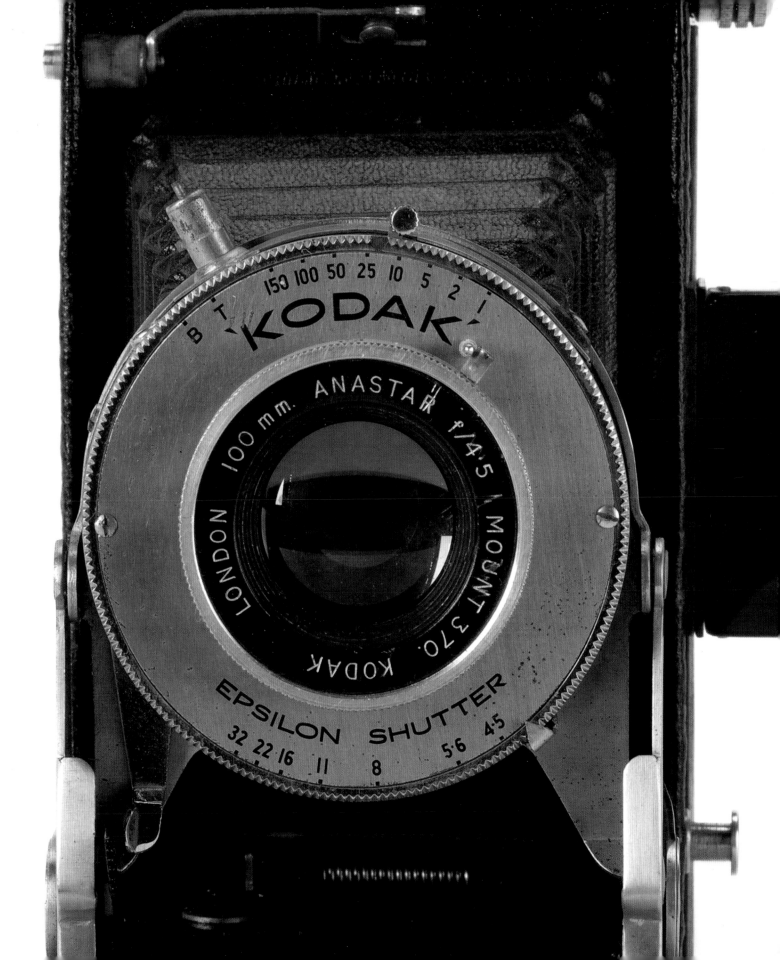

▷ KODAK TOURIST II
1951–1958

Lens: Anastar 1:4.5 101mm
Format: 6 x 9cm on 620 roll film
Kodak Ltd, London, England

POPPY FIELDS, HARROW HILL
Showing bad light leakage.
Fuji NPS 160

LIGHT LEAK

A frequent problem with bellows folding cameras such as this one is that over time the bellows degrade and rip, leaking light onto the film. There are specialist bellows manufacturers who can provide replacements, but they can be quite expensive and tricky to install. If this is not an option, it's easy to remove the lens and shutter assembly and use them on self-built camera projects. Kodak lenses of this era were renowned for being incredibly sharp.

NATURAL HISTORY
Kodak 100 taken with the
Voigtlander Brilliant

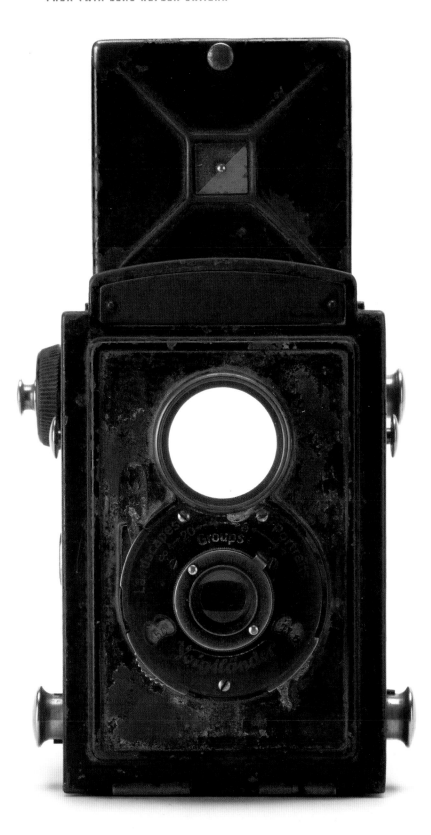

FAUX TWIN LENS REFLEX

The term 'Faux TLR' refers to cheaper twin lens reflex cameras where the viewing and taking lenses are not coupled for focusing. The top lens gives only a rough guide for composition; focusing still has to be set manually by judging the distance to the subject and rotating the lower lens accordingly. These cameras are perfect for 'through the viewfinder' photography (see page 200).

▷ **VOIGTLANDER BRILLIANT**
1932

Lens: Voigtar 1:7.7 75mm
Format: 6 x 6cm on 120 roll film
Voigtlander & Sohn AG, Germany

▷ **ENSIGN FUL-VUE II**
1950–1953

Format: 6 x 6cm
on 120 roll film
Houghton Ltd, London, England

Made in several colour variations: black, blue, grey and red.

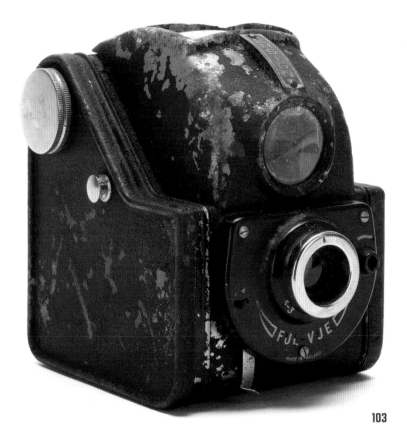

With a twin lens reflex camera, the top 'viewing' lens and the bottom 'taking' lens are coupled, so when you focus through the top lens, you are guaranteed that the bottom lens is in focus.

▷ **ECHOFLEX**
1952–1956

Lens: J. Echor Anastigmat
1:3.5 75mm
Format: 6 x 6cm
on 120 roll film
Japan

▷ **REFLEKTA II**
1951

Lens: ROW Pololyt
1:3.5 75mm
Format: 6 x 6cm
on 120 roll film
Welta-Kamera-Werke,
Freital, Germany

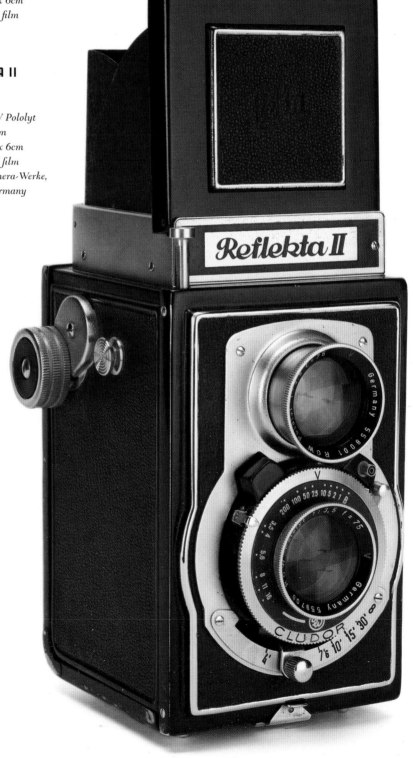

▷ YASHICA 44
1958

Lens: Yashikor 1:3.5 60mm
Format: 4 x 4cm
on 127 roll film
Yashica Co. Ltd, Tokyo, Japan

▷ AGFA FLEXILETTE
1960–1961

Lens: Agfa color Apotar
1:2.8 45mm
Format: full-frame 35mm
Agfa, Munich, Germany

Very unusual twin lens
35mm camera

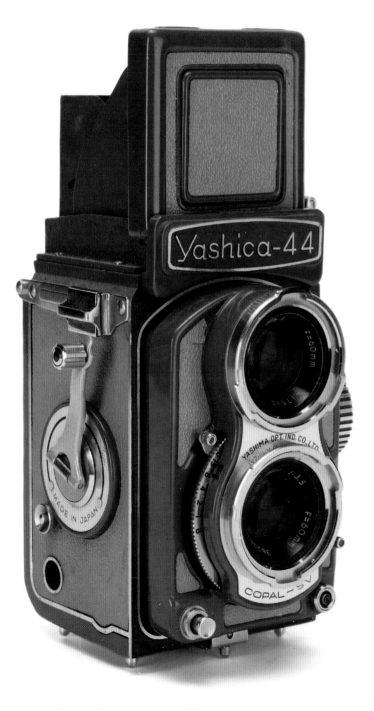

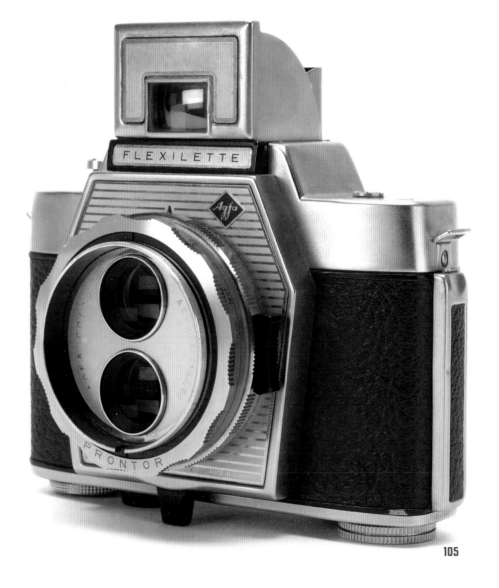

▷ **ROLLEIFLEX 2.8F TYPE 1**
1960–1961

Lens: Carl Zeiss Planar
1:2.8 80mm
Format: 6 x 6cm
on 120 roll film
Rollei-Werke Franke & Heidecke,
Braunschweig, Germany

This is the classic twin lens reflex camera, fitted with the exceptional Carl Zeiss Planar lens. This is the faster 2.8 model — a 3.5 version was also available. Shown here is the camera with the waist-level finder and the interchangeable pentaprism. Photographers famously using this camera include David Bailey, Irving Penn and the recently discovered Vivian Maier.

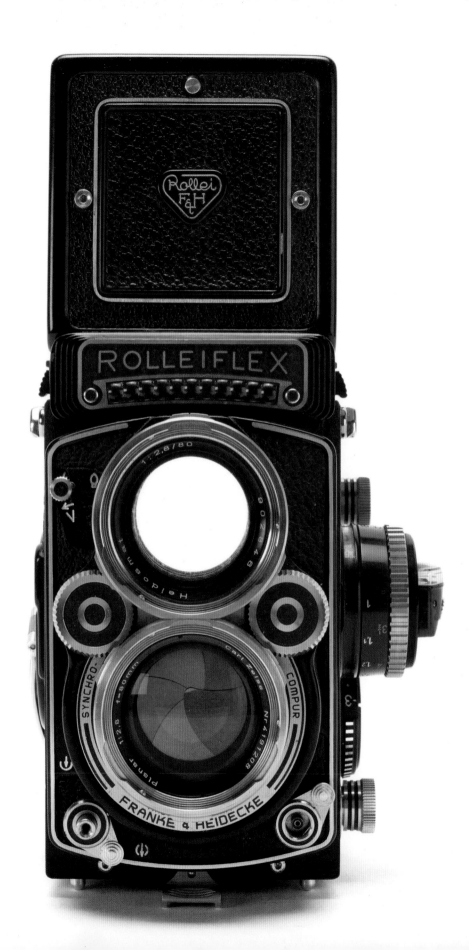
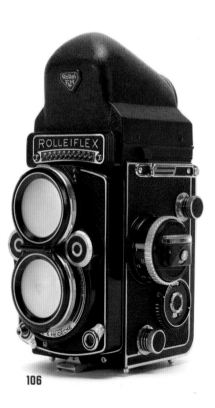

HOARFROST
Efke 25

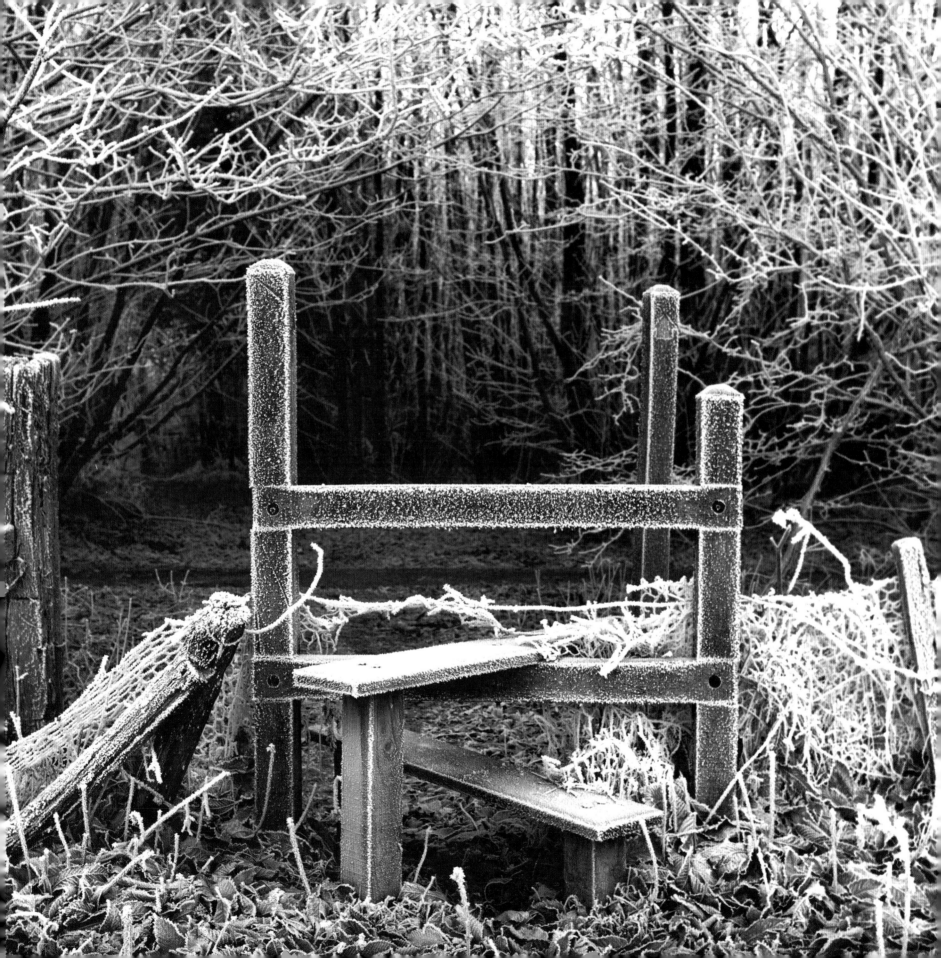

▷ **KOWA SIX**
1968

Lens: Kowa S 1:3.5 150mm
Format: 6 x 6cm
on 120 roll film
Kowa Optical Works, Japan

Unfairly called 'the poor man's
Hasselblad', the Kowa Six was
designed by Heinz Kilfitt, who
previously designed and patented
the Robot (see page 21).

the Robot (see page 21).

This Kowa is fitted with a leaf
shutter. A leaf shutter is uniquely
able to synchronise with flash at
any shutter speed. It is formed of
a number of metal leaves which
pull back simultaneously from the
centre of the lens, exposing the
whole area at once. In contrast,
a focal plane shutter, which
sits at the back of the
camera, moves across
the film. Most focal plane
shutters only synchronise at
speeds of 1/125th or lower and
at higher speeds 'clipping' of the
image will result.

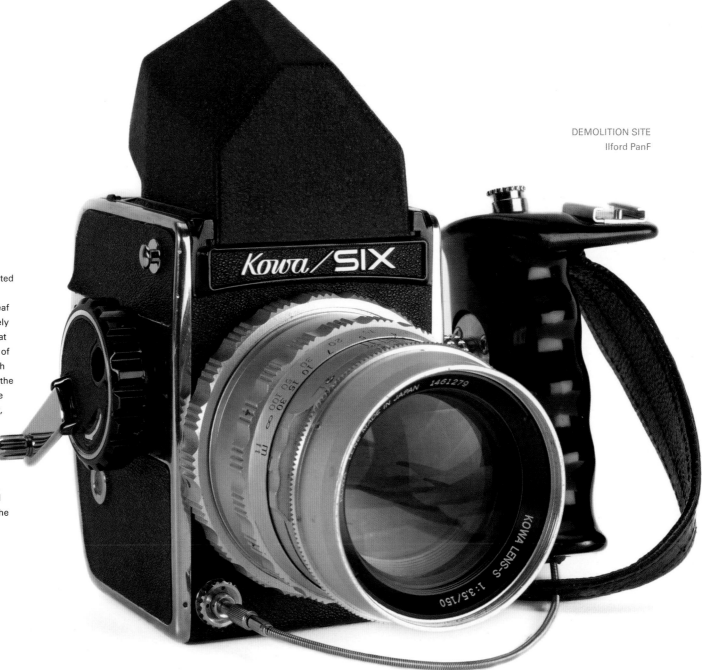

DEMOLITION SITE
Ilford PanF

108

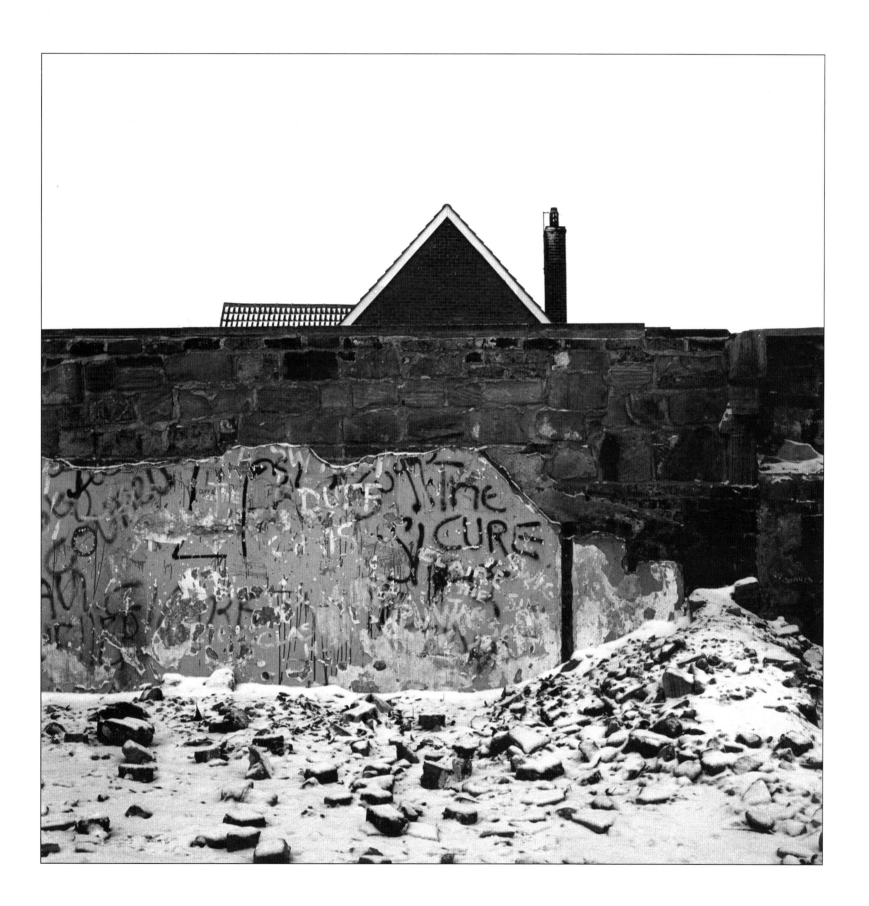

*Fitted with cut film back
and prism finder
Lens: Carl Zeiss Distagon T*
1:4 50mm*

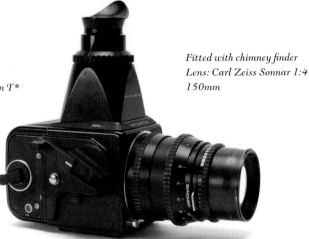

*Fitted with chimney finder
Lens: Carl Zeiss Sonnar 1:4
150mm*

▷ **HASSELBLAD 501C**
1994–1997

Fitted with waist-level finder

Lens: Carl Zeiss Distagon T
1:3.5 60mm
Format: 6 x 6cm
on 120/220 roll film
Victor Hasselblad,
Gothenburg, Sweden*

GORDON, ROMNEY MARSH
SHEPHERD
Ilford FP4

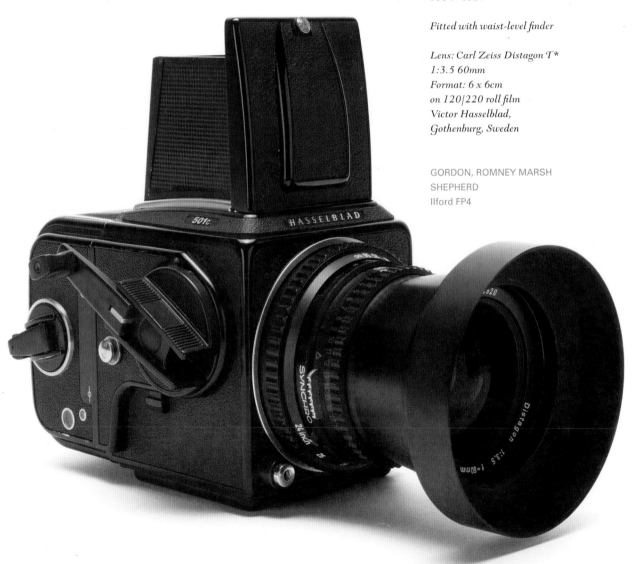

HASSELBLAD

Victor Hasselblad operated a photographic business called Victor Foto in Gothenburg, Sweden. He sold and distributed photographic equipment as well as running a photographic lab. Victor's knowledge of cameras was well known and in 1940, during the Second World War, he was asked to make a copy of a German air reconnaissance camera that had been recovered by the Swedish government. Victor and a small team designed the HK7. Orders from the air force resulted in the building of a factory.

At the end of the war, Hasselblad started to manufacture consumer cameras and in 1948 created the Hasselblad 1600F.

Hasselblads are beautiful. The camera's totally modular construction means a huge variation in configurations. It consists of four basic parts: the body, which contains the reflex system; the lens, which houses the leaf shutter; the viewfinder; and the back, which contains the film.

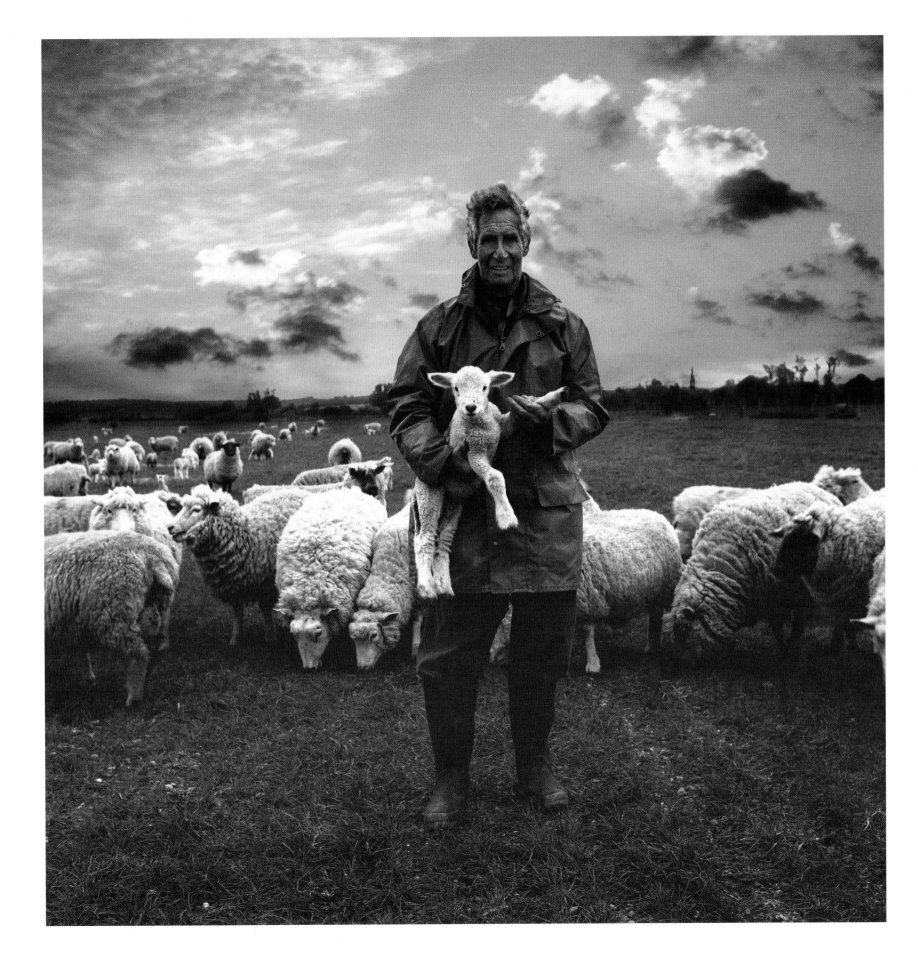

The ability to change film mid-roll by simply attaching another back made the Hasselblad a massive success. With a Rolleiflex twin lens system, not only can you not change the back, but the lens was also non-interchangeable.

To shoot both colour and black and white the only thing to do is carry two or more Rolleiflex cameras. Wedding photographers were known to carry ten or so preloaded Hasselblad film backs for super-fast shooting.

SHEEP ON THE DOWNS
Ilford FP4

AUTUMN
Kodak 100
Images taken with
the Hasselblad 501C

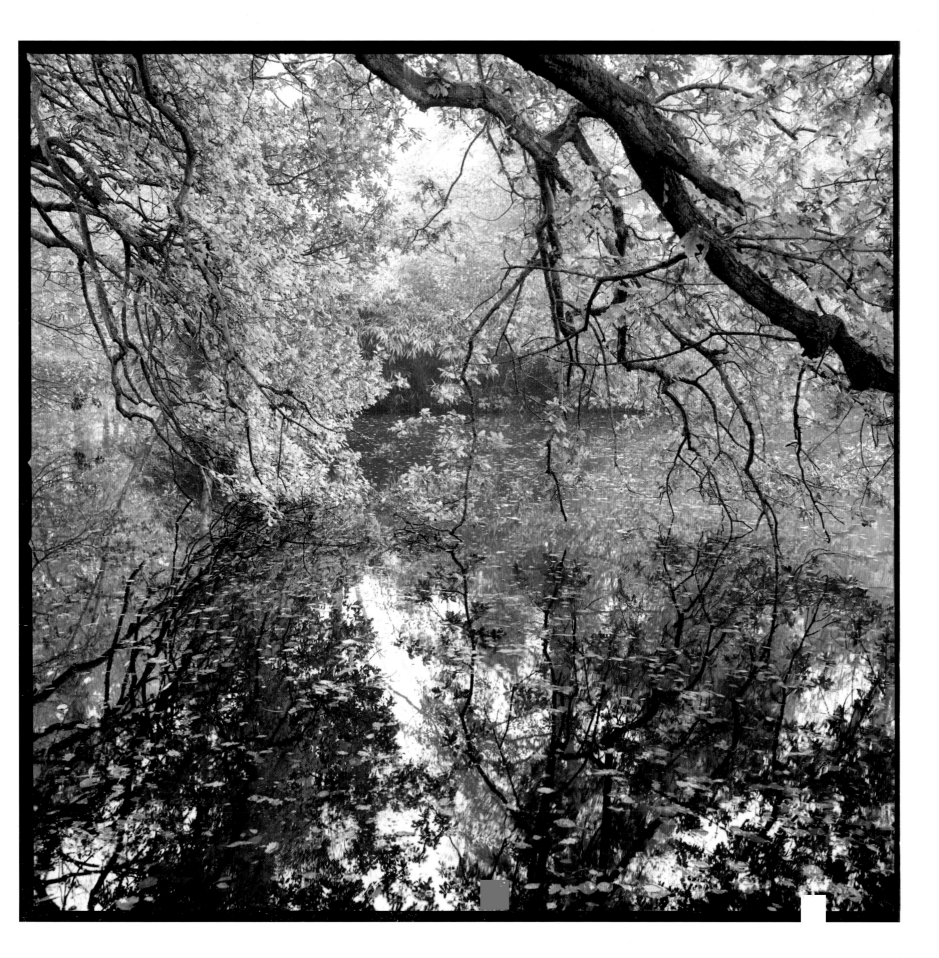

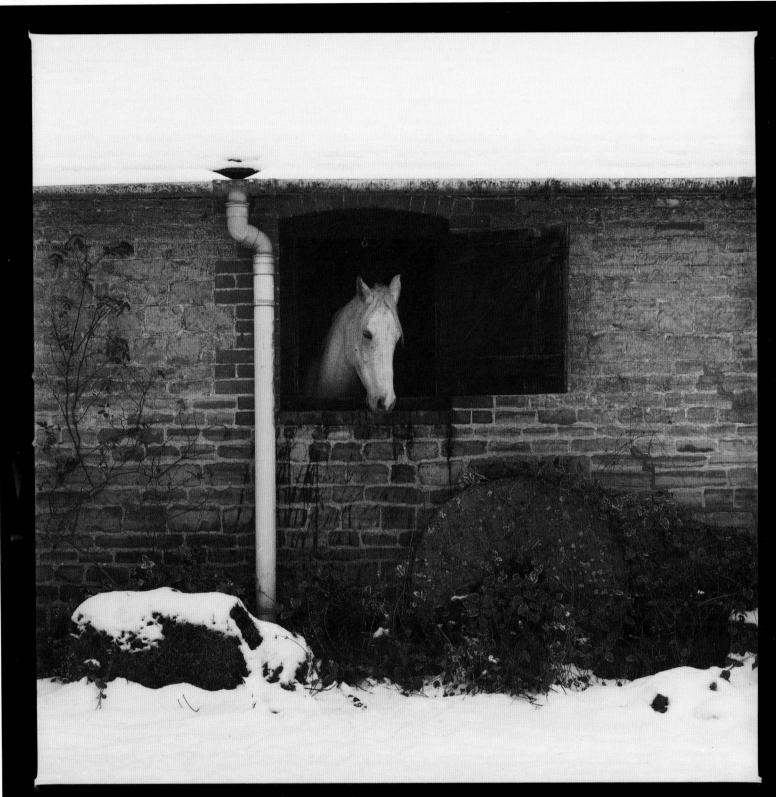

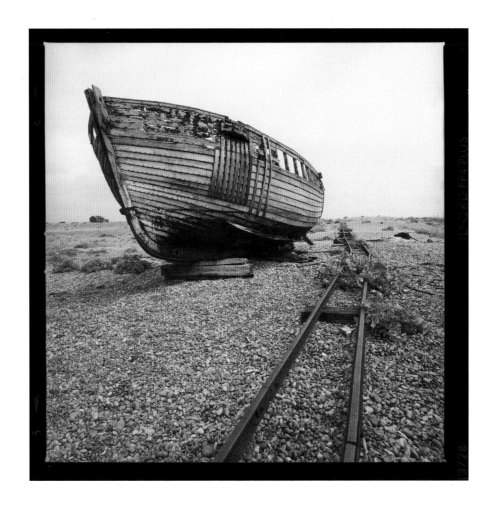

Once you master the Hasselblad's Carl Zeiss lens control (a small lever has to be moved to disengage the shutter speed and aperture ring), Hasselblads are a joy to use. Interesting that this style of lens control was also used by Zeiss on a smaller scale in some of the 35mm Contaxflex range. A Contaxflex 35mm SLR and a Hasselblad 500C together make a really usable compact outfit, covering both 35mm and roll film and both fitted with Carl Zeiss optics.

You can always identify a negative taken with a Hasselblad. Small notches in the film back are recorded down the left-hand side of the frame.

ALLANNAH'S GIRL
Ilford FP4

DUNGENESS
Ilford FP4
Images taken with
the Hasselblad 501C

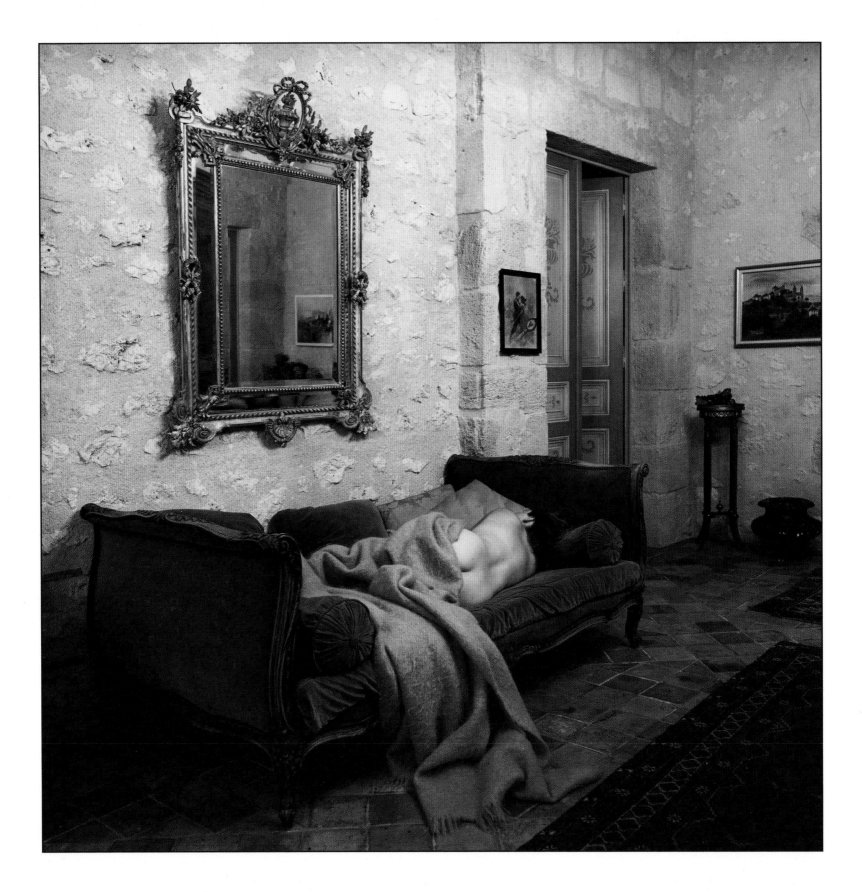

▷ ROLLEIFLEX SL66
1966–1986

Lens: Carl Zeiss Distagon 40mm
Format: 6 x 6cm
on 120/220 roll film
Rollei-Werke Franke & Heidecke,
Braunschweig, Germany

Rollei's first camera featuring interchangeable backs, to compete with the Hasselblad. The significant difference between the two is that the SL66 had a focal plane shutter rather than a leaf shutter as standard, although a few specialist leaf shutter lenses were made available for studio flash work.

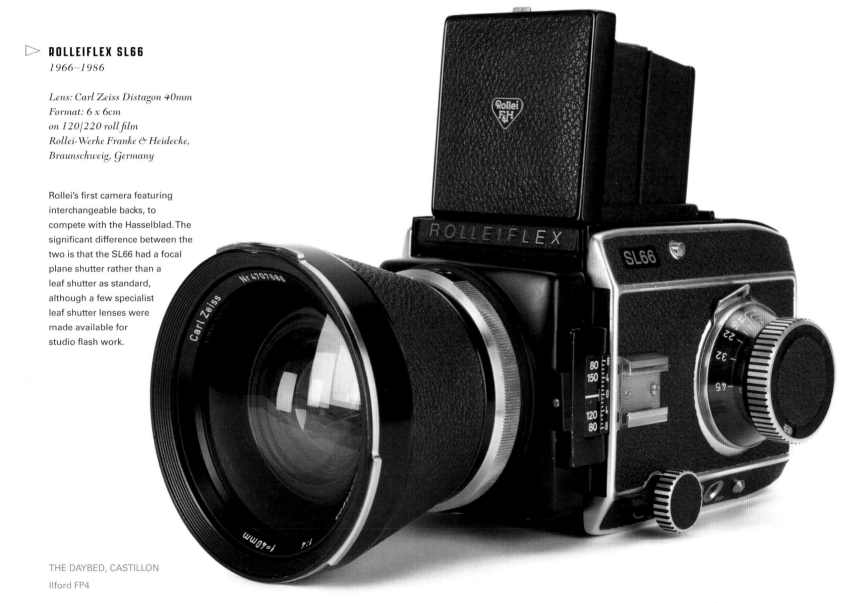

THE DAYBED, CASTILLON

Ilford FP4

▷ **HASSELBLAD SWC/M**
SUPERWIDE
1980

*Lens: Carl Zeiss Biogon T**
1:4.5 38mm
Format: 6 x 6cm
on 120 roll film
Victor Hasselblad,
Gothenburg, Sweden

The Hasselblad Superwide differs
from the standard Hasselblad
in that it doesn't have a reflex
mirror within the body. Due to the
extreme optics of the Biogon lens,
the point of focus is far shorter.
To compose with the camera, you
either use the hotshoe-mounted
optical viewfinder or attach
a ground-glass viewing
screen to the back.

MARIZU AND HIS
WET COLLODION VAN
Ilford HP5

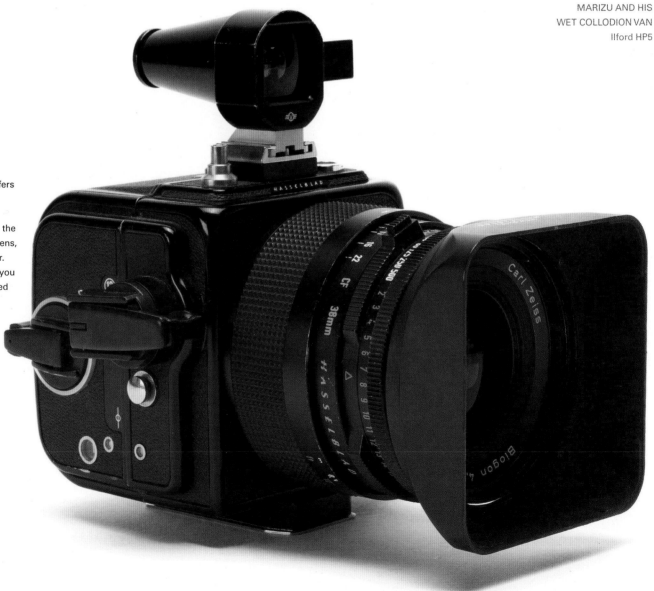

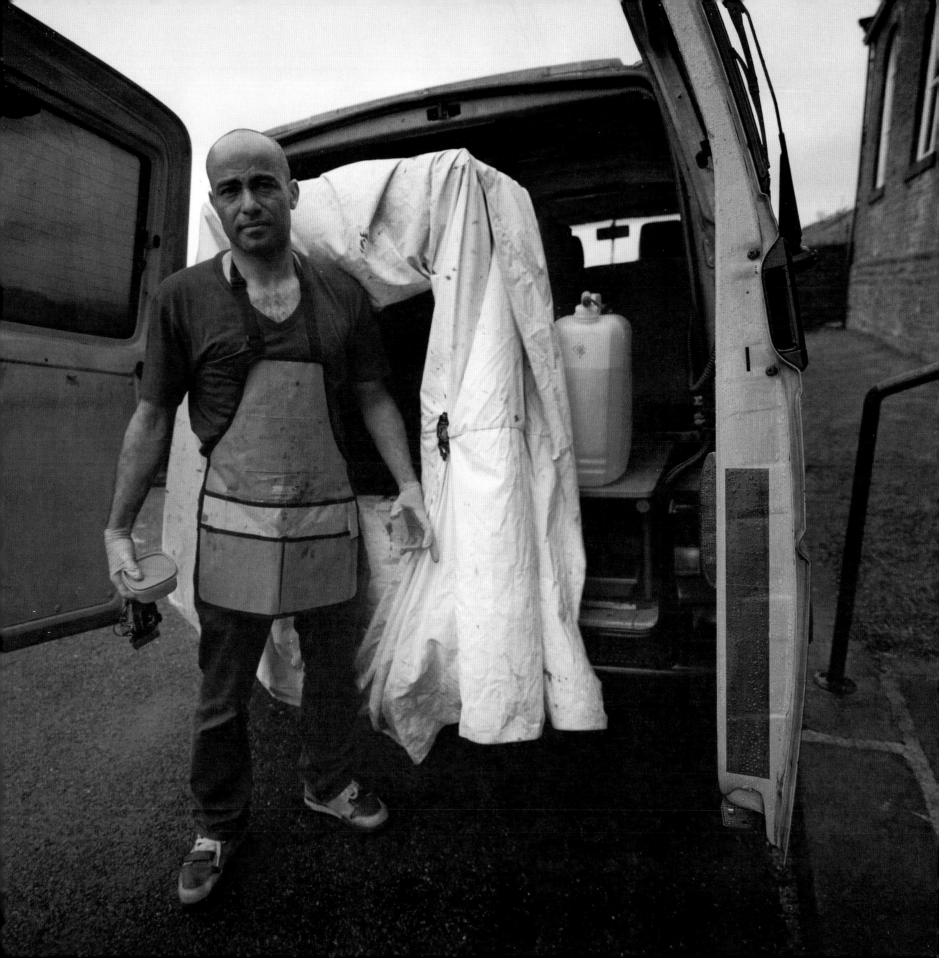

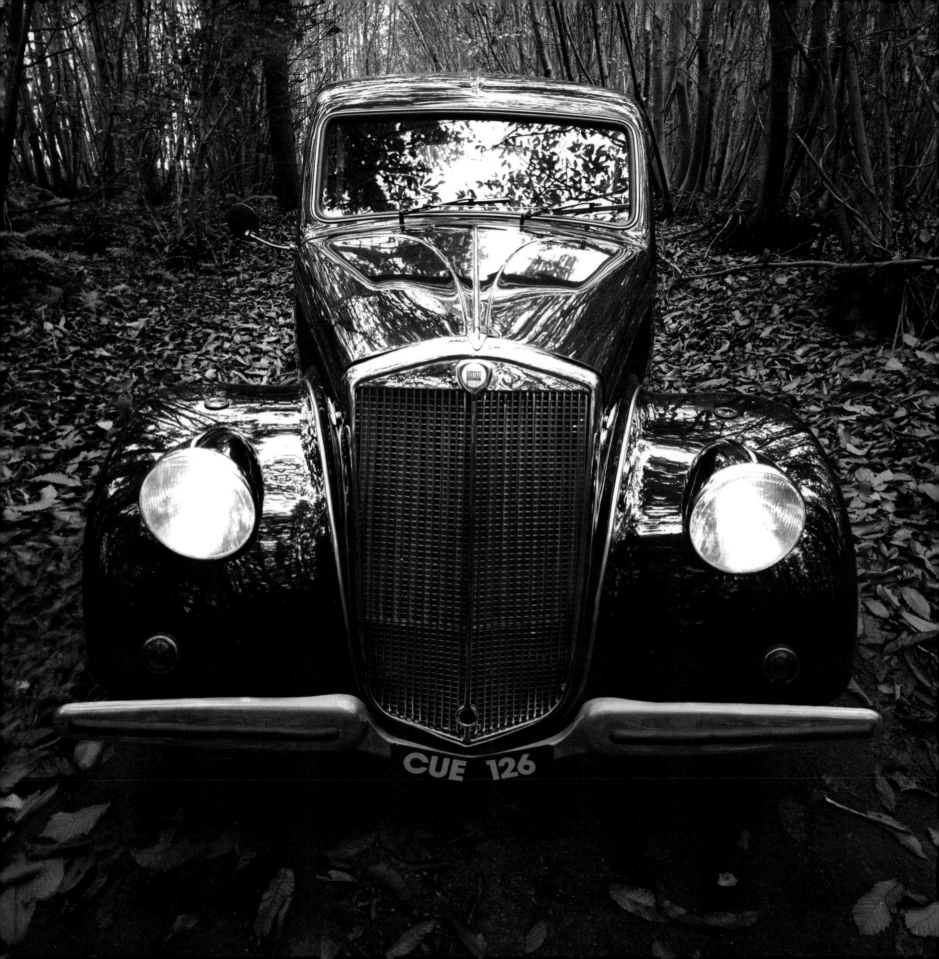

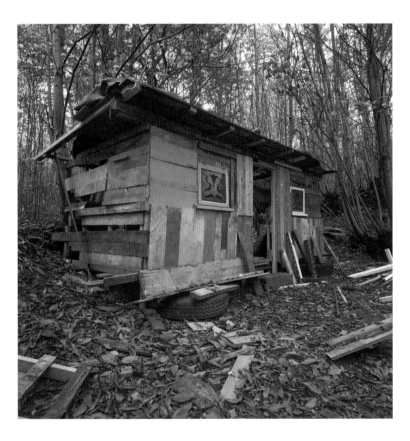

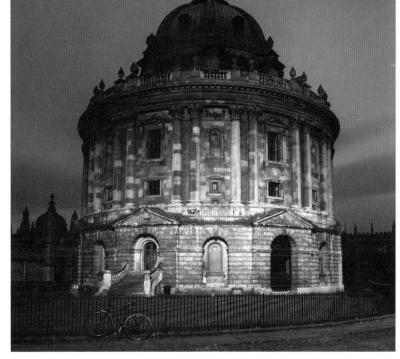

TERRY'S LANCIA
APRILIA
Efke 25
Images taken with
the Hasselblad SWC/M

HALF-BUILT HUT
Ilford FP4

RADCLIFFE CAMERA
Ilford HP5

▷ PENTAX 67 MIRROR-UP VERSION

1989

Lens: SMC Pentax 1:4 45mm
Format: 6 x 7cm
on 120 and 220 roll film
Asahi Optical Co. Ltd,
Tokyo, Japan

The Pentax 6 x 7 was launched in 1969 and quickly became a favourite of many fashion photographers. The 6 x 7cm format translated better to the full-page magazine format than the 6 x 6cm Rollei or Hasselblad.

The Achilles heel of the original 6 x 7 was vibration from the mirror mechanism. This was really noticeable in macro situations with medium shutter speeds. In 1992, a Pentax 67 outfit, including a 105 lens and a waist-level finder, cost $1106.95 and a pentaprism was an extra $179. At the same time, a Hasselblad 500c kit with standard lens and back was $2295.95, so in realistic terms a Pentax 67 was a bargain. The major drawback with the Pentax 67 system was that it had a non-interchangeable film back, unlike the SLR Hasselblads and Rolleiflexes. They are also quite fiddly to load film into, so many photographers like to carry a couple of bodies when on a shoot where time is critical.

The wooden handle is a must-have accessory, both for looks and ease of handling.

ACER WOOD
Kodak 100

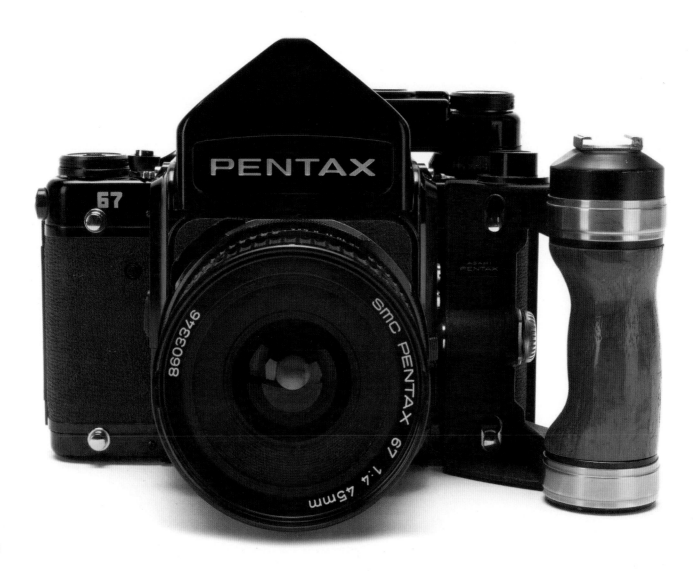

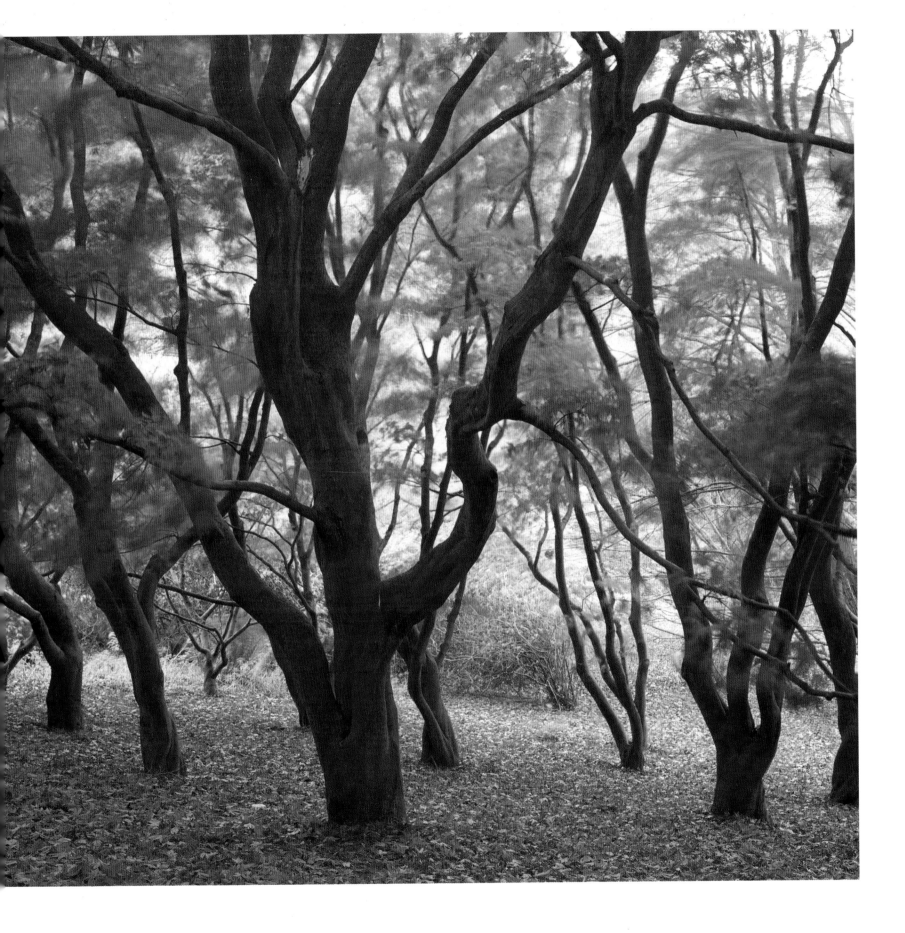

BACK
Ilford FP4
Lens: 105mm
Images taken with
the Pentax 67

THE LOVERS
Ilford FP4
Lens: 45mm

MISS ELLIOTT
Ilford FP4
Lens: 105mm

▷ **PENTAX 67
FITTED WITH
PENTAX AUTO BELLOWS**

*Lens: SMC Pentax 67 Macro 1:4
135mm
Format: 6 x 7cm
on 120 and 220 roll film
Asahi Optical Co. Ltd,
Tokyo, Japan*

The Pentax 67 is an incredibly
versatile system. It features a
complete set of lenses, from
35mm fisheye to 1000mm
telephoto, as well as finders and
accessories such as these auto
bellows, which allow extremely
close focusing.

DEWDROPS
Ilford PanF

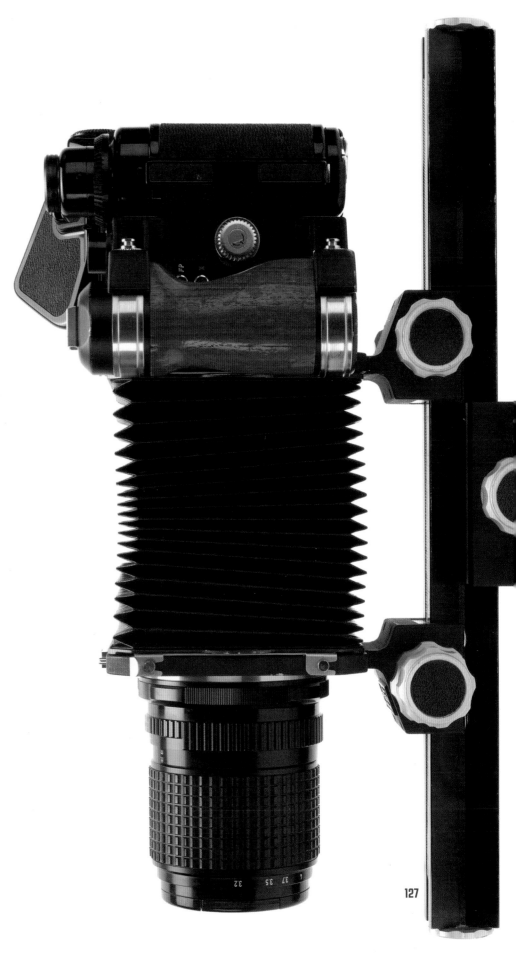

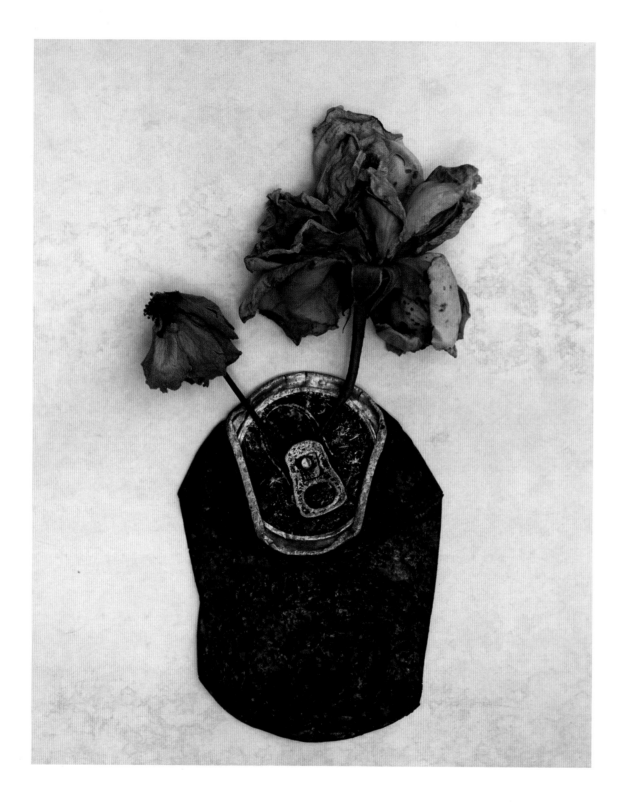

CAN OF ROSES
Pentax 67
105mm lens
Ilford FP4

THORNS
Pentax 67
165mm macro lens
Ilford PanF

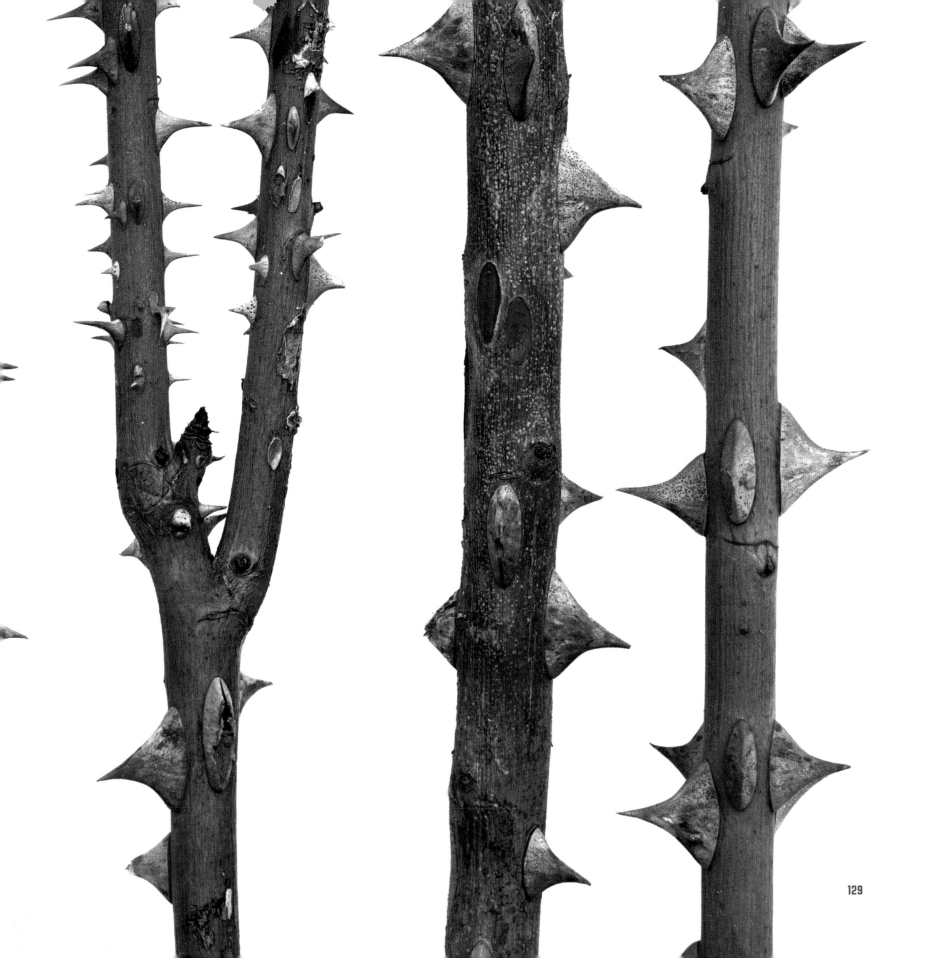

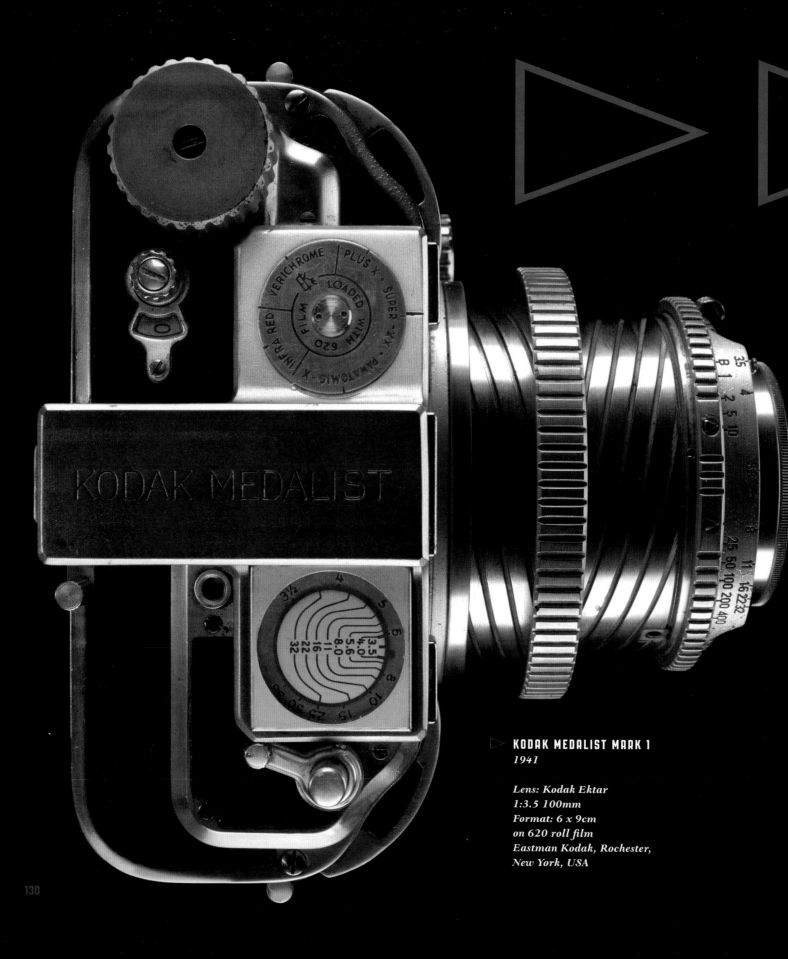

▷ **KODAK MEDALIST MARK 1**
1941

Lens: Kodak Ektar
1:3.5 100mm
Format: 6 x 9cm
on 620 roll film
Eastman Kodak, Rochester,
New York, USA

The Kodak Medalist was the pinnacle of American camera design in its day.

I love the split viewfinder rangefinder window. One sits on top of the other, unlike an early Leica, where they are side by side. The metal double helix focusing tube replaced the cloth bellows of previous Kodaks and combined precise focusing with rigidity. On the military versions this is anodised black. The massive 6 x 9cm negatives give super enlargements. Two models were produced: the Mark I from 1941 to 1948 and the Mark II from 1946 to 1953.

The Mark I was used extensively by the Allied Forces during the Second World War. An ad for the Medalist Mark II describes the camera as 'a great favourite with Navy men' and advises: 'When it's time to choose your postwar camera, remember — you haven't seen the finest until you've seen the Kodaks'.

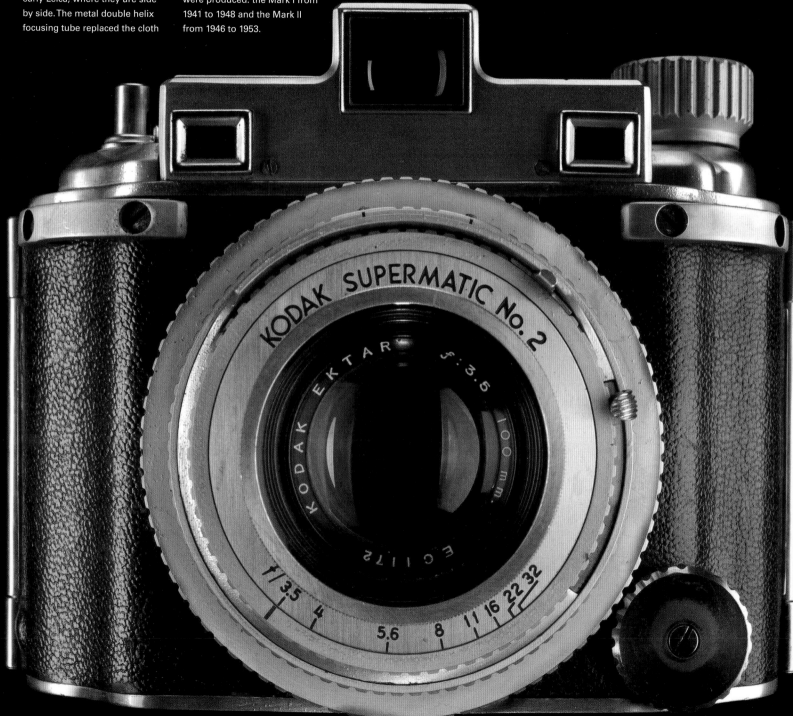

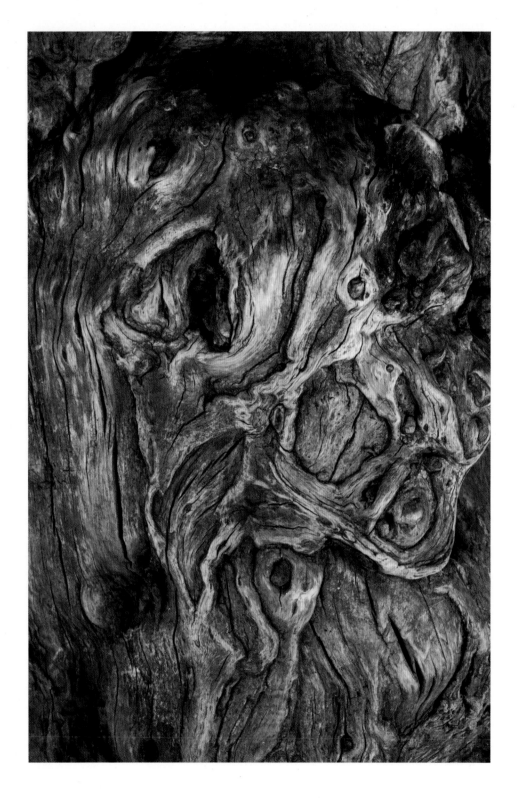

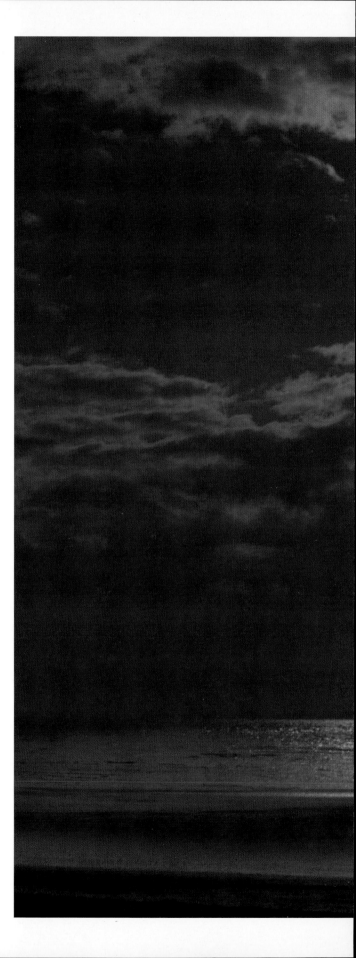

DRIFTWOOD CLOUDY DAY
Fujicolor Pro 400H Kodak 400TX
Both images taken with
the Kodak Medalist

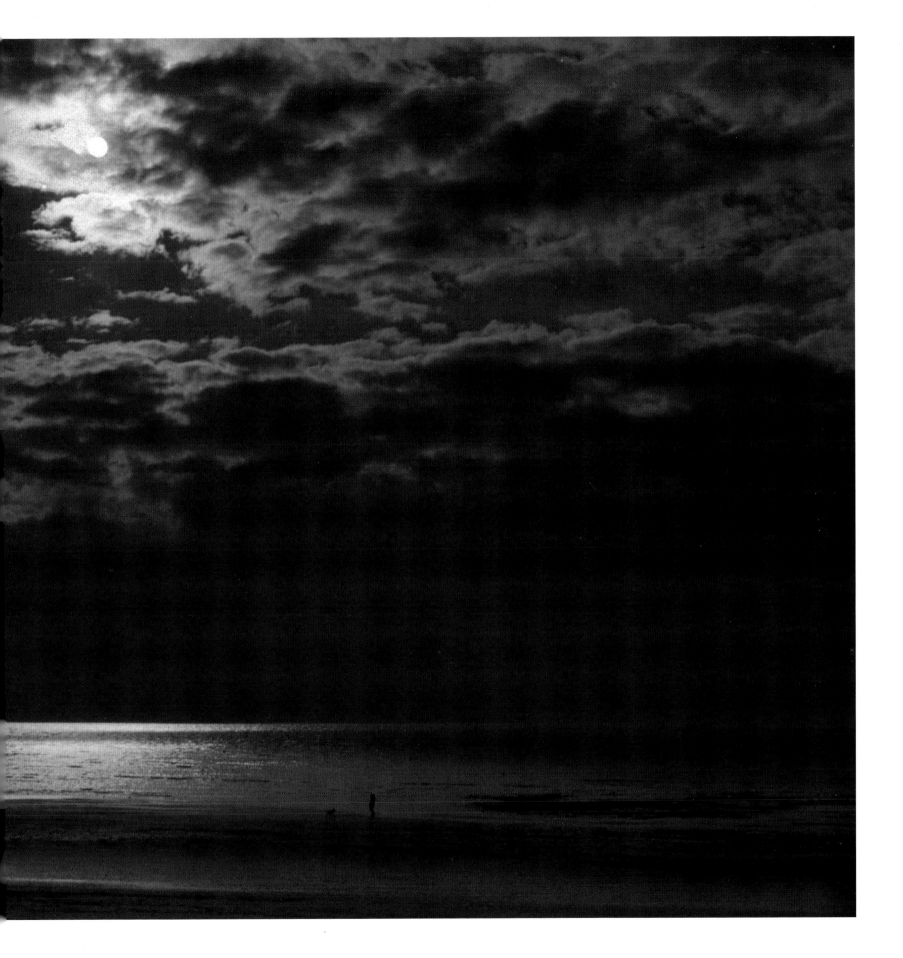

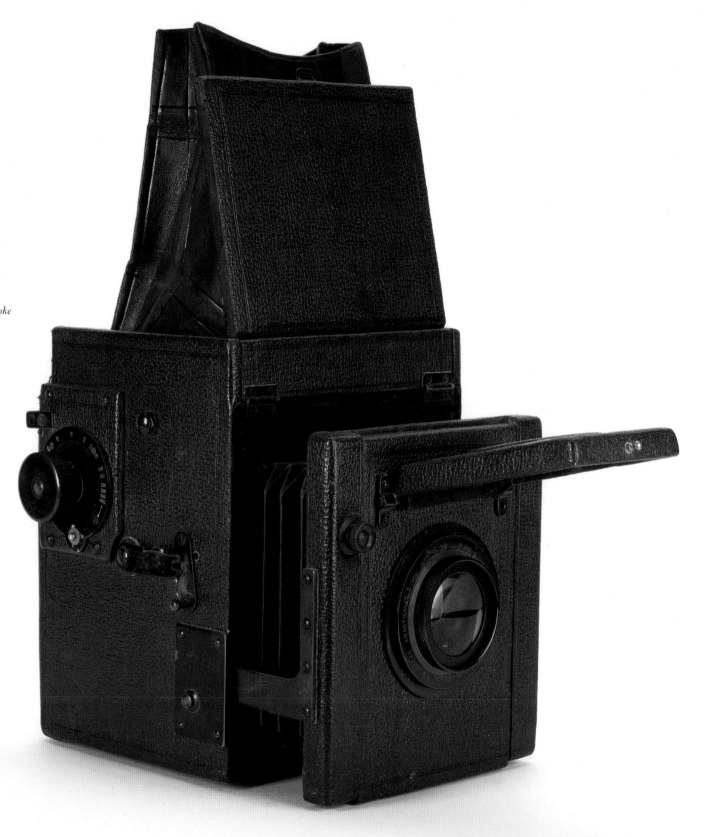

▷ **THORNTON-PICKARD**
REFLEX UNBADGED
1912–1930

Lens: Taylor-Hobson T P Cooke
Anastigmat 1:4.5 6in
Format: plate or
120 roll film back
Thornton-Pickard Mfg. Co.,
England

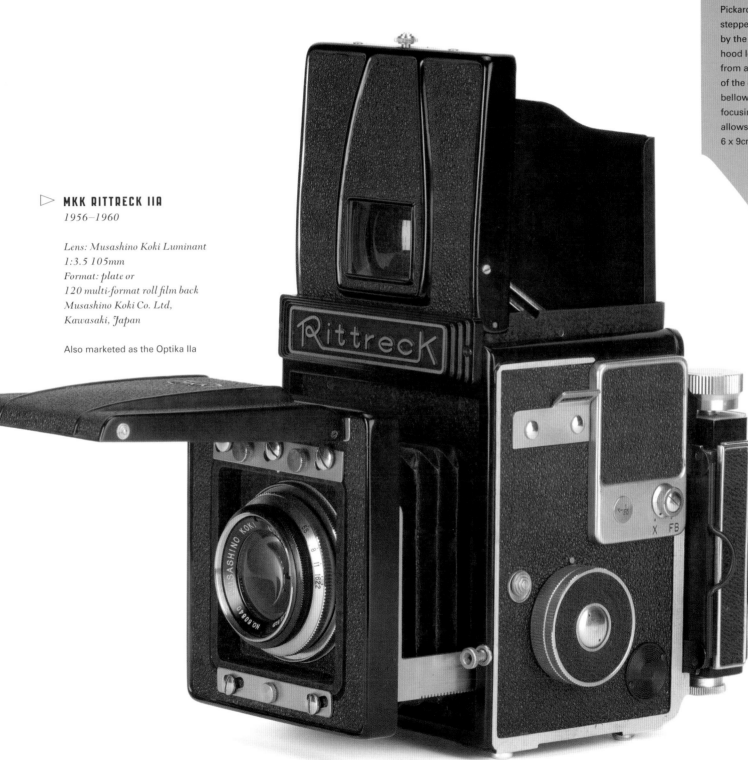

▷ MKK RITTRECK IIA

1956–1960

Lens: Musashino Koki Luminant
1:3.5 105mm
Format: plate or
120 multi-format roll film back
Musashino Koki Co. Ltd,
Kawasaki, Japan

Also marketed as the Optika IIa

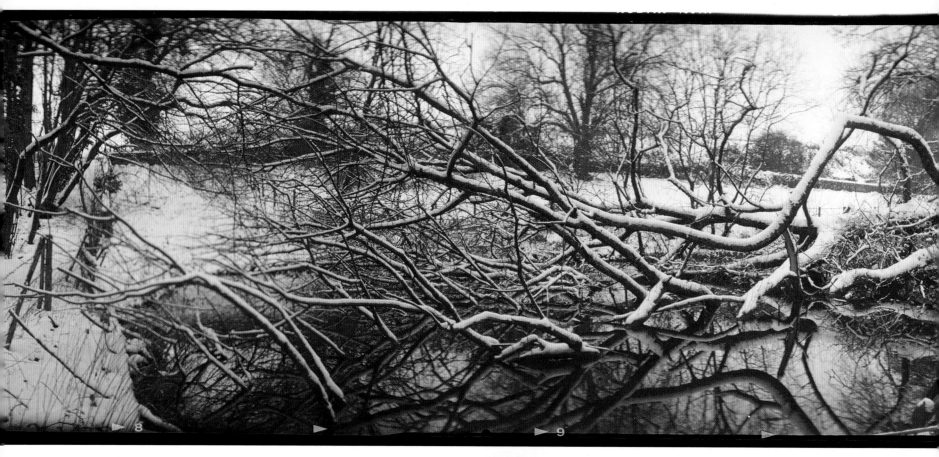

▷ KODAK NO. 1 PANORAM MODEL

1900–1926

Lens: unmarked
Format: 2¹/₄ x 7in
Originally intended for 105 roll film but the camera will take 120 roll film.
Eastman Kodak, Rochester, New York, USA

The camera is built on the same principles as the Widelux (see page 60) — a pivoting lens exposes onto a curved film plane.

The 'Poet of Prague' Josef Sudek produced some beautiful work on a Kodak Panoram.

THE POND IN WINTER

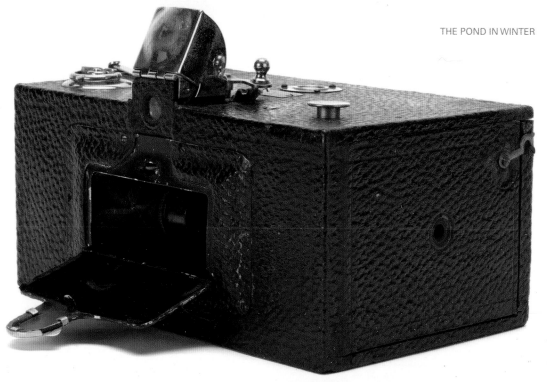

136

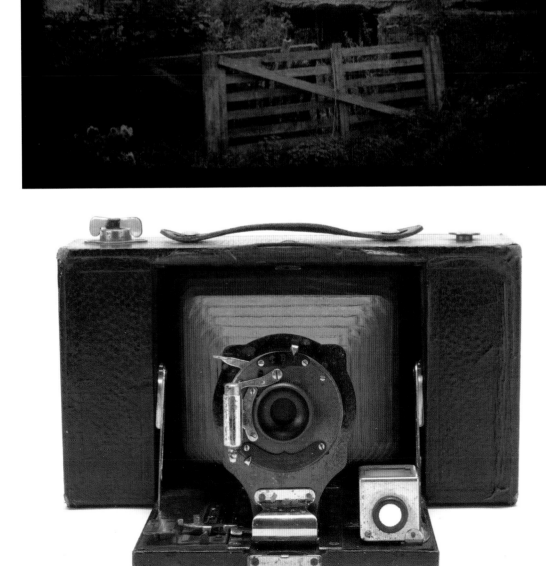

▷ **KODAK NO. 3 FOLDING BROWNIE MODEL D**
1909–1915

Lens: unmarked
Format: 3¼ x 4¼ in
on 124 roll film

Almost 40,000 units of this model were made. It can now only be used with paper or sheet film, as the 124 roll film is no longer available. The pictures it takes really do look like they were taken in the early 1900s.

OLD BARN 2015

137

3

LARGE FORMAT
SHEET FILM,
PAPER AND PLATES

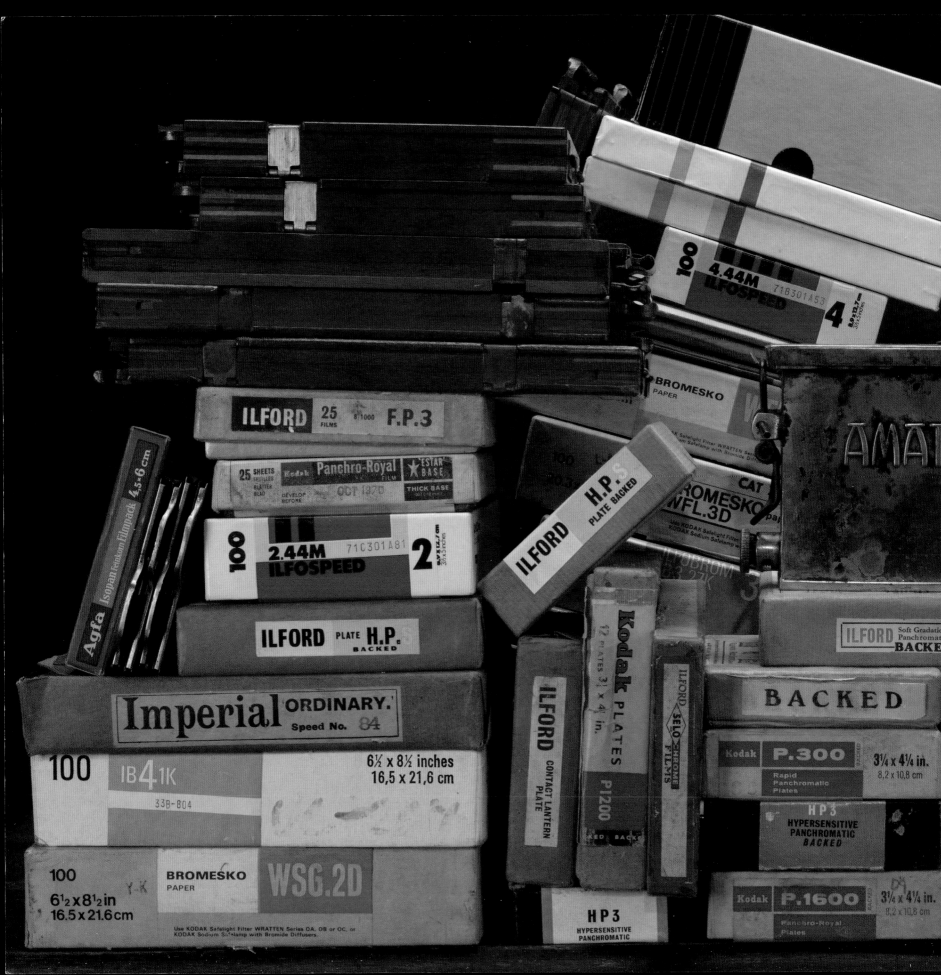

LARGE FORMAT SHEET FILM, PAPER AND PLATES

▽

The quickest way to understand all the fundamental principles of photography is to start big. At a larger scale, the process is slow and methodical. You compose the photograph onto a ground glass screen at the back of the camera and see precisely what the lens sees. Lenses reverse images, so you have to compensate in your head for the fact that it will be upside-down and back-to-front.

Working in large format is a totally different art to shooting 35mm or roll film. You shoot an individual image, so processing control is easier. If you have a badly exposed plate or a darkroom disaster you only lose one shot, not a whole roll.

William Fox Talbot's first camera, known as the 'mousetrap', was relatively small, but it was not long before cameras started to grow. In 1846, Talbot and his experimenter friends were using quite sizeable cameras. The basic principle being the bigger the negative, the better the quality.

The Main Formats:
Old Style: quarter plate, half plate, whole plate
Newer Style: 5 x 4 (inches), 5 x 7, 10 x 8, 11 x 14, 12 x 16, 16 x 20 and 20 x 24

Ilford Ltd takes orders once a year for more unusual sheet film sizes and will produce film in any of the above sizes.

Some of the great large format photographers liked to make 1:1 contact prints. This is considered by many to be the pinnacle of excellence in photography. I remember being transfixed by the contact prints at an Edward Weston show. The tonality and sharpness of the image were like nothing I'd seen before. But large format photography can be a very free process. It can be messy, like a wet collodion, or soft and subtle like a salt print. There is an infinite combination of lenses and cameras, of film and developers.

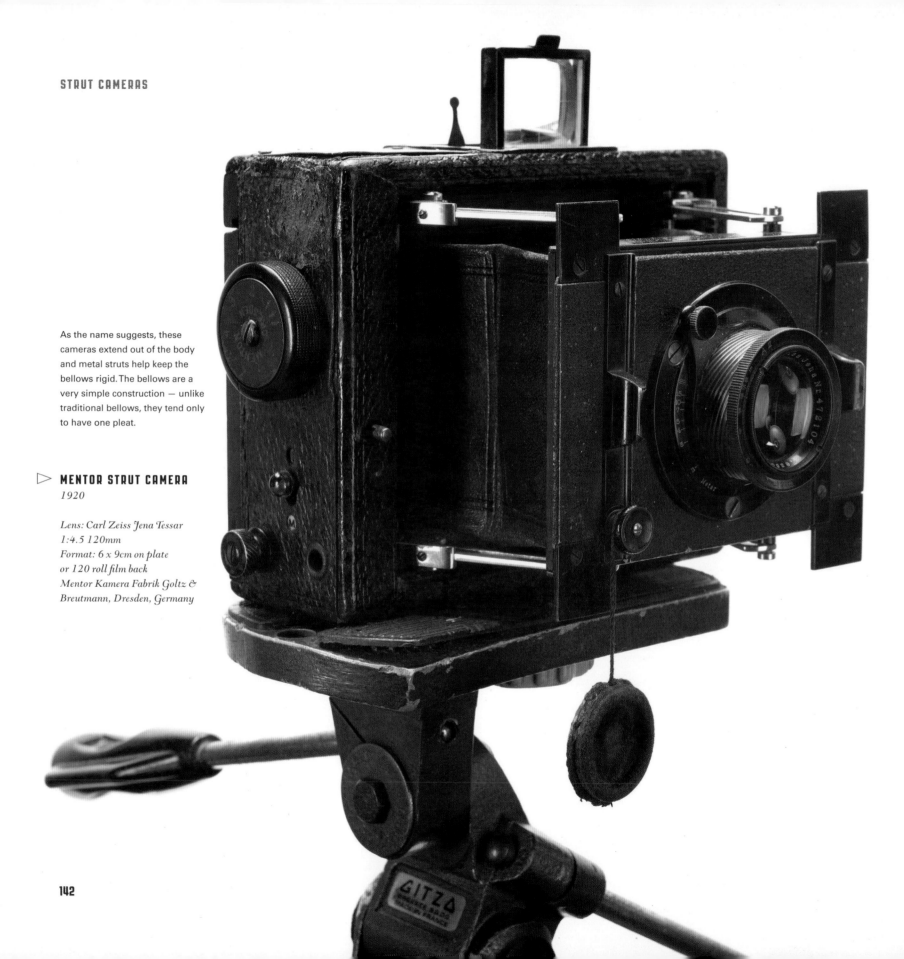

As the name suggests, these cameras extend out of the body and metal struts help keep the bellows rigid. The bellows are a very simple construction — unlike traditional bellows, they tend only to have one pleat.

▷ **MENTOR STRUT CAMERA**
1920

*Lens: Carl Zeiss Jena Tessar
1:4.5 120mm
Format: 6 x 9cm on plate
or 120 roll film back
Mentor Kamera Fabrik Goltz &
Breutmann, Dresden, Germany*

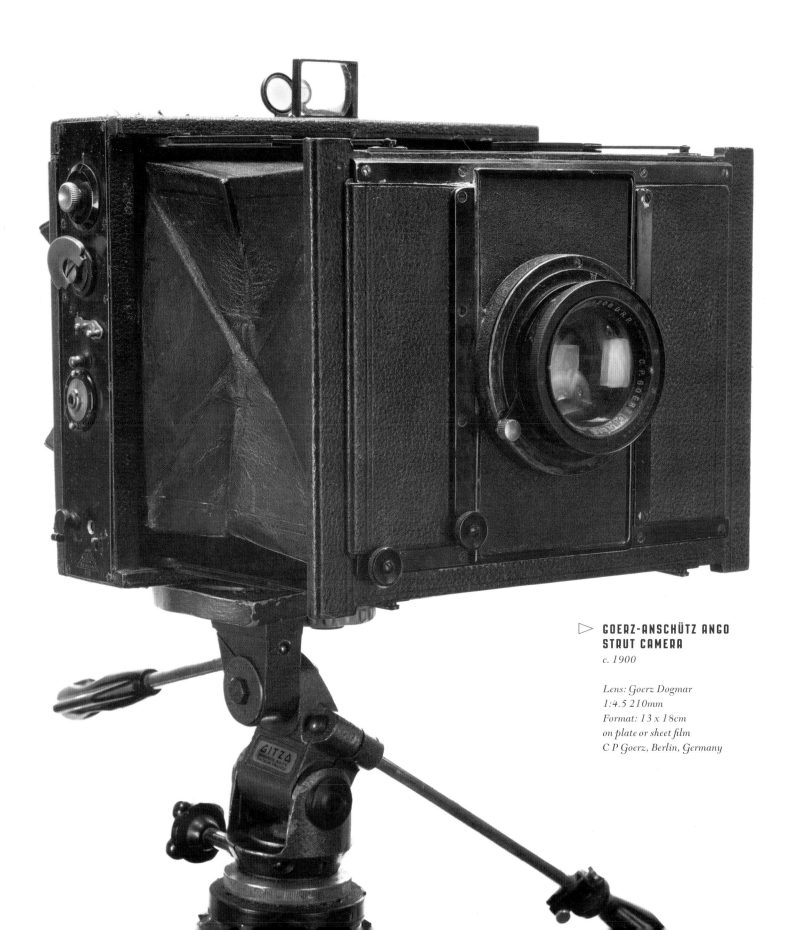

▷ **GOERZ-ANSCHÜTZ ANGO STRUT CAMERA**

c. 1900

Lens: Goerz Dogmar
1:4.5 210mm
Format: 13 x 18cm
on plate or sheet film
C P Goerz, Berlin, Germany

Like food, film has always carried
a 'use by' date, but it never ceases
to amaze me how well out-of-date
plates and paper can work.
I have had results from plates over
a hundred years old. They will
dramatically lose contrast but this
can be brought back significantly
with computer software after
scanning. It's always advisable
to keep new film stock in
refrigerated conditions.

BEN

CAMERA COLLECTION
Both images taken on
the Goerz-Anschütz Ango strut
camera using vintage glass plates

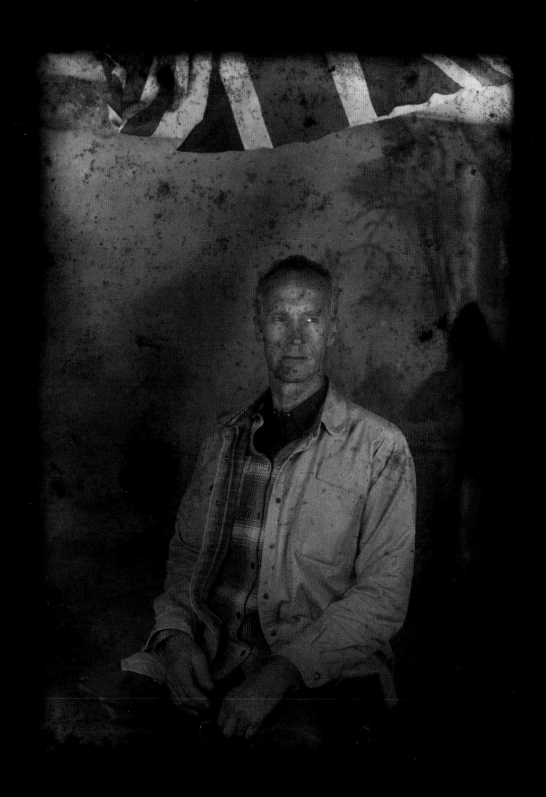

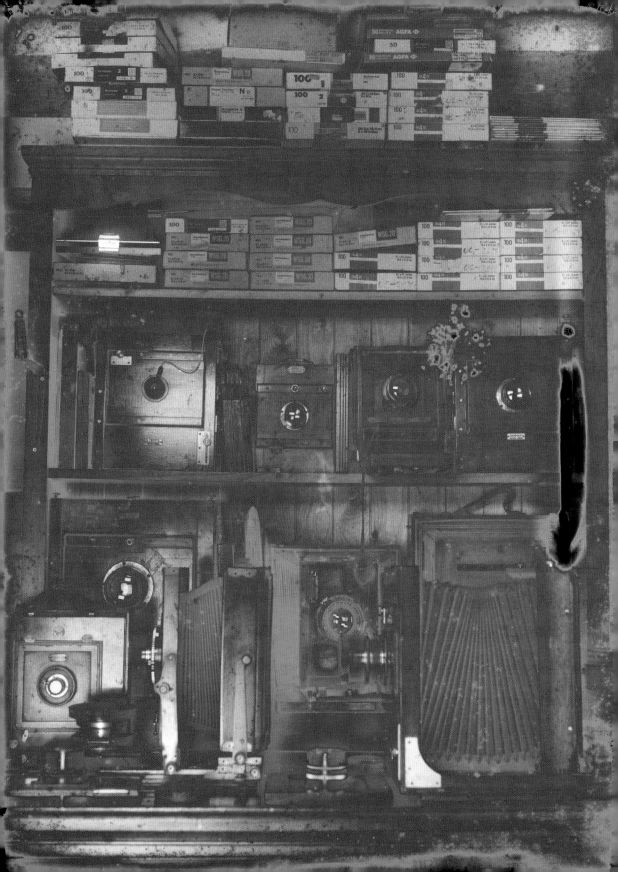

SOUTH DOWNS
Kodak 320 TXP

THE SCENT OF PHOTOGRAPHY

I mentioned in the introduction that film has an intoxicating aroma, and the same can be said of cameras. Old wood and brass cameras smell, and as they warm up under studio lighting, the strength of the odour increases. Rolling the bellows in and out, like an accordion, wafts of smelly air escape through the gaps around the ground glass viewing screen. It's spicy and if you could bottle it, it would make a brilliant aftershave. At the other end of the spectrum, a brand-new Leica straight out of the box smells pretty good too. Darkrooms have a unique aroma. Stopbath (acetic acid), smelled by mistake out of the bottle, will blow your nose off, and there are some really horrible odours, like the bad egg whiff of sulphur-based toners.

▷ **CUSTOM HOMEMADE
6 X 9CM**

c. 1930

*Lens: Carl Zeiss Jena Tessar
1:4.5 105mm
Format: plate or 120 roll film;
Rollex back for 6 x 9cm*

This camera appears to be of a homemade construction or, possibly, a prototype. It has an ingenious collapsing lenshood (very Heath Robinson!) and it appears that bits have been borrowed from other cameras.

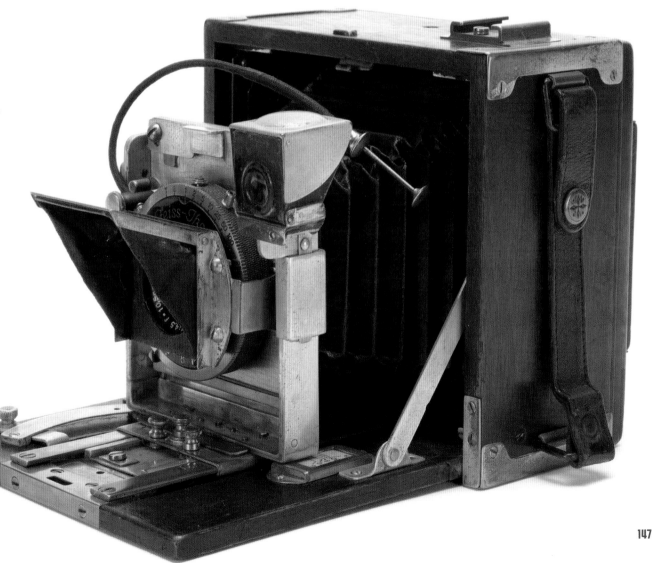

▷ ### GANDOLFI QUARTER PLATE PRECISION
Early 1950s

Lens: Carl Zeiss Jena Tessar
1:4.5 135cm
Format: 3¹/4 x 4¹/4in
on glass plates or film
(via adaptors)
into book-form holders
Gandolfi, London, England

The Gandolfi brothers have become legends in the history of camera manufacture. The quality of their large format cameras was second to none. They were constructed by hand in a small workshop in London, using only the finest quality timber. Most Gandolfi cameras were made to order. Founded in 1885 by Louis Gandolfi, an Italian immigrant, the company was making cameras for a hundred years before production ceased.

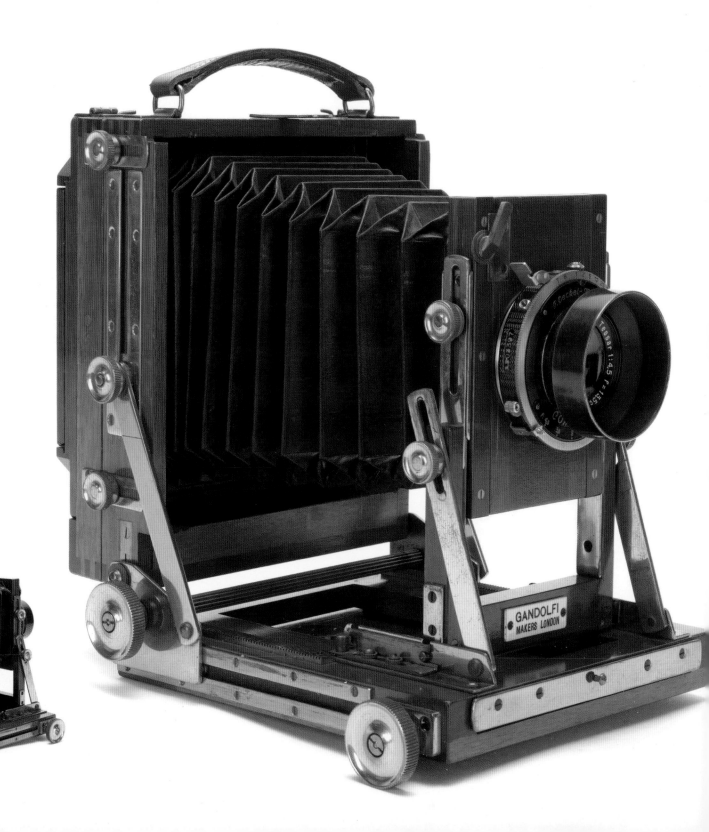

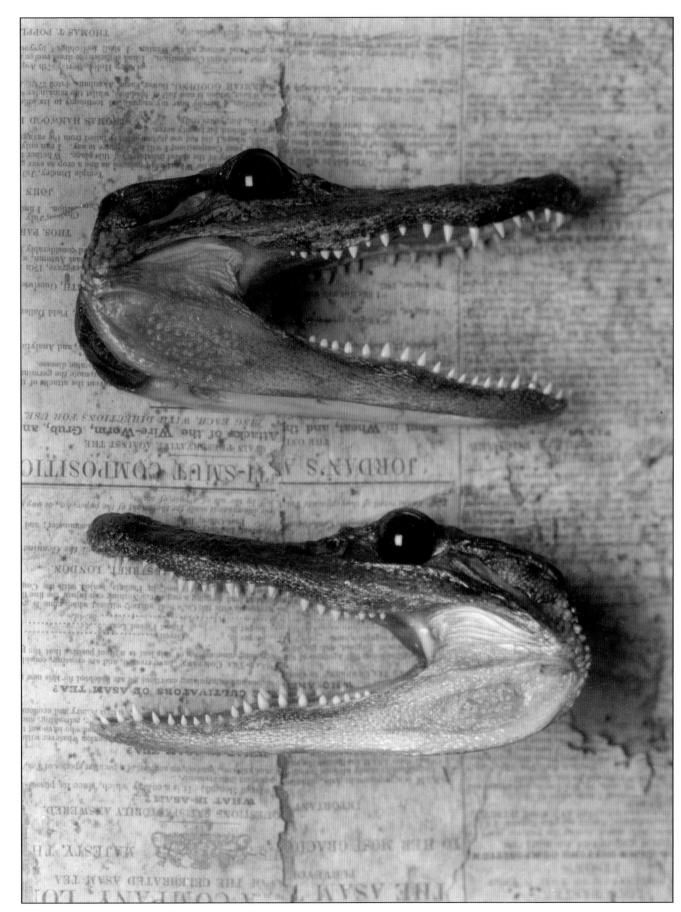

PREDATORS
Wephota Planfilm NP22

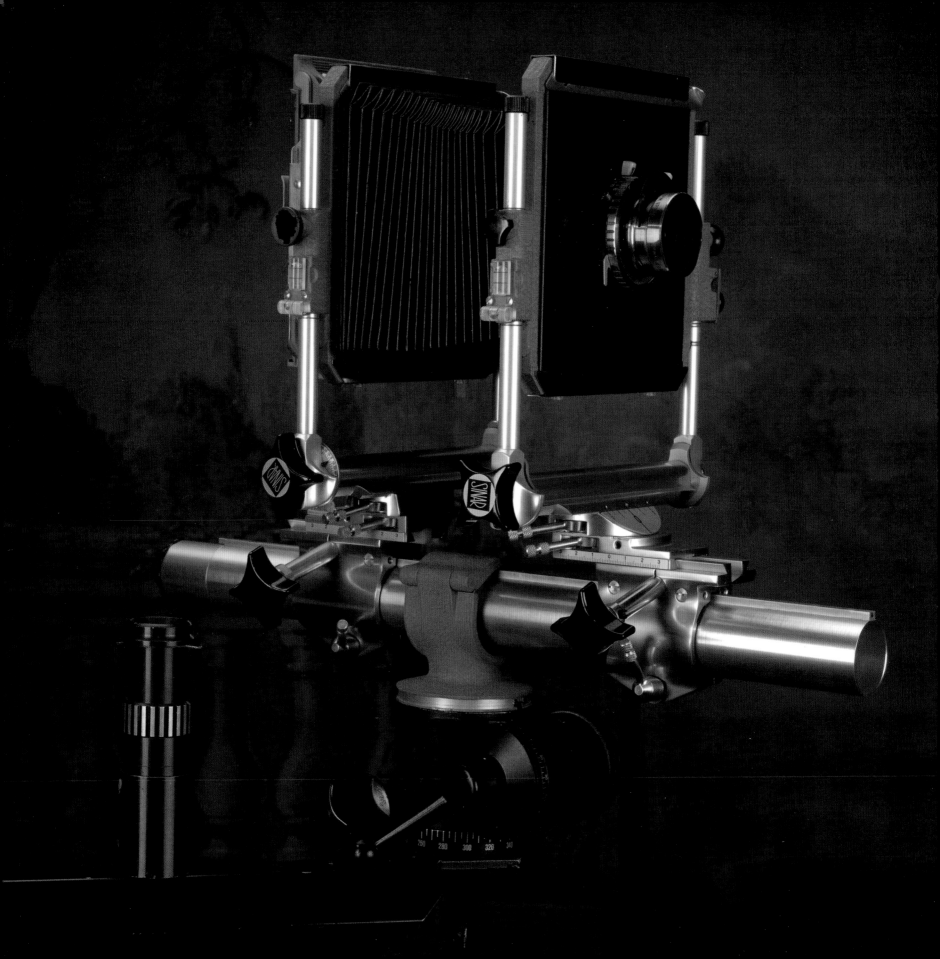

▷ **SINAR NORMA**
1968

Lens: Busch Wide-angle Aplanat
Ser.C 1:16 No.2 6 inch
attached to a SynchroCompur
shutter
Format: 5 x 4in on sheet film
Emil Busch A.G. Rathenow,
Germany

Carl Hans Koch invented the Sinar
camera in 1947 because he was
dissatisfied with the poor range
of movement in contemporary
wooden view cameras. His work
resulted in the finest studio
technical cameras available. At
one time, a Sinar was to be found
in virtually every professional
studio. The company produced
cameras in 5 x 4, 5 x 7 and 10 x 8
and it was possible to convert
a 5 x 4 camera to a 10 x 8 and
viceversa by simply changing the
front or rear standards. The name
Sinar stands for Still, Industrial,
Nature, Architecture and
Reproduction photography.

THE LITTLE BOOK
Ilford FP4

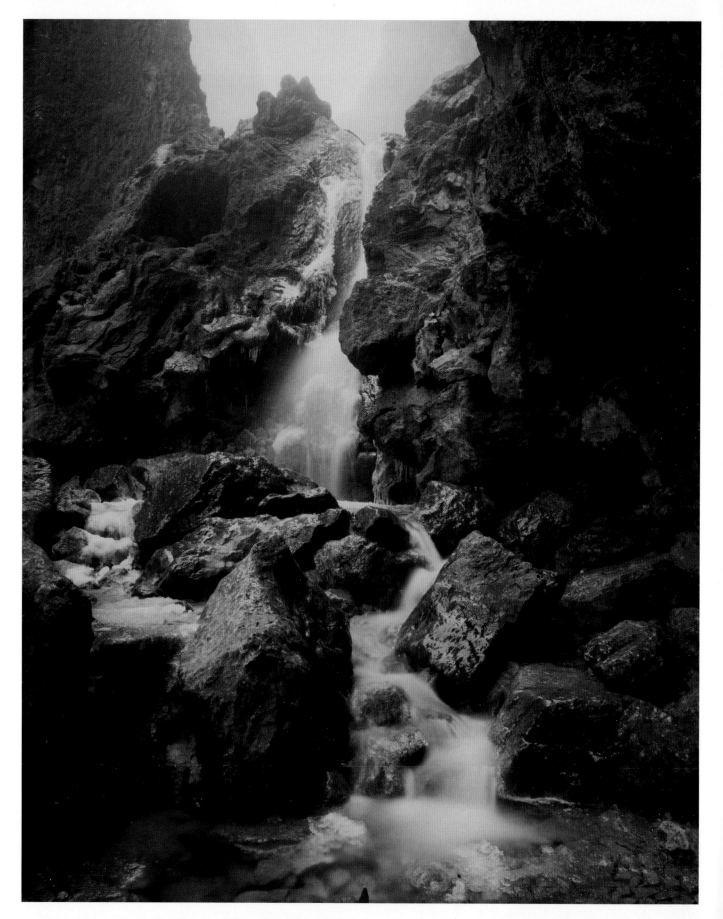

GORDALE SCAR
Taken on MPP Mark VIII
(see page 159) with Schneider
Angulon 90mm lens
Polaroid Type 55

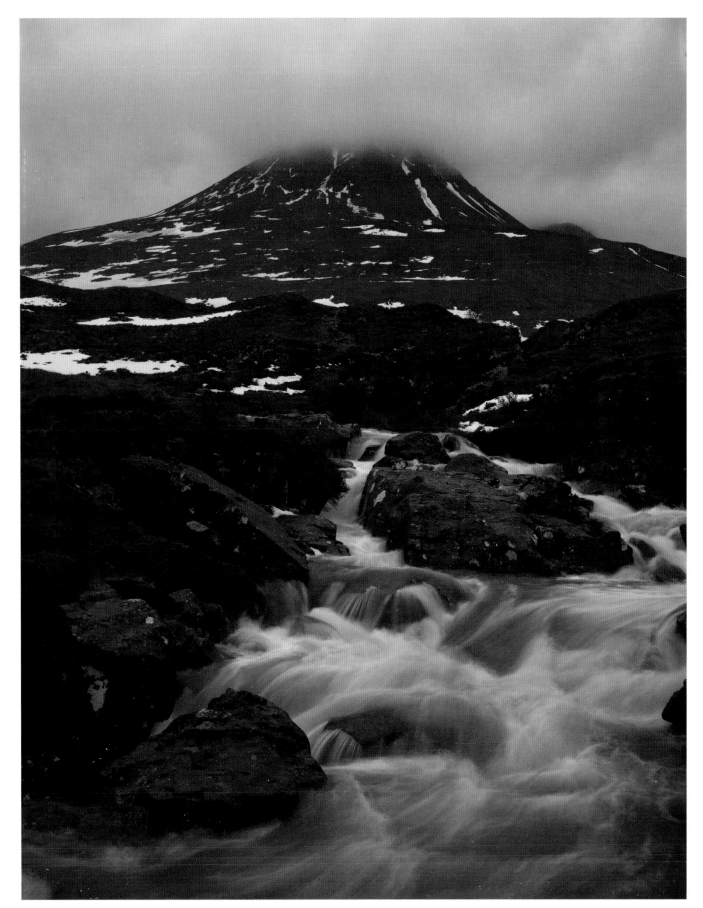

GLEN ETIVE
Taken on MPP Mark VIII with
Schneider Xenar 135mm lens
Efke 100

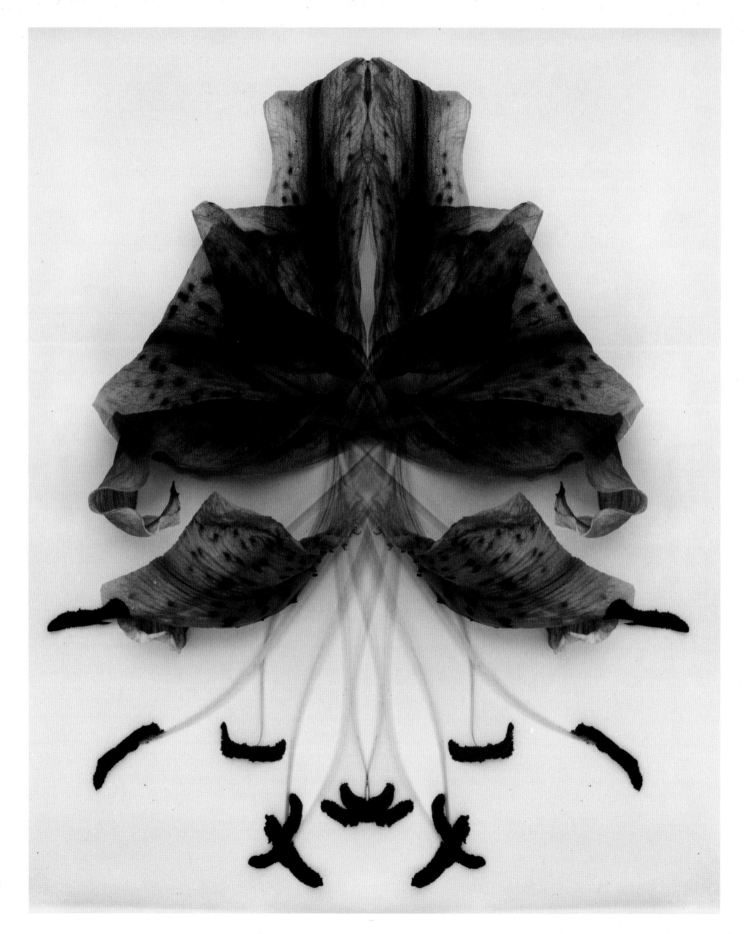

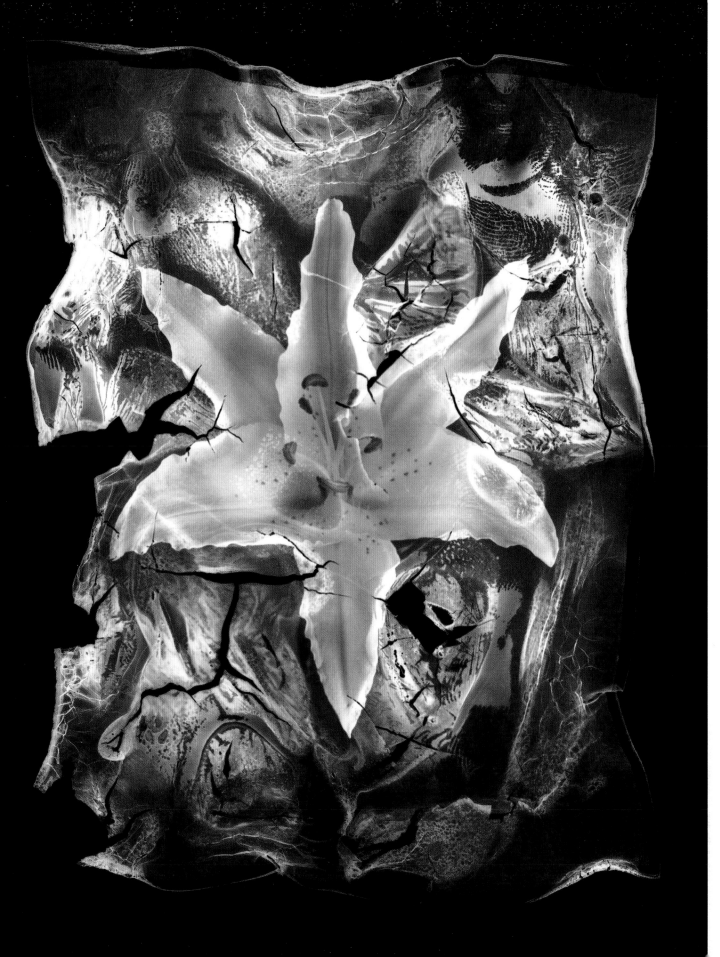

LILY I
Two negatives were sandwiched together, one reversed, and then scanned.

LILY II
The sheet of film was placed under a grill and subjected to fierce heat before it was scanned.

Both pictures taken with the Sinar Norma (see page 150) using a Schneider Symmar 150mm lens.

▷ **ROBIN HILL CLOUD CAMERA**
c. 1955
Lens cell 1924

Custom hammer finish body
MPP Universal back 5 x 4in

ASH IN THE COPPICE
Wephota Planfilm NP22

ROBIN HILL

Robert, otherwise known as Robin, Hill, 1899–1991, was a biochemist and inventor famed for his ground-breaking work on photosynthesis. He was a fellow of the Royal Society and received both the Royal and Copley Medals from the Society. In 1924, when he was only twenty-five, he filed a patent for a design of the first hemispherical 'fisheye' lens, together with Conran Beck of Beck Ltd, Lens Makers of London. The patent is listed as follows:

'Our invention consists of a new form of optical system for taking photographs on a flat plane of views which subtend very large angles as for instance of a sky subtending 180 degrees'.

This is an extremely rare camera, one of a handful known to exist. This particular camera is interesting because the lens element predates the lens housing, camera body and back. The story goes that in 1959 two botanists, Evan and Coombe, wanted to photograph the upper hemisphere of woodland canopies to estimate the direct and diffuse solar radiation present. They knew of the Hill Cloud camera but could not find an example to use. They did, however, find that Robin Hill still had a set of lens elements. They had them mounted into a custom (maker unknown) complex self-cocking shutter.

The Hill camera has to be used with a monochromatic filter because the lens is not fully corrected for chromatic aberration. The lens incorporates a filter wheel between the elements.

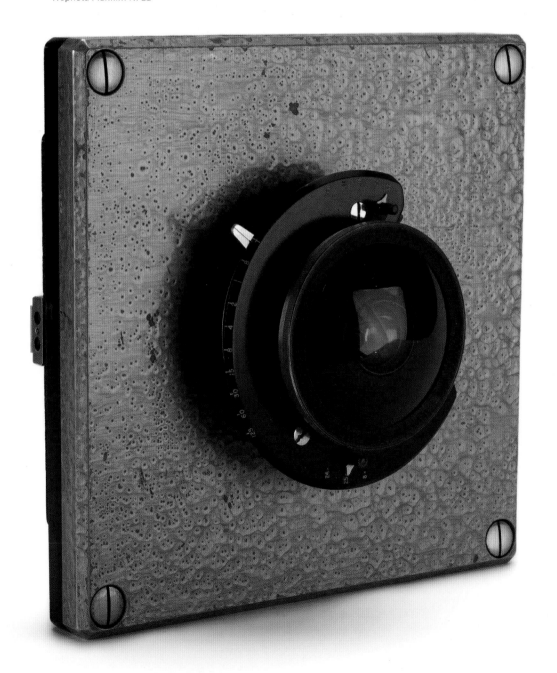

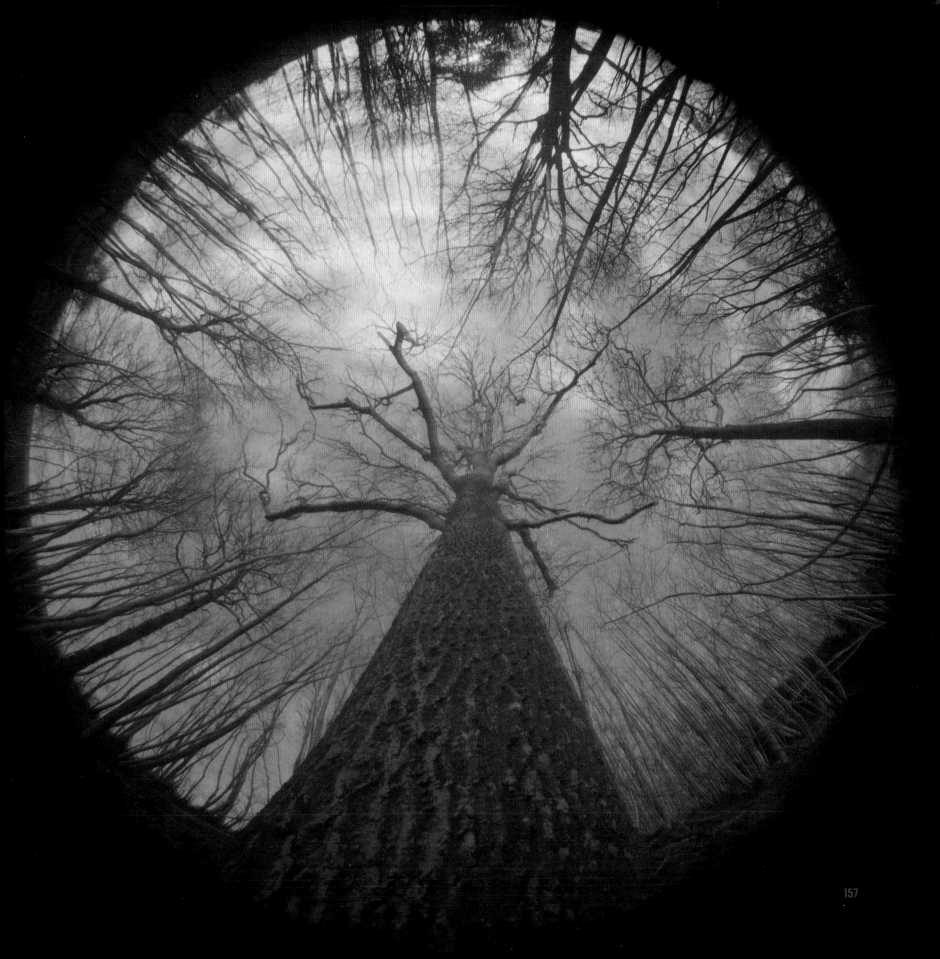

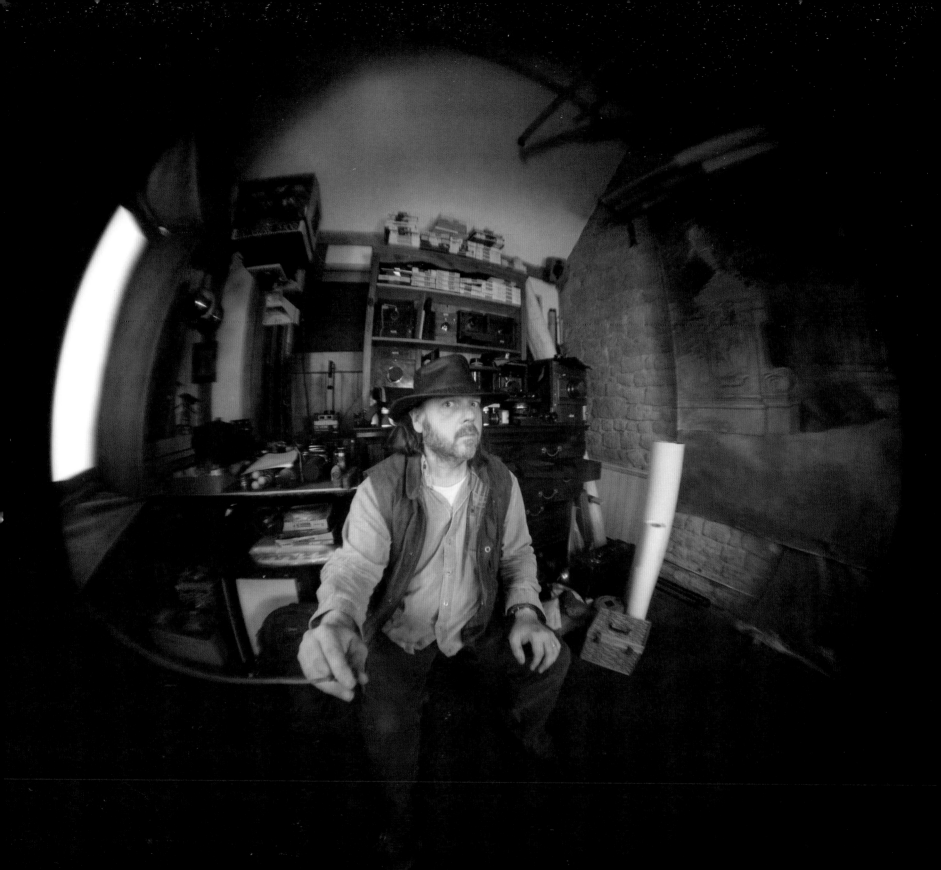

SELF-PORTRAIT WITH MPP 1990
Ilford FP4
This was a favourite camera for
many years (see pages 152 and 153).

TESTING THE HILL CLOUD
CAMERA, 2015
Ilford FP4

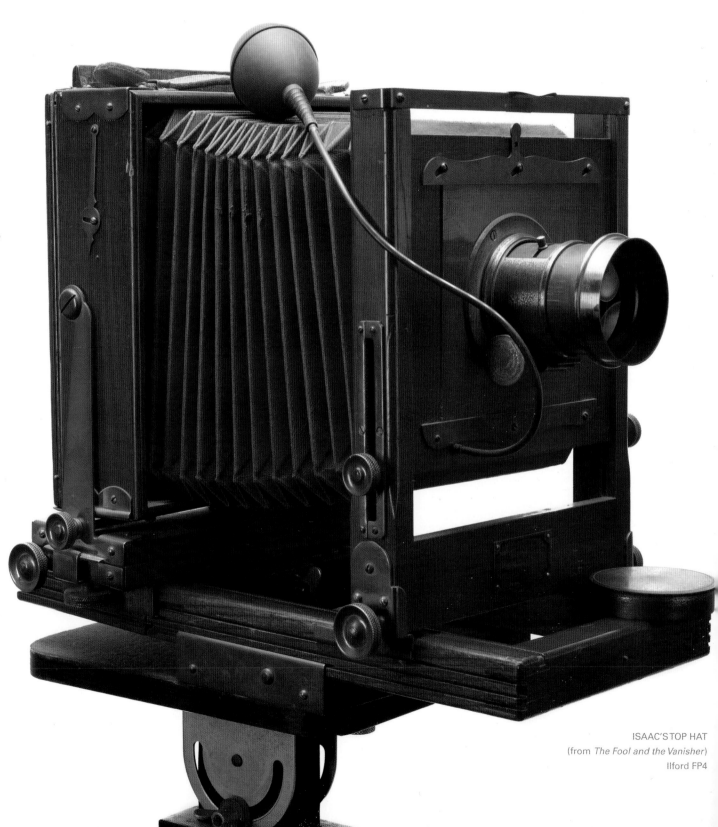

▷ **EASTMAN VIEW NO. 2**
*Improved model of Century View
and Empire State No. 2
1914–1920*

*Lens: generic unmarked
brass-bound lens
Format: 5 x 7in
on sheet film or plate*

ISAAC'S TOP HAT
(from *The Fool and the Vanisher*)
Ilford FP4

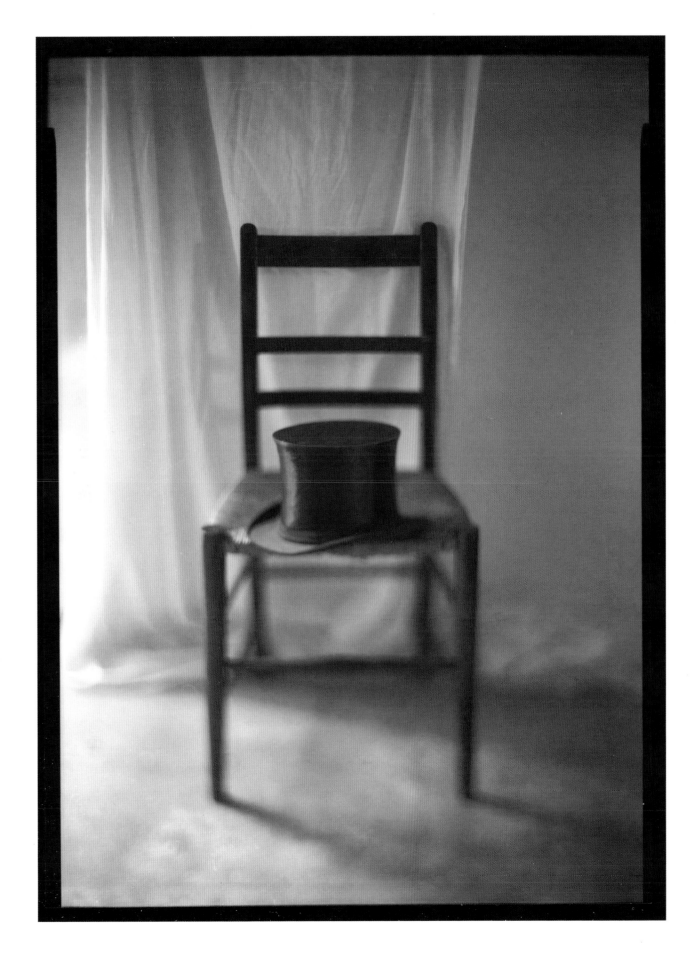

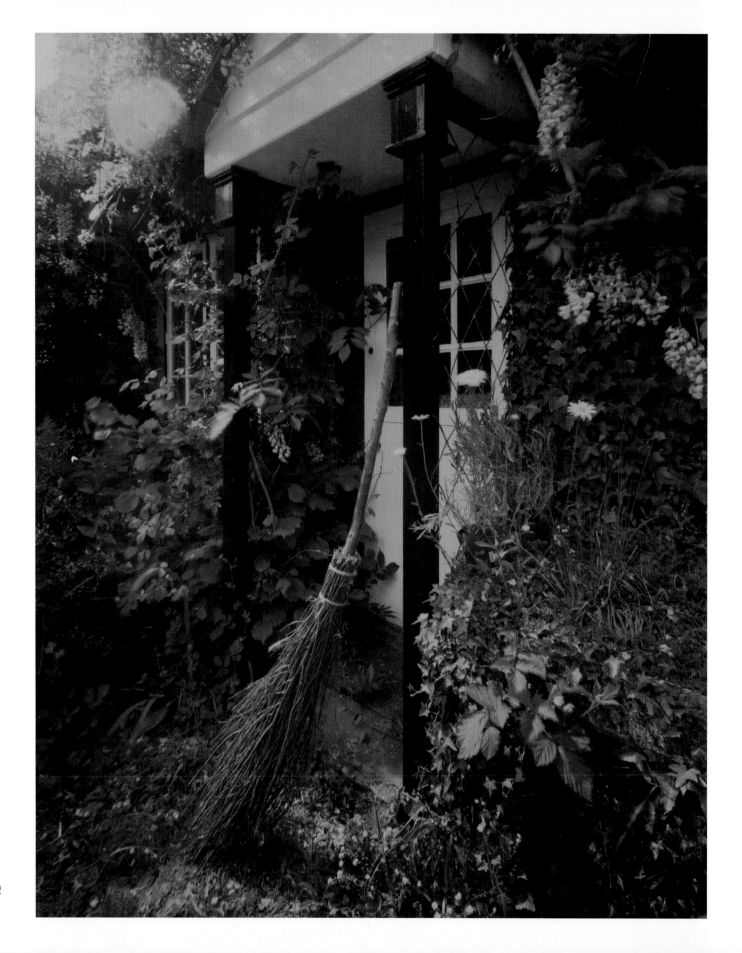

▷ **IVENS & CO**
FOTO-ARTIKELEN
AMSTERDAM
c. 1920

Format 13 x 18cm
on film or plate
Unusual revolving bellows
for format change
Lens: Wray 6in
Wray, London, England

It would appear that this camera
was actually manufactured by
Falz & Werner in Leipzig,
Germany and badged
as an Ivens & Co.

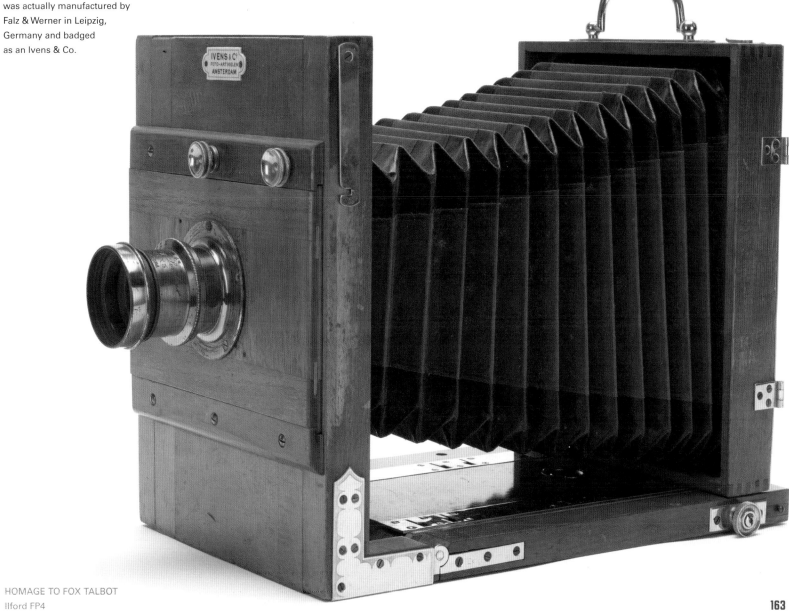

HOMAGE TO FOX TALBOT
Ilford FP4

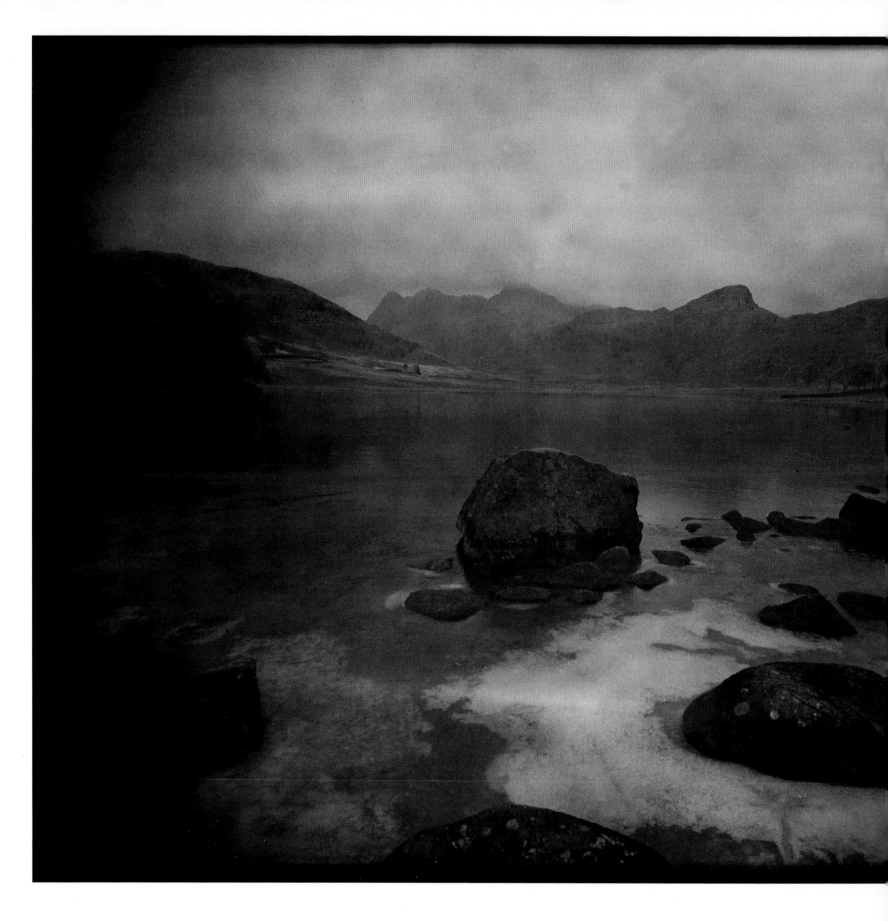

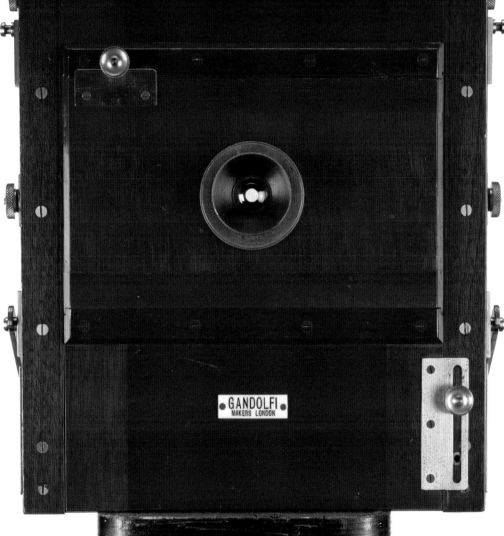

▷ **GANDOLFI UNIVERSAL
WHOLE PLATE
TAILBOARD CUSTOM WIDE**
c. 1930s

*Lens: Pantoscop No. 3, 1911
ROJA vorm. Emil Busch,
Rathenow, Germany
Format: whole plate on 8 1/2 x
6 1/2 in sheet film or plate
Gandolfi, London, England*

BLEA TARN,
GREAT LANGDALE
LAKE DISTRICT
Ilford FP4

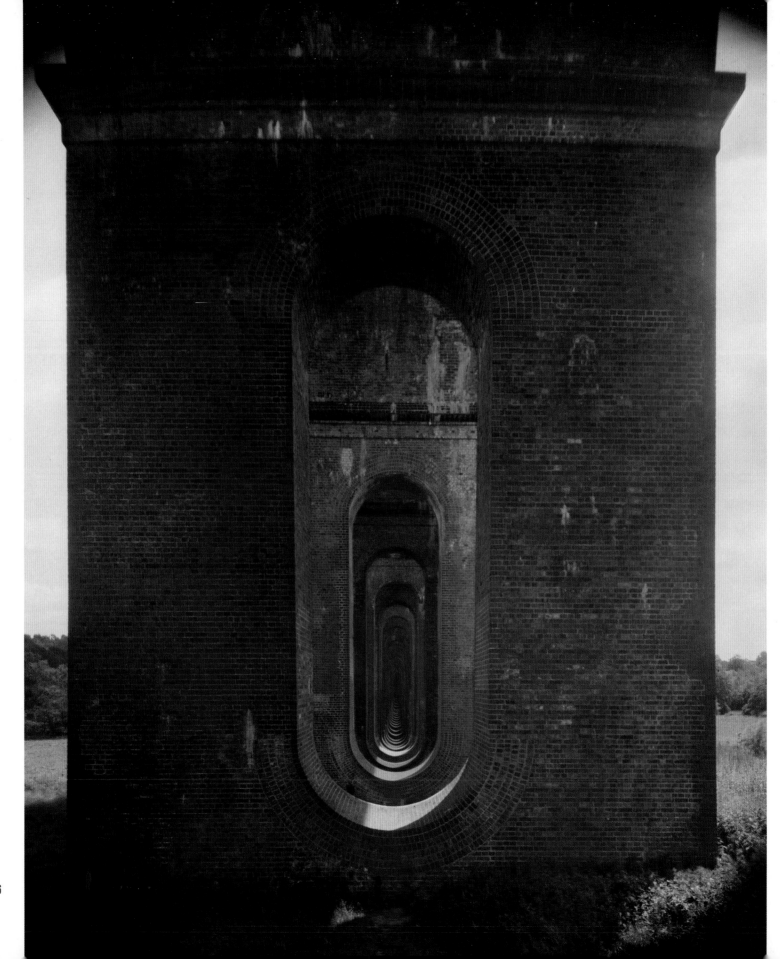

▷ **KODAK ANGLE CAMERA**
c. 1940

Lens: Carl Zeiss Jena Protar
1:18 8.5cm
Format: whole plate on 8 1/2 x
6 1/2 in sheet film or plate
Kodak Ltd, London

BALCOMBE VIADUCT
Efke 25

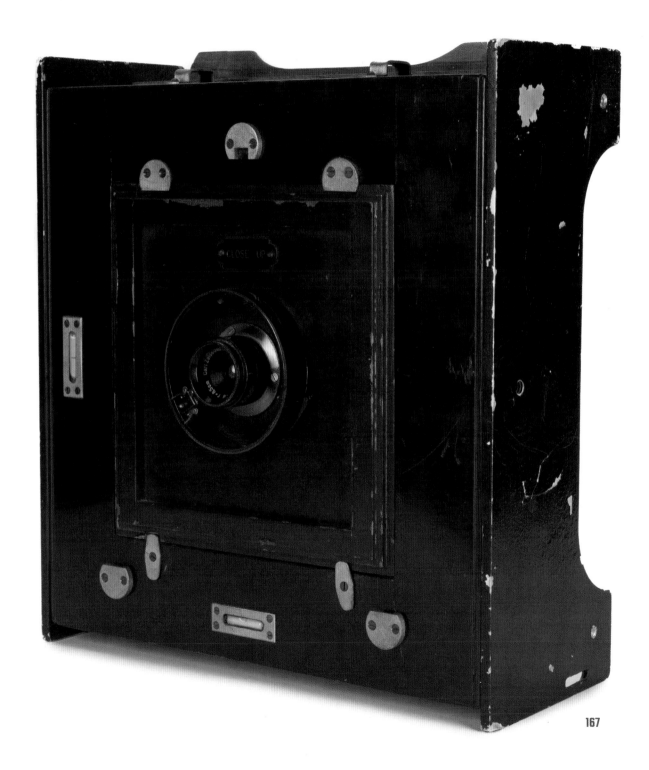

KODAK ANGLE CAMERA

The Kodak Angle camera was intended primarily for forensic work and was popular with police forces for scene-of-crime photography. The camera produced extreme wide-angle photographs, making it ideal for capturing room interiors. The design allowed the camera to sit on the floor or lie on its back to shoot upwards. Often they were attached underneath a large tripod and positioned to photograph the entire floor of a room. I have seen old crime scene photographs where you can see the tripod legs in the shot. The tiny lens makes viewing and composing on the screen very difficult. It's really intended as a 'position roughly and expose' camera — simply remove the lens cap and count your exposure.

Kodak made two versions of the Angle camera. The one shown here has a reversible lens panel, one side marked 'close-up', the other marked 'universal'. A more advanced multi-panel version was used by Bill Brandt for his famous nude series.

A very rare camera and very few seem to remain.

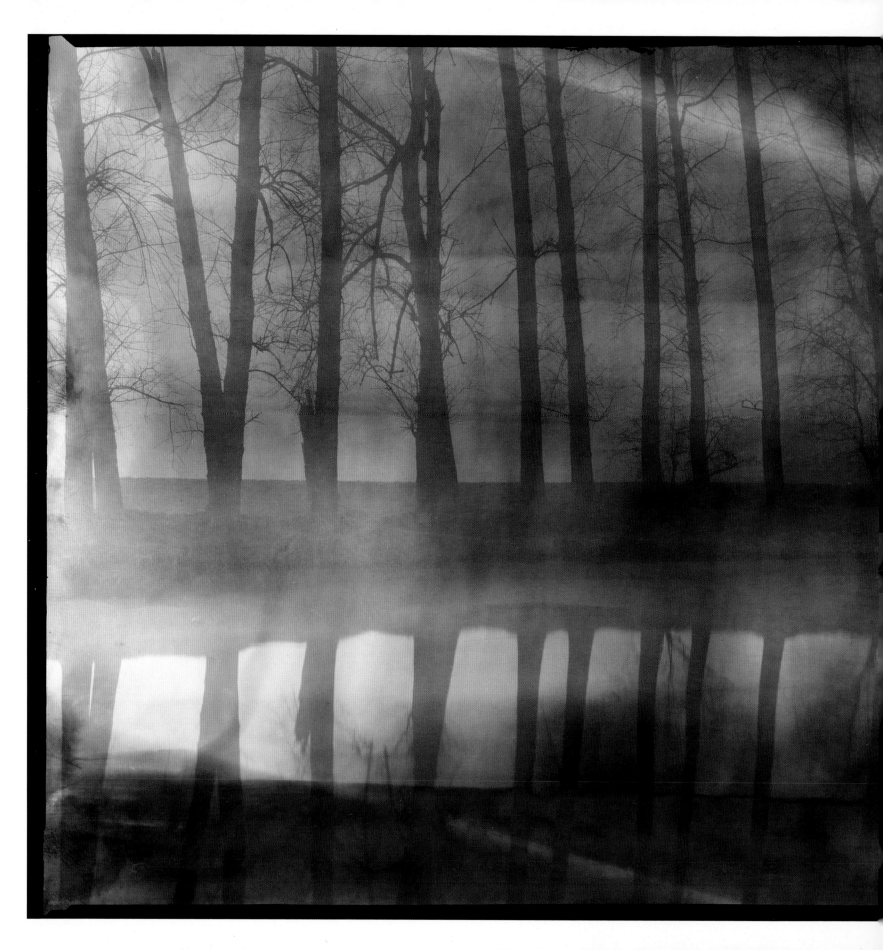

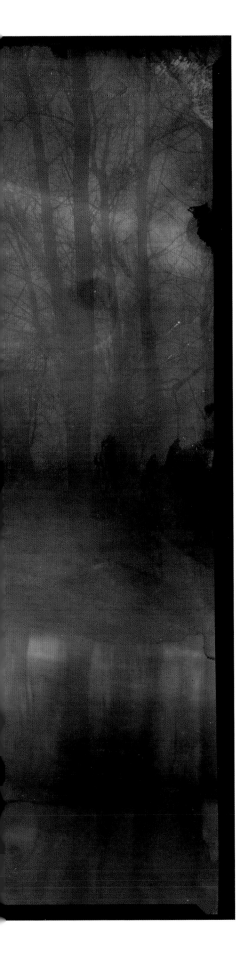

▷ GANDOLFI UNIVERSAL WHOLE PLATE TAILBOARD CAMERA

c. 1920

Lens: brass bound unnamed 1:8 10in approx.
Format: whole plate on 8 1/2 x 6 1/2in sheet film or plate
Gandolfi, London, England

One way to tell an early model Gandolfi is the brasswork. On early examples the brasswork has a more rounded finish because it was produced by specialist outworkers. The later models, crafted entirely by the brothers, have a handmade feel.

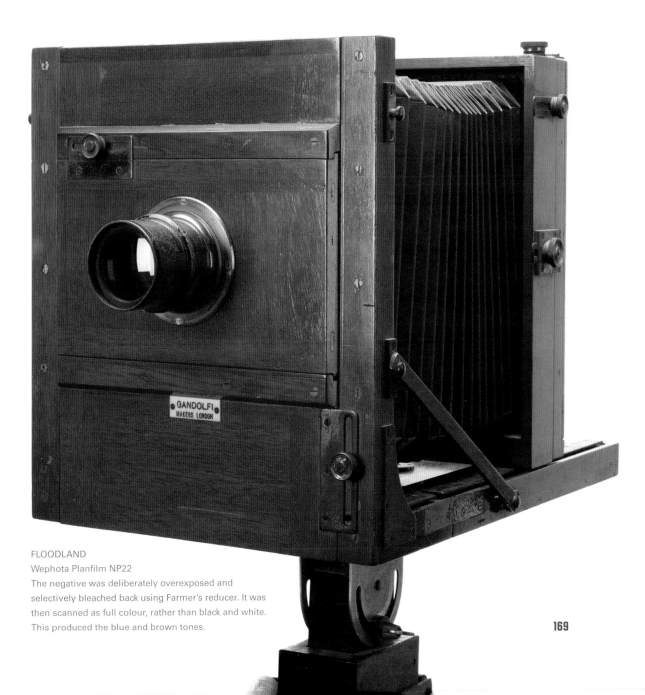

FLOODLAND
Wephota Planfilm NP22
The negative was deliberately overexposed and selectively bleached back using Farmer's reducer. It was then scanned as full colour, rather than black and white. This produced the blue and brown tones.

▷ **W. HEATH OPTICIAN
PLYMOUTH 8 X 5INCH**
c. 1890

*Lens: brass bound unnamed
1:8 8in approx.
Format: rare 8 x 5in
sheet film or plate*

W. Heath Optician is more
likely to be the retailer than the
manufacturer of this camera,
which is possibly a Rochester,
from New York. Heath was active
in producing and retailing fine-
quality scientific instruments.
The 8 x 5 inch format is quite
unusual and is ideal for
landscapes (even though I've
used it here for a still life). The
real benefit of this camera is that
you can just cut a sheet of 10 x 8
inch film in half to produce your
own film stock.

 If you are buying a second-
hand wooden large format
camera that takes the old book
form plate or filmholders, try
to buy a camera with some
included. It can be incredibly
difficult to find matching holders
for cameras, since there are so
many different size variations
from maker to maker. If the
camera has a universal back, it's
quite easy to find the later type
film holders in most formats.
Film and plate holders are also
known as dark slides.

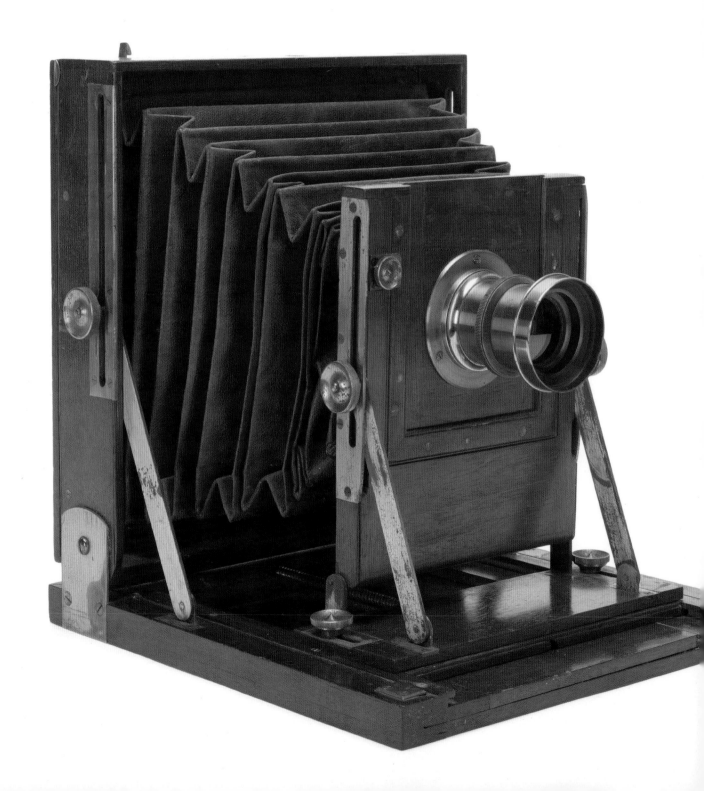

SORCERY
Ilford FP4

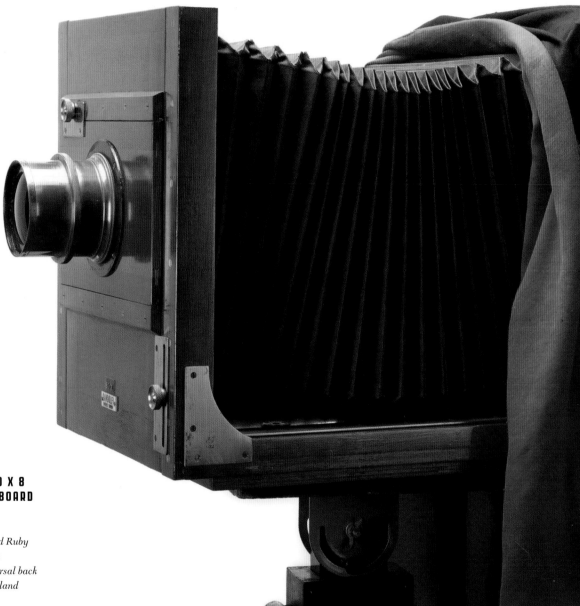

▷ **GANDOLFI RIGID 10 X 8 INCH STUDIO TAILBOARD**
c. 1940

Lens: Thornton-Pickard Ruby Anastigmat 1:6.3 14in
Format: 10 x 8in universal back
Gandolfi, London, England

This rare Gandolfi was of rigid construction, rather than the more typical folding tailboard design. Probably manufactured for scientific use.

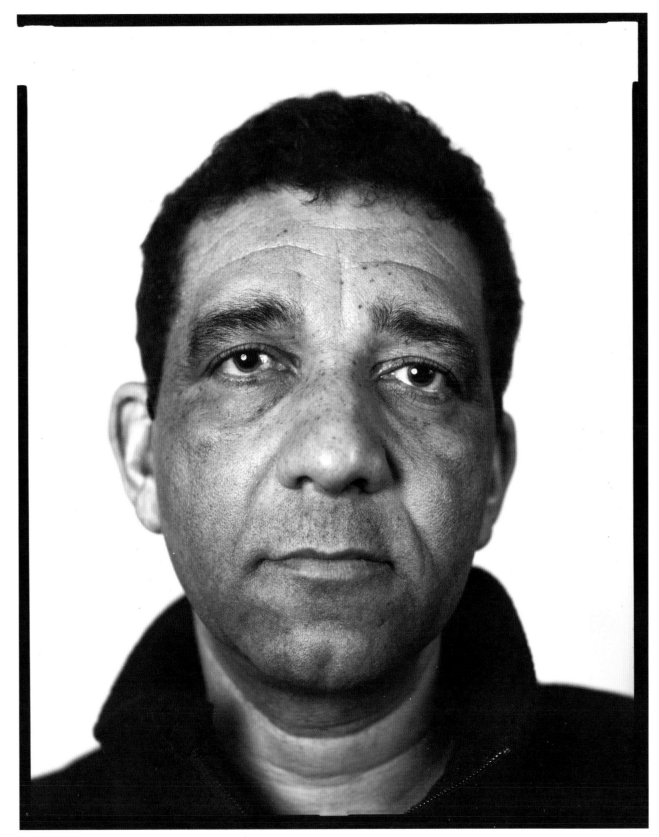

LANCE
Efke 25

▷ ## GEORGE HARE NEW PATENT FIELD CAMERA
1882

Lens: WWII vintage, fast f4 Ross Air Ministry 8 ¹/₂in wide-angle Xpres (used for aerial surveillance)
Format: 10 x 8in holders converted to take wet collodion plates
George Hare, London, England

George Hare, 1828–1913, was a cabinetmaker from York. He moved to London in the mid-1850s and started working for the camera maker Thomas Ottewill. By 1863, Hare had his own company making the finest cameras money could buy. Hare's new patented model was a milestone in camera design. Produced in all formats from quarter plate to 12 x 15 inches, it was much copied by other makers.

An arrow symbol, or A.M., stamped on the lens barrel, indicates a lens produced for the war effort. A.M. stands for Air Ministry. A lot of these lenses were used in reconnaissance aircraft. They are often quite large apertures as most were designed to shoot infinity fully opened. This makes them ideal for wet collodion, which, because of its low speed, requires long exposures.

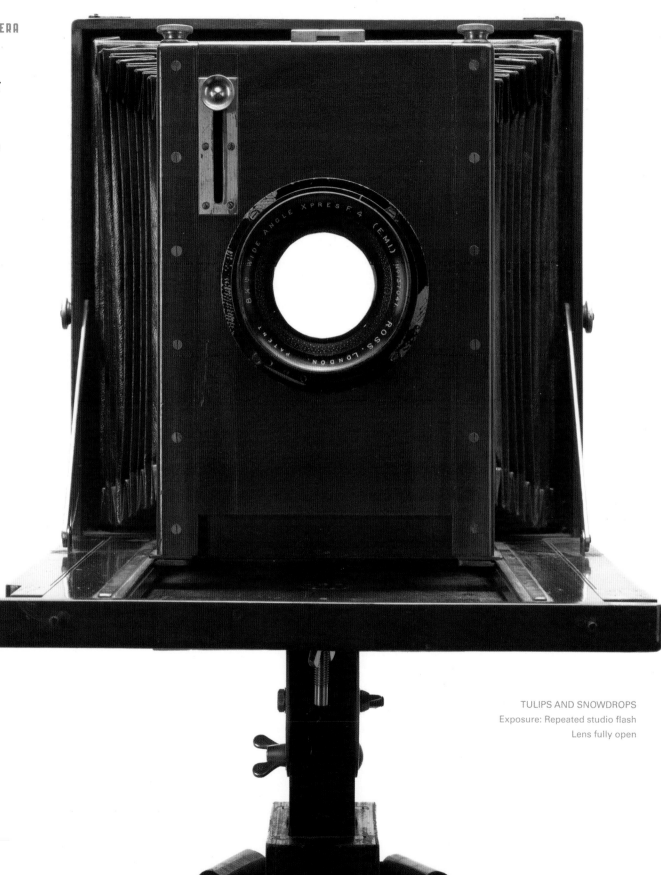

TULIPS AND SNOWDROPS
Exposure: Repeated studio flash
Lens fully open

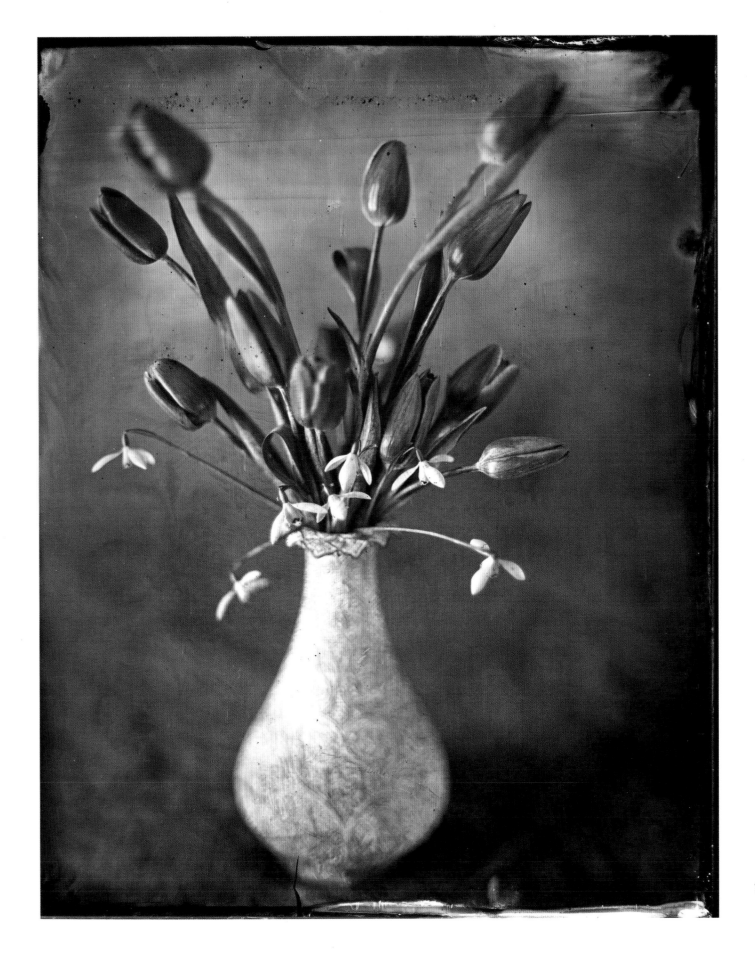

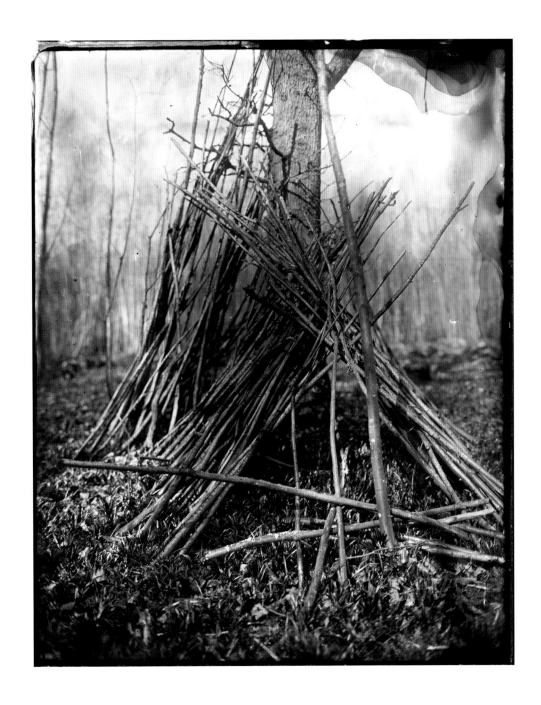

WILLOW TREE
Lens: Ross Air Ministry 8½in
wide-angle Xpres
Exposure: 30 seconds
Lens fully open

ABANDONED DEN
Lens: Thornton-Pickard Ruby 14in
Anastigmat
Exposure: 90 seconds
Lens fully open

Both images taken with the
George Hare field camera

177

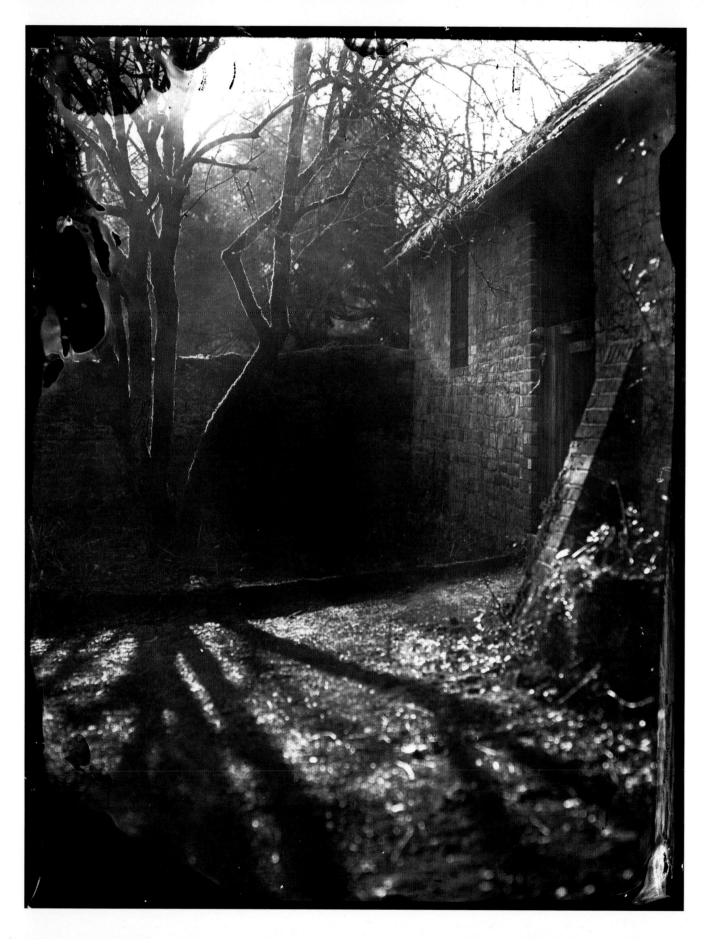

THE STABLE
Lens: Thornton-Pickard Ruby
14in Anastigmat
Exposure: 90 seconds
Lens fully open

SUNFLOWERS IN THE EVENING
Lens: Thornton-Pickard Ruby
14in Anastigmat
Exposure: 2 minutes
Lens fully open

Both images taken with the
George Hare field camera

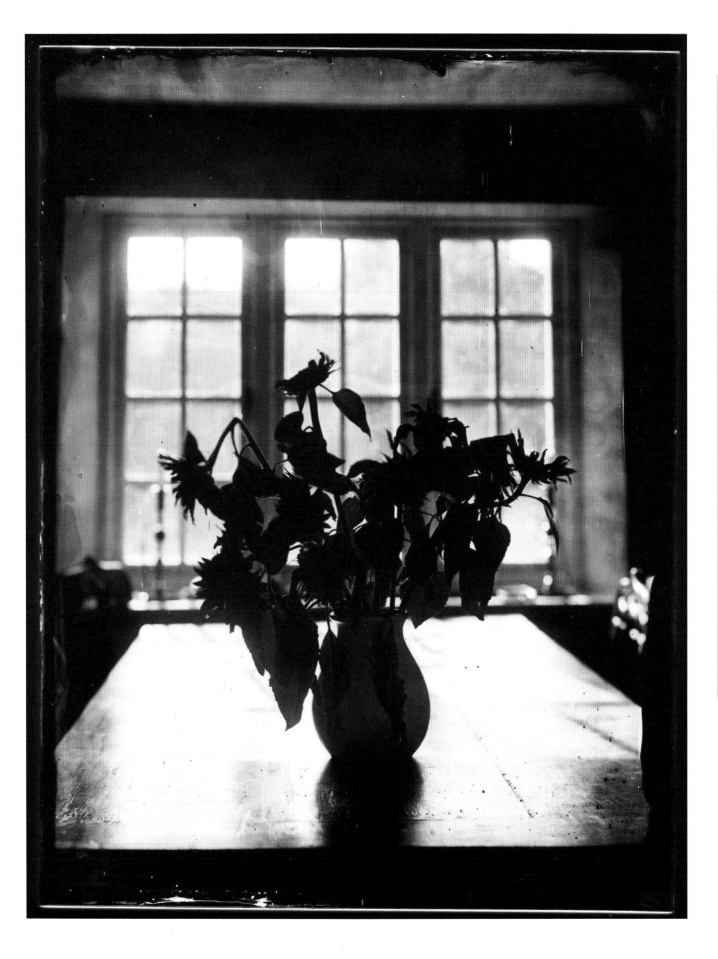

THE COLLODION PROCESS

As the name suggests, wet collodion plates are hand-coated onto glass and exposed whilst wet. The process was invented in 1851 by Frederick Scott Archer, supplanting the daguerrotype and later superseded by dry gelatin plates. A piece of glass is thoroughly cleaned and then coated on one side with a collodion solution. This plate is then immersed in a tank of silver nitrate and after a few minutes is sensitised and ready to expose in a camera. After exposure, the plate is removed from the holder and developed in ferrous sulphate. The image is fixed in sodium thiosulphate and the plate dried and varnished with a mixture of gum sandarac, alcohol and lavender oil. The plate is then ready to print or scan. The necessity for the plate to be exposed within ten minutes of coating means that you either have to have a portable darkroom or be studio-based. The runs, streaks and bubbles can add character to the finished print. The great thing about wet collodion is that the photographer can mix their own emulsion and chemicals and is therefore not dependent on mass manufacturers.

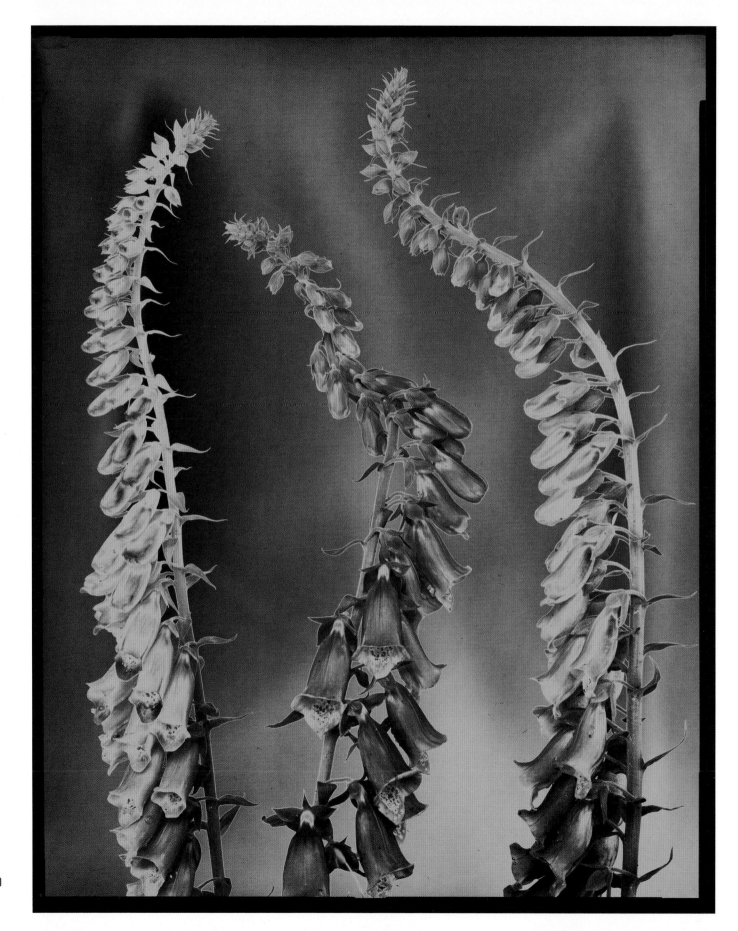

▷ **KODAK VIEW CAMERA
10 X 8 INCH**

c. 1910

*Lens: Great Wall I.S. 1:4.5 21cm
Beijing, China, c. 1970
Format: 10 x 8in film or plate
Kodak Ltd, London, England*

This unusual 21cm wide-angle lens is something of a rarity. I found it at a camera fair in London and here have taped it to the lens plate to do a test shot. I have owned this camera for twenty years, but it had no bellows and the bottom sliding rail was missing. I was lucky enough to find a set of bellows exactly the right size and to be able to restore the camera myself. I am currently making a lens panel in order to be able to do away with the black tape!

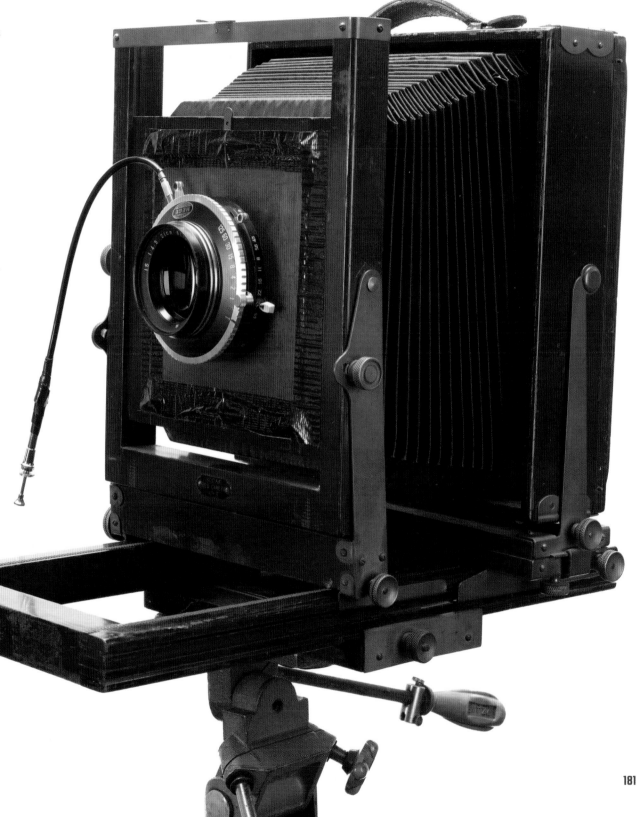

FOXGLOVES (DIGITALIS)
Ilford FP4 solarised negative

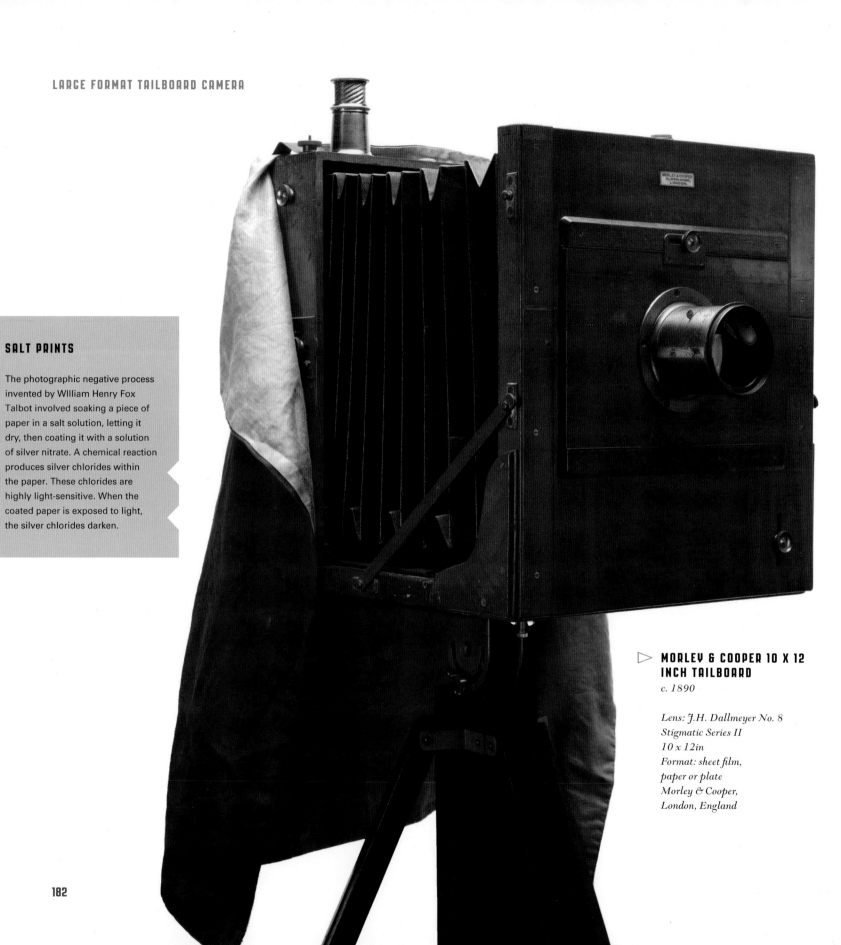

SALT PRINTS

The photographic negative process invented by WIlliam Henry Fox Talbot involved soaking a piece of paper in a salt solution, letting it dry, then coating it with a solution of silver nitrate. A chemical reaction produces silver chlorides within the paper. These chlorides are highly light-sensitive. When the coated paper is exposed to light, the silver chlorides darken.

▷ **MORLEY & COOPER 10 X 12 INCH TAILBOARD**
c. 1890

*Lens: J.H. Dallmeyer No. 8
Stigmatic Series II
10 x 12in
Format: sheet film,
paper or plate
Morley & Cooper,
London, England*

AFTER THE SUMMER
Salt print from a salt negative

▷ **UNBADGED 10 X 12 INCH
FIELD CAMERA**
c. 1900

*Lens: J.H. Dallmeyer 12 x 10in
Rapid Rectilinear
Format: sheet film, paper or plate
10 x 12in*

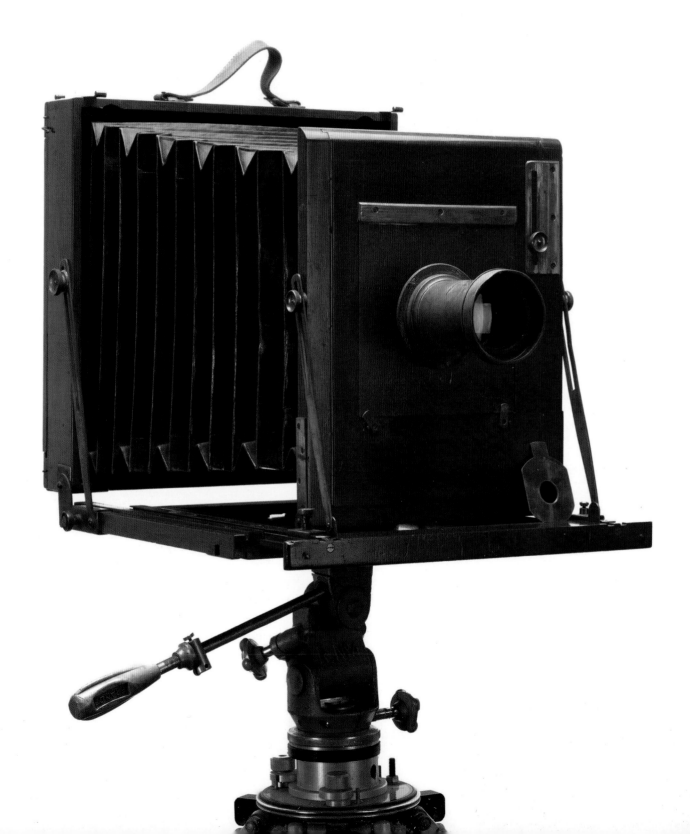

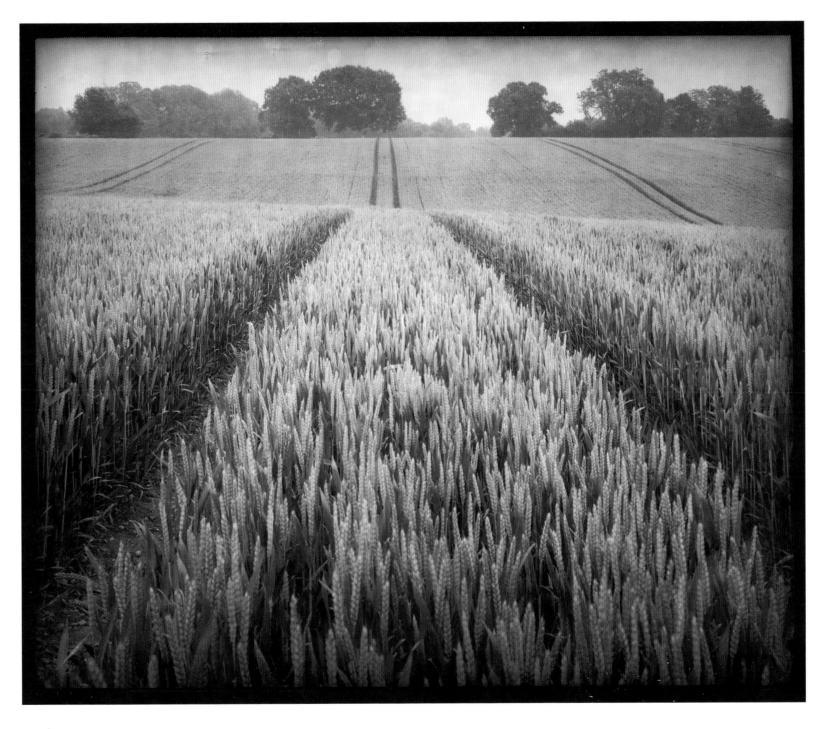

HUNDRED ACRE FIELD
Wephota Planfilm NP22

▷ **HUNTER PENROSE
PROCESS CAMERA**
c. 1950

*Lens: Hermagis Paris Eidoscope
1:4.5 No. 2
Format: 12 x 15in fitted with
a 10 x 8 reducing back
Hunter Penrose,
London, England*

This Hunter Penrose would
originally have run on a rail
system. It was designed for
reprographic purposes, and
the Hunter Penrose company,
which was founded in 1896,
is still in the reprographic and
printing business today. As
well as these 'smaller' models,
they manufactured enormous
repro cameras — in some
cases standing more than six
feet tall. I had the camera ten
years before I was able to find a
strong enough stand for it. Even
though this aluminium ex-Danish
military stretcher trolley looks
out of place with the brass and
mahogany, it does the job well.
These cameras are starting to
gain in popularity as they lend
themselves extremely well to wet
plate conversions, but I prefer to
use paper and sheet film in the
original film holder.

DECANTERS
Fuji X-ray Film

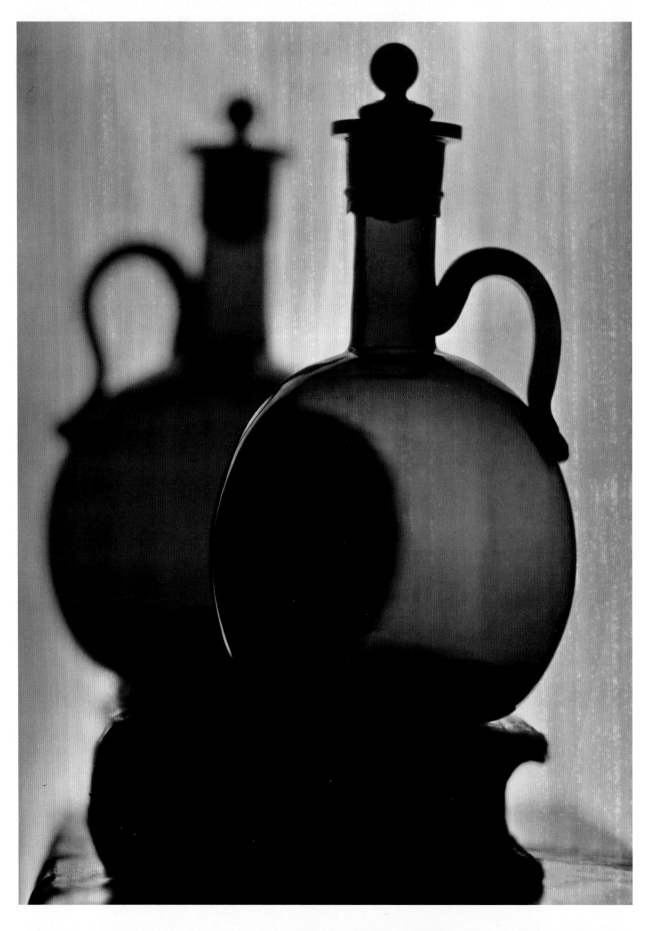

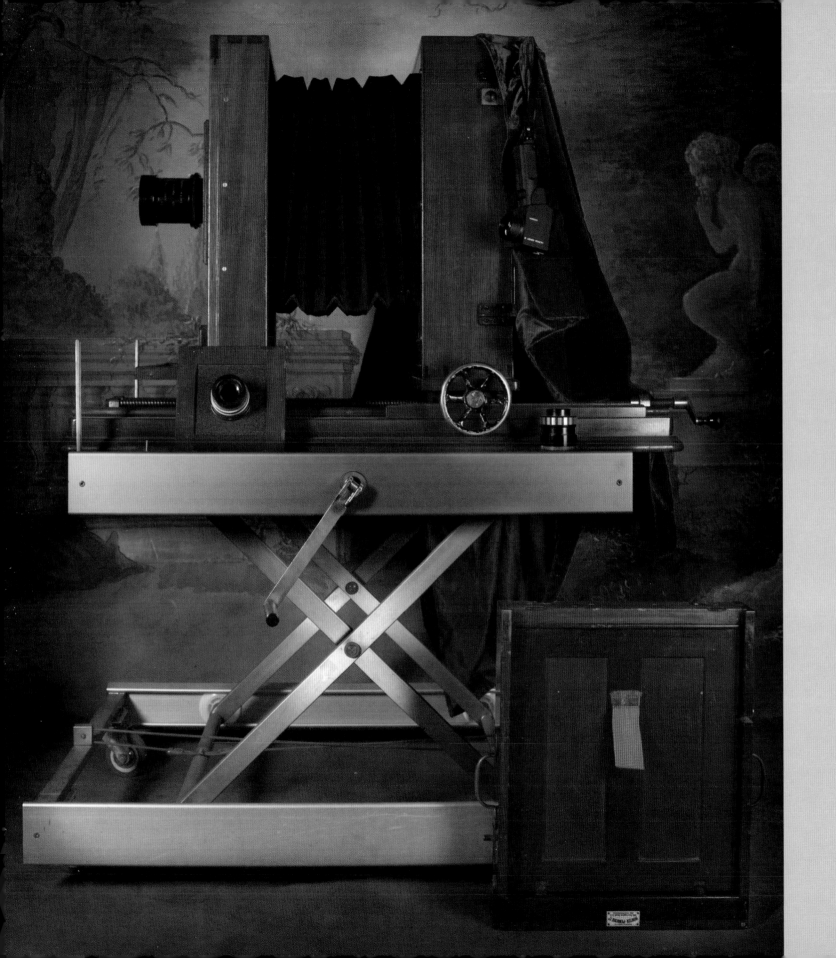

4

REINVENTIONS

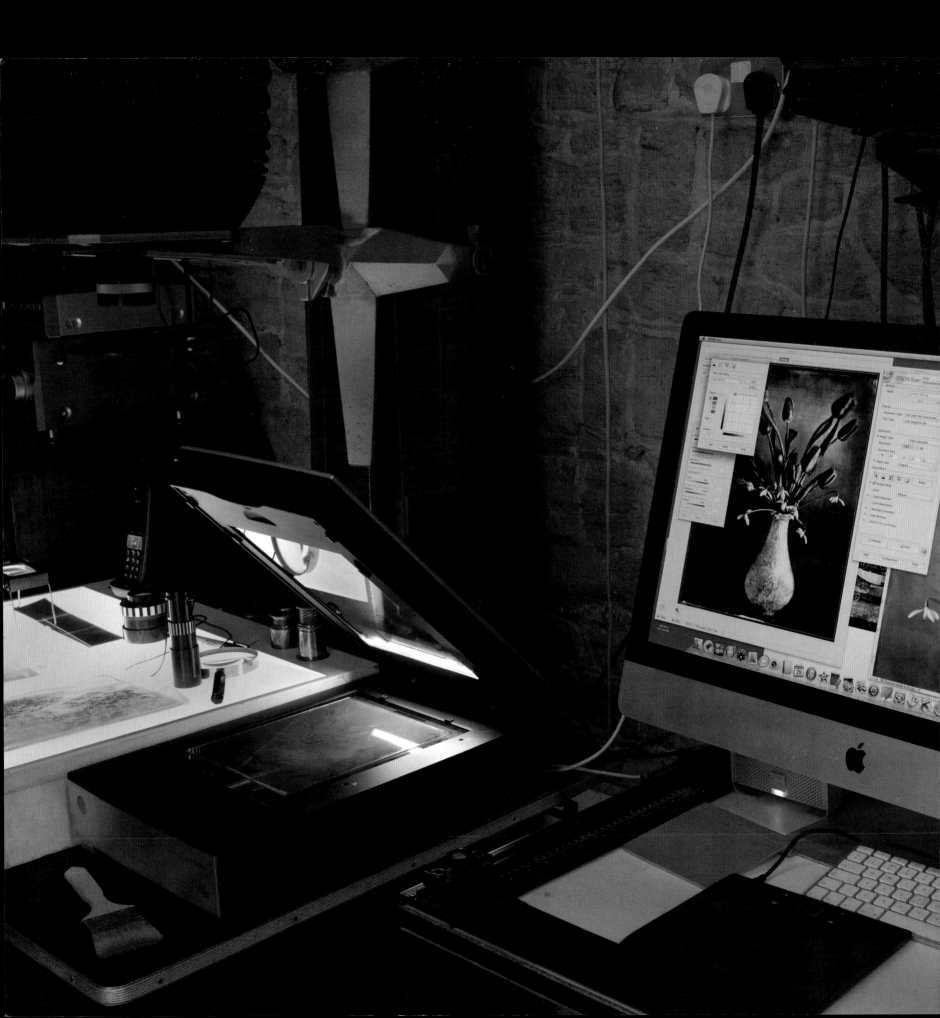

REINVENTIONS

This is where we cover a few topics that don't fit neatly into any other section, from the instant film Polaroid SX70, which has recently risen from the ashes through the introduction of a new film manufacturer, to the simplest of photographic principles, the pinhole; constructing custom cameras and, finally, the fusion of analogue and digital equipment. It was not that long ago that the only way to digitise film was to have a scan made by a professional repro house using hugely expensive drum scanners. It is now relatively easy to digitise film using one of the vast array of home scanners available. Even if you don't have access to a scanner, you can simply photograph the film with a digital camera fitted with a macro lens or even use a smartphone and invert the result using editing software. Several companies now make special film holders to make it easier to photograph film with a phone. Before editing software was available, the only way to remove dust marks and scratches from print and film was to paint them out using special inks—how things have changed!

POLAROID SX70 LAND CAMERA NO. 2

The first model SX70 was released in 1972. By the following year Polaroid was making 5,000 a day.

The camera's design was like nothing seen before. A collapsible reflex housing meant the camera could fold completely flat.

The word Land used in association with Polaroid refers to its inventor, Dr Edwin Land, who in 1929 produced the world's first synthetic polarising material for commercial use. The Polaroid Corporation was founded and became hugely successful selling polarising sunglasses.

In 1943 Edwin Land's three-year-old daughter asked why she couldn't see the photograph he had just taken. This moment sparked an idea which took five years to become a reality. Land's invention changed photography dramatically. By 1956 Polaroid had sold one million cameras.

In 1976 Kodak announced its own instant photo system, only to be sued by Polaroid. The court ordered Kodak to pay $909.5 million dollars and stop instant film production.

It is impossible to estimate how many cameras Polaroid have made, but one source suggests that in 1978 alone they sold 14.3 million worldwide.

The professional market loved Polaroid as much as the amateur. Photography studios everywhere shot Polaroids to determine exposure and check composition. Camera manufacturers like Hasselblad produced Polaroid backs (basically the back of a Polaroid camera grafted onto an adaptor plate).

Polaroid cameras and film were massively affected by the advent of digital.

In 2009 a group called the Impossible Project raised funds to buy the last factory making Polaroid film and now supplies film for the SX70 and other models. It is chemically different from the original material and takes a lot longer to develop, but is capable of great results.

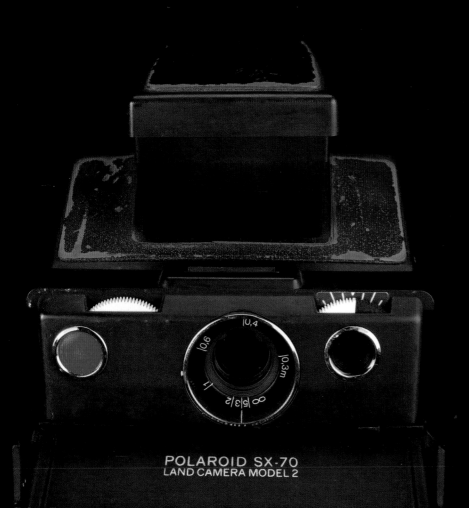

POLAROID SX-70
LAND CAMERA MODEL 2

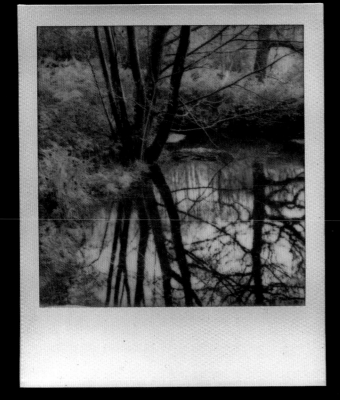

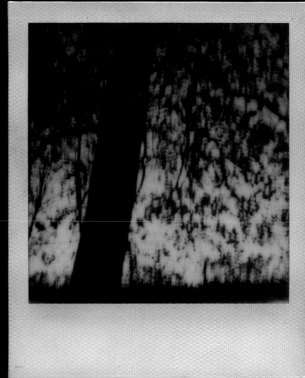

SNAPS
Taken on Impossible Project
colour instant film

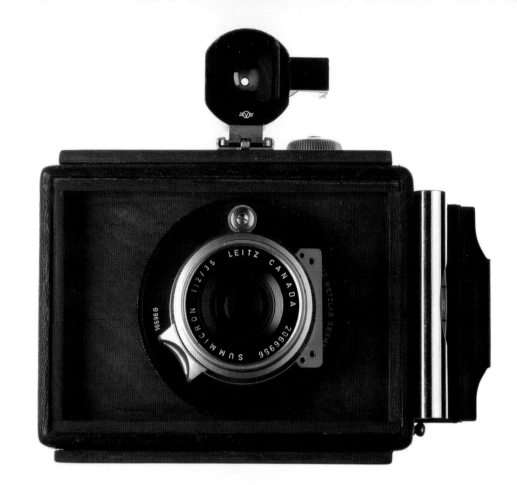

▷ **CUSTOM CIRCULAR IMAGE CAMERA**
2011

Lumma 6 x 9cm roll film back attached to a simple mahogany body fitted with a Leitz bayonet mount
Lens: Leitz Canada Summicron 1:2 35mm
Viewfinder from Hasselblad SWC

This was a project undertaken a few years ago. I wanted to make some circular images and achieved this by mounting a roll film back onto a mahogany body recycled from an old studio camera and fitting it with a 35mm focal length lens originally intended for a Leica. All lenses produce a circular image, but usually they are cropped by the camera film gate. The large opening of the medium format back means that everything the lens projects is exposed onto the film.

CUSTOM CAMERA BUILDING

I often cobble projects together with tape and glue first to see how things work. Start with a piece of ground glass for a viewing screen. You can make this yourself by grinding the surface of a piece of plain glass with silicon carbide, or use the screen out of an old camera. If you can't find glass, opaque plastic or even tracing paper stretched over a frame will do. Use the screen to work out the focal length of a lens. Hold the lens up to a well-lit subject with the aperture fully open. Place the glass between you and the lens and move the lens backwards and forwards until the image is in focus on the viewing screen. This will give you an approximate focal length and thus the dimensions for the camera. Useful if the lens has no focal length marked.

Never dismiss a broken or damaged camera. A jammed-up bit of old rubbish may have a Dallmeyer Super 6 lens attached (these can be worth many thousands of pounds!).

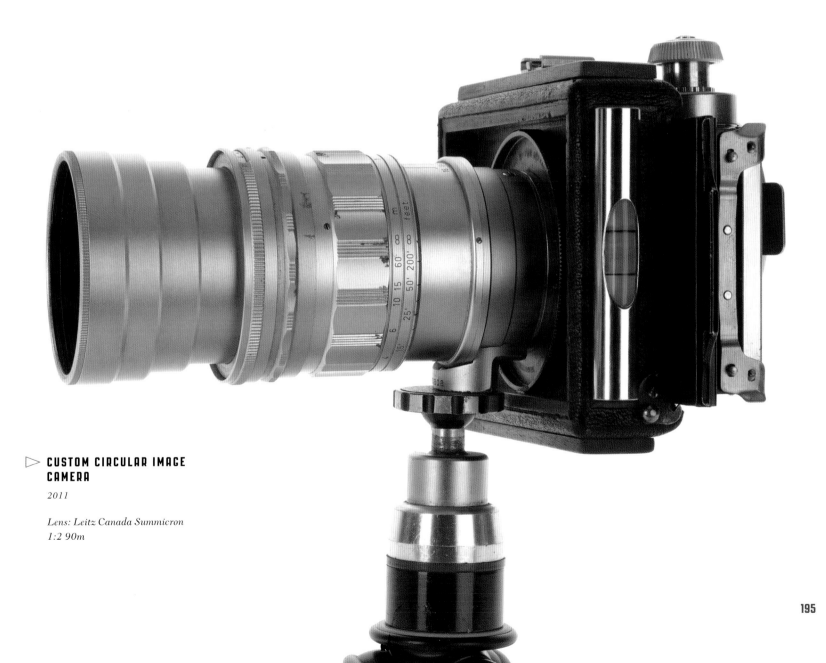

▷ **CUSTOM CIRCULAR IMAGE CAMERA**

2011

Lens: Leitz Canada Summicron
1:2 90m

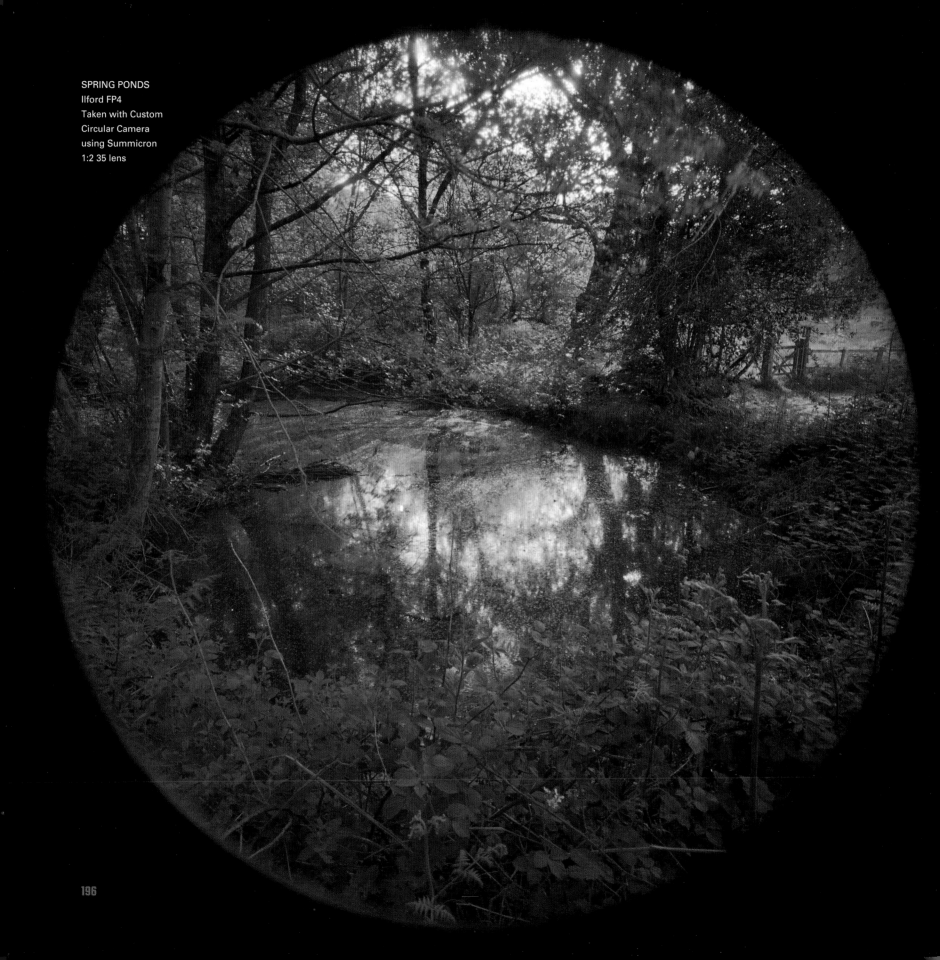

SPRING PONDS
Ilford FP4
Taken with Custom
Circular Camera
using Summicron
1:2 35 lens

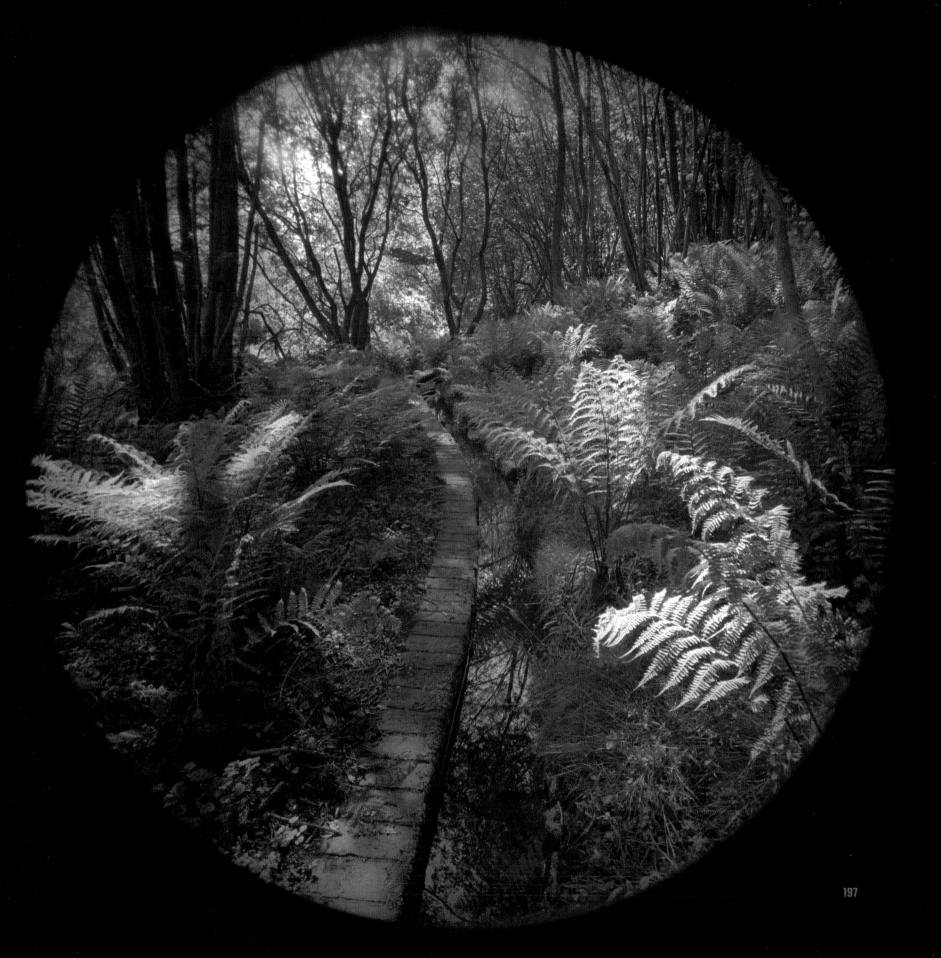

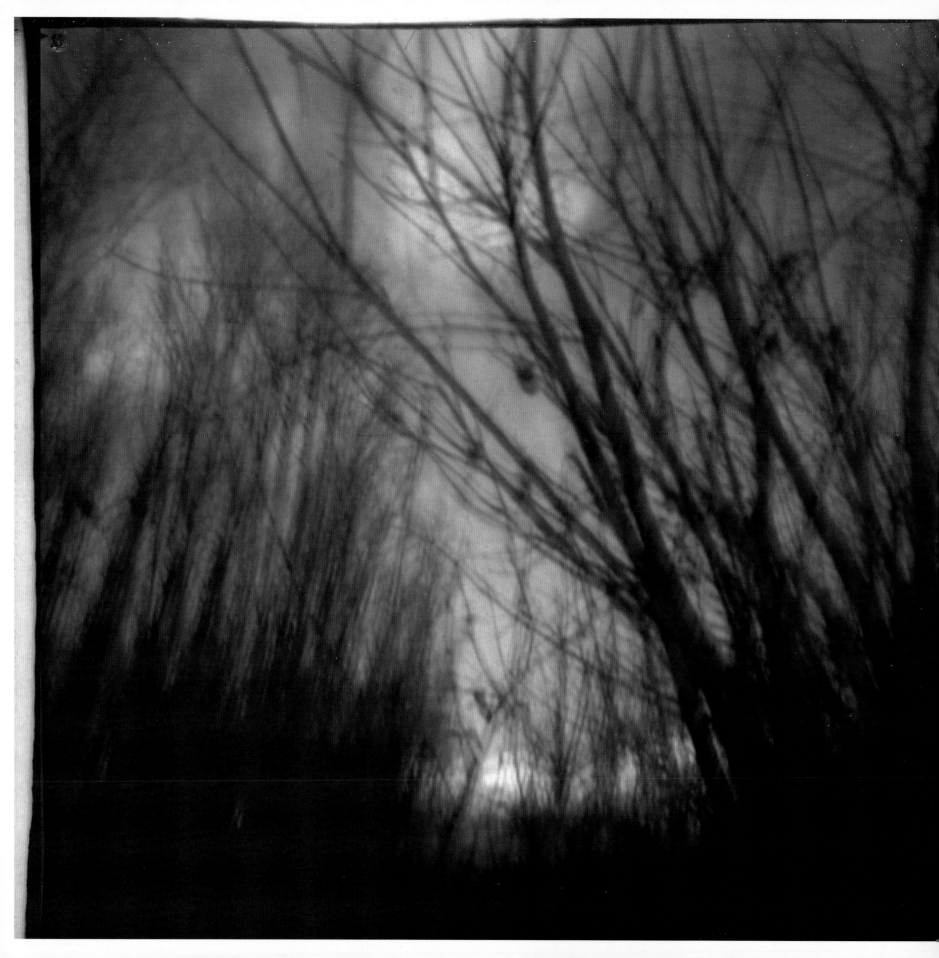

▷ PINHOLE CAMERA
2014

*The simplest form
of photography.
5 x 5in cardboard box*

Pinhole photography is a great introduction to analogue image-making. Pinhole cameras can be made out of virtually anything that can be made light-tight, from wheelie bins to matchboxes. The biggest I have made is 40 x 40 inches, out of polystyrene sheets painted black. The example here is a small cardboard box.

The pinhole has ben drilled into a very thin piece of brass and then attached to the inside of the box. The tiny lens cap is made of foam rubber. Simply open the box in the dark and load the photographic paper or film into the back. Ensure the box is sealed shut before removing the lens cap to expose the film.

WIND IN THE COPPICE
Ilford Multigrade Paper

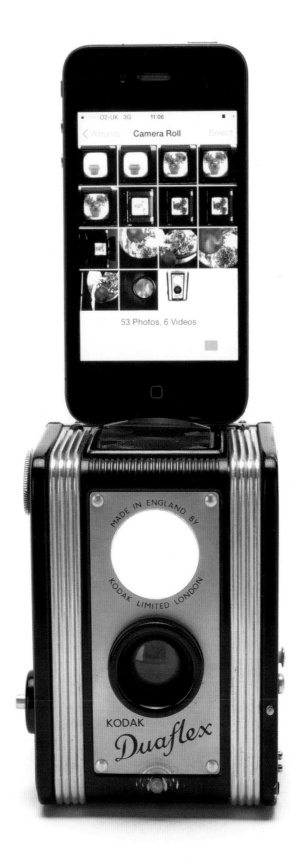

▷ **KODAK DUAFLEX**
FAUX TLR
1955

620 roll film
Kodak Ltd, London, England

IPHONE 'THROUGH THE VIEWFINDER' PHOTOGRAPHY

This is something to try if you find a suitable camera (a cheap, twin-lens model — see page 103) and want to make an unusual image. In this case an Apple iPhone 4 was used to photograph the viewfinder screen of a Kodak Duaflex, but any digital camera or phone is suitable. The resultant image records the picture projected onto the viewfinder, rather than what the camera actually takes. Certain cameras have particularly bright magnified viewfinders, such as Ensign's Ful-Vue and certain models of Brownies. The iPhone is simply held over the viewing window and zoomed in slightly. You will need to do this under cover of a piece of dark material (or a coat) to ensure no stray light reflects on the viewfinder screen while you're taking the picture. The results have a strange, ethereal quality and it's a great first step into retro photography. All the cameras mentioned can be picked up very cheaply.

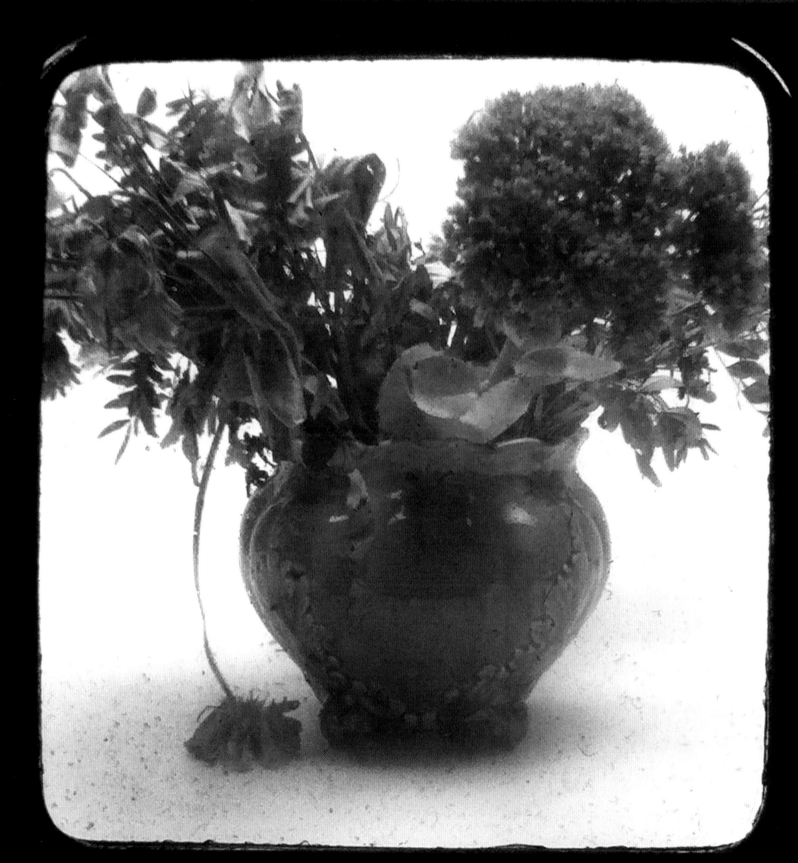

▷ LINA TOY CAMERA (DIANA TYPE)

c. 1970

Lens removed and attached to iPhone 4

This Lina camera shutter had malfunctioned so the lens was removed and attached to an iPhone. This creates a fantastic macro, complete with blurry chromatic problems, which all seem to add to the effect.

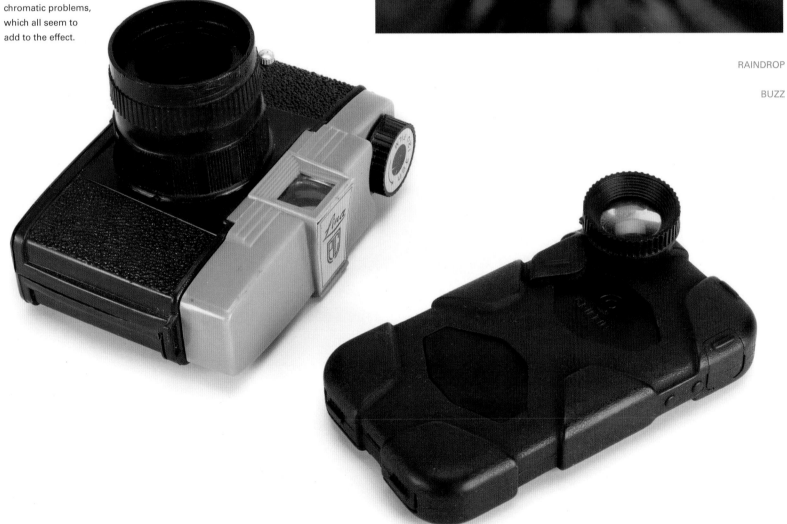

RAINDROP

BUZZ

▷ **FUJI XPRO 1**
2012

*Format: 16 megapixel with
an 'X-Trans' CMOS sensor
APS C-size
Fuji, Japan*

The beauty of this smaller format
retro-styled digital camera is its
electronic viewfinder, meaning
there is no need for a reflex
housing. An adaptor can be used
between the camera body and
lens, allowing retro 35mm film
lenses to focus on the digital
sensor.

 In the past it was very
difficult and costly to adapt one
manufacturer's lens to another
maker's body. There are now
mounts available to attach
virtually every 35mm lens ever
made to this Fuji Xpro 1.

CAMPION FIELD
Fuji XPro1 with Leitz 90mm
Summicron lens shot fully
open at f2

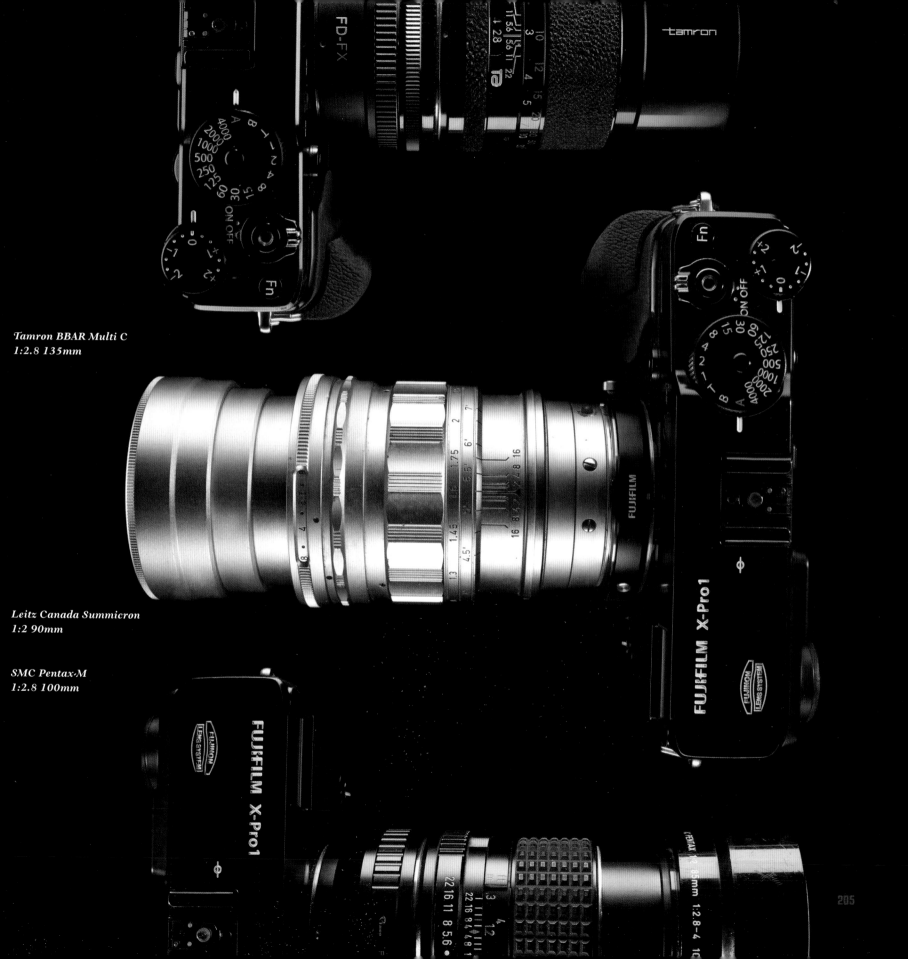

Tamron BBAR Multi C
1:2.8 135mm

Leitz Canada Summicron
1:2 90mm

SMC Pentax·M
1:2.8 100mm

The first digital camera was invented in 1975 by Steven Sasson, whilst working for the Eastman Kodak Company. It shot only 0.01 megapixels and the black and white images were recorded onto magnetic tape cassette. In 2009 Sasson was awarded the National Medal of Technology and Innovation by President Obama.

▷ **PENTAX 645Z**
2014

51.4mp sensor
Lens: Hartblei 1:3.5 45mm
Ukrainian manufacture,
Pentax mount

When developing its 645 digital, Pentax sensibly kept the original lens mount for the 645 film cameras. This is perfect for old-time photographers like me, who don't feel comfortable with autofocus lenses. I find the quality of the Hartblei lens exceptional, giving a real painterly feel. All the camera portraits in this book were shot on this camera, with old analogue lenses. The Pentax 6 x 7 lens range can also be used with this camera, via an adaptor supplied by Pentax. Independent manufacturers produce adaptors which permit the use of Hasselblad lenses. Truly the best of both worlds.

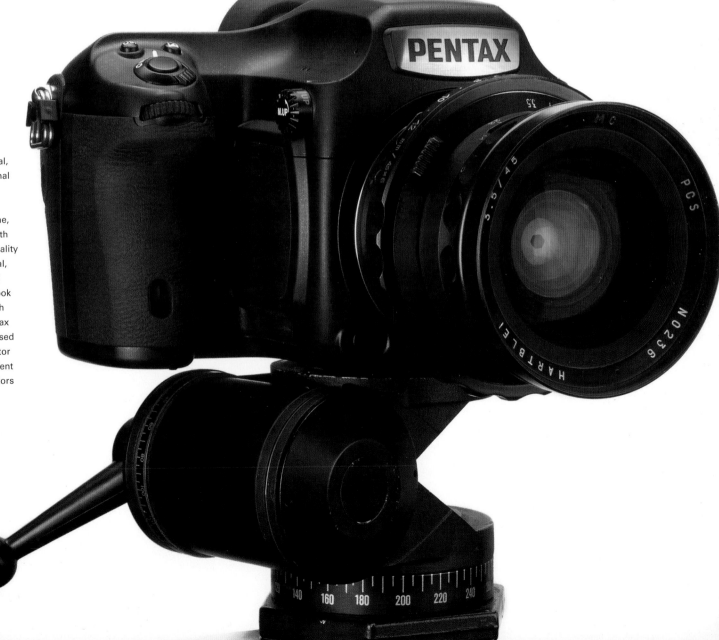

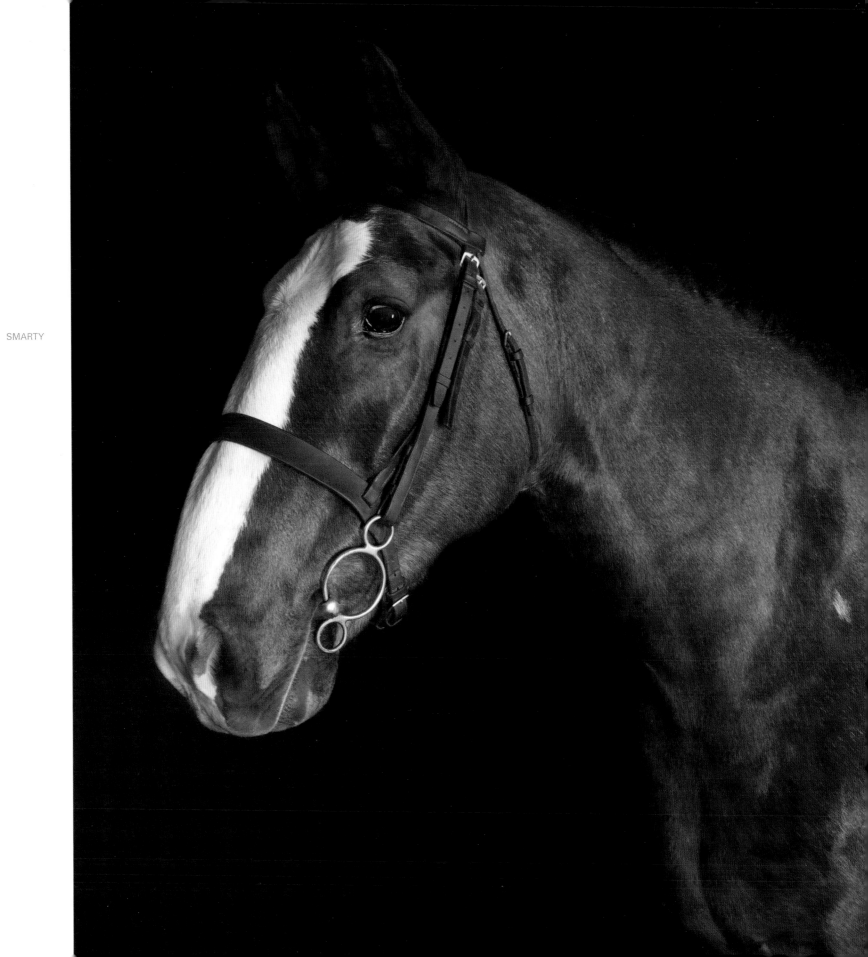

SMARTY

INDEX

Retro Photo is not intended to be a technical manual, but to be of interest to the casual browser with no prior knowledge of film photography as well as to the advanced user who may not have come across some of the cameras featured here. All views expressed are David Ellwand's personal opinions and whilst every effort has been made to verify the accuracy of all the technical information included, no camera or photographic company of any kind has been involved in the creation of this book.

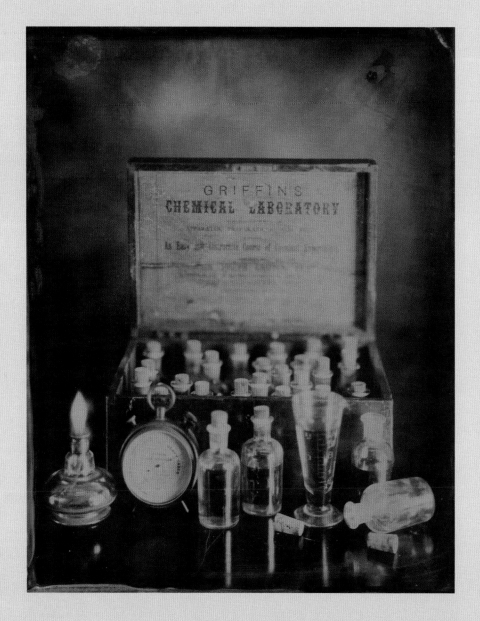

THE SOCIETY OF
SUPERNATURALS
Wet collodion taken with George
Hare 10 x 8 inch (see page 174)

We are indebted to the following
sources for much of the technical
information included in this book:

*CAMERA: From Daguerrotypes to
Instant Pictures,* Brian Coe, 1978

*The Focal Encyclopaedia of
Photography,* ed. Frederick
Purves, 1956

*The Illustrated History of the
Camera,* Michel Auer, 1975

McKeown's Cameras, 2006

FOLMER AND SCHWING
11 x 14 inch
Awaiting restoration.
Taken with Herbert George
Satellite (see page 74).